Realistic Architectural Visualization with 3ds Max and mental ray

Second Edition

Realistic Architectural Visualization with 3ds Max and mental ray

Second Edition

Roger Cusson
Jamie Cardoso

ELSEVIER

AMSTERDAM • BOSTON • HEIDELBERG • LONDON • NEW YORK • OXFORD
PARIS • SAN DIEGO • SAN FRANCISCO • SINGAPORE • SYDNEY • TOKYO

Focal Press is an imprint of Elsevier

Focal Press is an imprint of Elsevier
30 Corporate Drive, Suite 400, Burlington, MA 01803, USA
Linacre House, Jordan Hill, Oxford OX2 8DP, UK

Notices

Knowledge and best practice in this field are constantly changing. As new research and experience
broaden our understanding, changes in research methods, professional practices, or medical treatment
may become necessary.

Practitioners and researchers must always rely on their own experience and knowledge in evaluating
and using any information, methods, compounds, or experiments described herein. In using such
information or methods they should be mindful of their own safety and the safety of others, including
parties for whom they have a professional responsibility.

To the fullest extent of the law, neither the Publisher nor the authors, contributors, or editors assume
any liability for any injury and/or damage to persons or property as a matter of product liability,
negligence or otherwise, or from any use or operation of any methods, products, instructions, or ideas
contained in the material herein.

Library of Congress Cataloging-in-Publication Data
Cusson, Roger.
Realistic architectural visualization with 3ds max and mental ray / Roger Cusson, Jamie Cardoso. –
2nd ed.
 p. cm.
Previous ed. published as: Realistic architectural rendering with 3ds max and Mental ray.
Includes bibliographical references and index.
ISBN 978-0-240-81229-8 (pbk. : alk. paper) 1. Architectural rendering–Computer-aided design.
2. 3ds max (Computer file) 3. Mental ray (Computer file) I. Cardoso, Jamie. II. Title.
NA2728.C87 2009
720.28'40285536–dc22

2009034334

British Library Cataloguing-in-Publication Data
A catalogue record for this book is available from the British Library.

ISBN: 978-0-240-81229-8

For information on all Focal Press publications
visit our website at www.elsevierdirect.com

09 10 11 12 13 5 4 3 2 1

Printed in Canada

Working together to grow
libraries in developing countries

www.elsevier.com | www.bookaid.org | www.sabre.org

ELSEVIER BOOK AID
 International Sabre Foundation

Contents

Companion Website

Visit http://www.elsevierdirect.com/companions/9780240812298 for bonus content and project files.

Bonus Chapter:
Day Lighting an Interior Space
Project Files for Day Lighting and Interior Space

Project files for:
Chapter 1: Preparing Your files
Chapter 5: Materials Interior Space
Chapter 7: Night Lighting for Interior Space
Chapter 8: Photomontage Materials
Chapter 9: Photomontage Lights
Chapter 11: Atrium Scene Materials
Chapter 12: Atrium Scene Lighting
Chapter 13: Working with the mr Physical Sky Shader

Appendices with project files:
Appendix 1: CAD Transfer

Appendix 2: Caustics
Project files for Appendix 2

Appendix 3: Flash Effect
Project files for Appendix 3

Appendix 4: Common Errors

Appendix 5: Tips and Tricks
Project files for Appendix 5

Preface

3ds Max has existed for many years with alternate plug-in renders to the default scanline renderer. These plug-in renderers—like Brazil, VRay, and mental ray—have existed for years and have been used by the 3ds Max community to some degree. But how these renders integrate with 3ds Max and the availability of training material has limited the rate of adoption of these plug-in renders.

In 1997, a connection from 3ds Max to mental ray was introduced. This was soon followed by an agreement whereby a license of mental ray was included whenever a seat of 3ds Max was purchased. Despite the fact that mental ray came at no cost to the customer, there were still many 3ds Max users who stuck with the traditional scanline render or went to other plug-in renders.

In 3ds Max 9, Autodesk has made a concerted effort to make the use of mental ray more approachable by simplifying the interface of the lighting and creating a new material type that is flexible enough to create most materials. Now, in 3ds Max Design 2010, Autodesk has advanced the functionality and potential for you to produce stunning rendered images.

In this book, we have tried to do two things: give you a fundamental understanding of the tools you are using and put you into real-life situations in which you would be required to produce renderings of real-life projects. The approach was to go over tasks that an architectural illustration artist would typically find him- or herself in.

The discussions and tutorials are limited to materials and lighting—essentially, what makes up mental ray. We have assumed that you already know how to create architectural models and leave it up to you to determine what software you feel the most comfortable using to create those models. An appendix on transferring CAD files from AutoCAD and Revit to 3ds Max is available on the website.

Due to the variety of graphics cards, some readers may encounter viewport refresh slowness when executing the tutorials. A good professional graphics card will alleviate this problem. For more information about appropriate graphics cards for 3ds Max, please visit this website:

http://usa.autodesk.com/adsk/servlet/item?siteID=123112&id=9886527

Acknowledgments

I would particularly like to acknowledge Nadeem Bhatti and Geof Chilvers for being very supportive throughout this project.

My dear brother, Martins Cardoso, has been my strength. In fact, he was the backbone behind this entire project from the outset. Shawn Khan, Olivier Ladeuix, Andrew Gibbon, Simon Blackeney, Nadeen Nasri, and my uncle, Richard Bobb, have given me valuable advice throughout and I will forever be grateful to them.

Finally, I would like to dedicate this book to my family.

Jamie Cardoso

I would like to acknowledge a number of people who have helped me over the years: Amer Yassine, Pia Maffei, Ted Boardman, Daniel Hurtubise, and Michele Bousquet. They have all helped me both technically and by being great friends.

I would like to dedicate this book to my parents, my partner in life, and my son, who are ultimately my greatest supporters.

Roger Cusson

The Authors

Jamie Cardoso

Jamie is a senior 3D artist and special effects designer who has been producing 3D graphics for professional organizations and commercial companies since 1994. He has been involved in numerous multinational and multimillion-dollar projects ranging from graphic design work to 3D visualizations. Currently, he is working as a 3D consultant for a variety of professional organizations worldwide. E-mail: jamiecardo@hotmail.com

Roger Cusson

Roger caught the AutoCAD bug in 1985. After learning and applying the software to his profession, he became a consultant to architectural firms implementing AutoCAD and 3ds Max into their work process. Roger has been an active educator for years in the professional and academic communities. He has worked as a full-time professor at Vanier College and a training manager at Autodesk. He has authored two Autodesk VIZ books and several installments of the *3ds Max Essentials* book. Roger lives and works in Montreal.

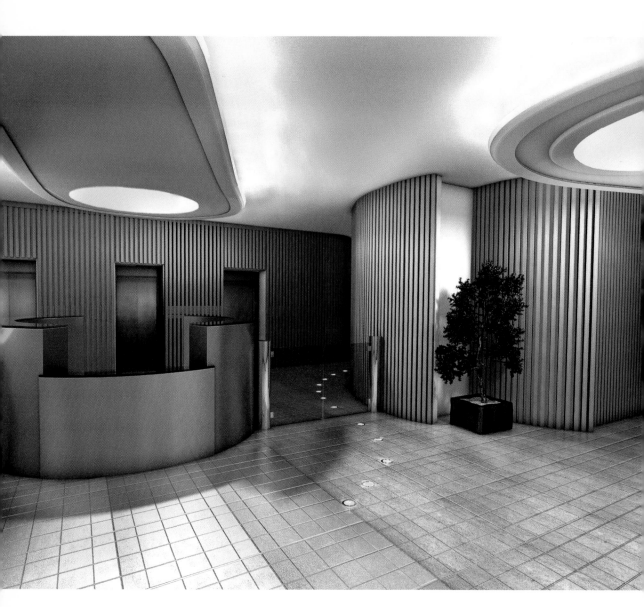

Lobby rendering

Section 1

Introduction to mental ray

Introduction

In this section, you will be introduced to the use of 3ds Max Design with mental ray for the purposes of creating realistic architectural visualizations. Specifically, you will learn how to:

- Prepare your modelled files for rendering
- Light scenes in 3ds Max Design using mental ray techniques
- Use mental ray materials
- Render your scenes

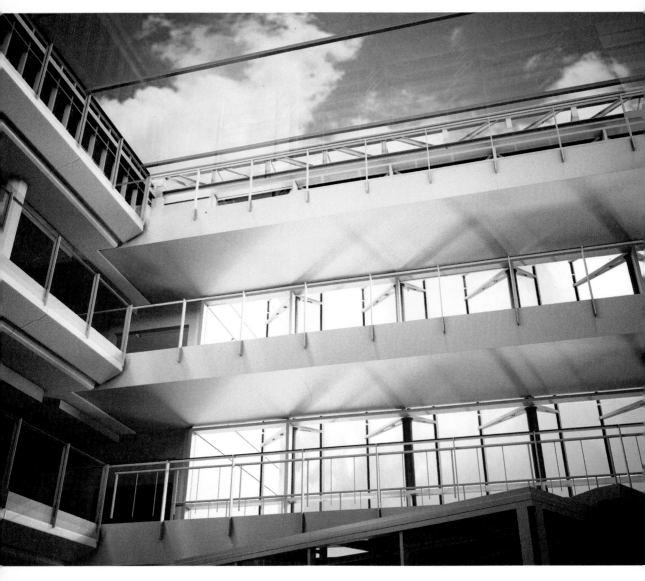

Atrium Rendering

Chapter 1

Preparing Your Files

1.1 Introduction

In this book, you will not learn about modeling your architectural projects. This book is about the ins and outs of creating renderings using mental ray® in 3ds Max Design. In this chapter, you will see some things to look out for and some specific techniques that can be used in mental ray when preparing models for rendering.

Specifically, you will learn how to:

* Use the Units Setup dialog to properly set up units in a scene
* Work with System Units
* Configure Modifier Sets
* Create mr Proxy objects

1.2 Preparing the Units in the Scene

Before beginning on a new 3ds Max Design scene, it is imperative that you ensure that the units are properly set up in your scene. Otherwise, you will later encounter a number of undesirable results.

1. Start or Reset 3ds Max.
2. From the Customize pull down menu, select Units Setup....
3. In the Units Setup dialog, in the Display Unit Scale, set the scale to metric millimeters.
4. In the Unit Setup dialog, click on the System Unit Setup button.

Customize menu

Units Setup dialog

5. In the System Unit Setup dialog, set the System Unit Scale to millimeters.

6. Click OK to Exit both dialog boxes.

Note: It's important that the Unit setup and System Unit setup are the same, to prevent undesirable results when rendering.

7. Whenever you begin a scene file in 3ds Max Design and intend to use mental ray for rendering, you should follow this procedure.

1.3 System Units Mismatch

Architectural firms use different systems of measure in their CAD and visualization files. You should be aware that once the system units in 3ds Max Design are changed, they remain at that setting until you change them again. For example, if you set your system units to inches, all new files will be created in inches.

Once a file is created and saved, the file itself maintains the system unit you were using at the time. So, as is often the case where firms use different units on different projects, there can be confusion between the current system unit and the system unit stored in the file. Opening a file with different system units will cause the Units Mismatch dialog to appear.

Typically, you will accept the default option, Adopt the File's Unit Scale. This will then set the current system unit to be the same as the file system unit. In the previous example, where you set the current system unit to be inches, if you open a drawing that has meters as the system unit, the current system units will become meters. Creating new files from that point onward will use meters as the system unit.

1.4 Configuring Modifier Sets

Whenever you identify a series of modifiers that you use often, or plan to use often, it is a good idea to take a moment to configure a modifier set. There are some predefined modifier sets that you can change, or you can create your own. In order to configure a modifier set, do the following:

1. In the Modifier tab of the Command panel, select the Configure Modifier Sets button.

2. In the menu that appears, select the Configure Modifier Sets selection.

System Unit Setup dialog

Units Mismatch dialog

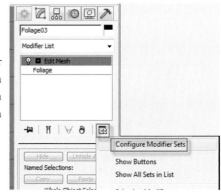

Configure Modifier Sets menu

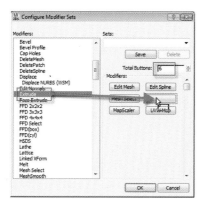

Configure Modifier Sets dialog

Configure Modifier Sets dialog

3. Change the Total Buttons value to the number desired.
4. Click and drag the modifiers you are interested in from the list on the left to the buttons on the right.
5. Once you have all the modifiers you want in the Modifier Set, enter a name for your set and click the Save button.
6. Click OK to exit the dialog.
7. Select the Configure Modifier Sets button, and in the menu select Show Buttons.

Show buttons

Modifiers configured and displayed as buttons

This technique is used to increase efficiency while working in the Modifier panel, as it avoids searching for commonly used modifiers in the Modifier list (i.e., Extrude, Edit Mesh, Edit Spline, UVW Map, etc.).

1.5 mr Proxy Objects

The mr Proxy object is an object in 3ds Max Design that replaces a Geometry object with an alternative representation that is less difficult for the graphics subsystem of the computer to refresh. Often, when a scene becomes heavily laden with polygons, it will take time to redisplay the scene during zooms, pans, and even transformation operations. The proxy can be displayed as a series of points in space (a point cloud) or by a bounding box, thereby reducing refresh time. Proxies can be used when working with highly dense objects, such as trees, furniture, and other entourage objects. Prior to the introduction of proxies, it was almost impossible for normal computers to cope with scenes that contained multiple highly dense mesh objects.

Proxies can be generated from only one object at a time. If you require that multiple objects become a single proxy, the separate objects need to be attached together. When you attach the objects, you will need to conserve

the material IDs of the objects. A proxy should be created from a unique object that is not instanced or referenced to other objects.

The following exercise will show you how to create a mr Proxy object out of a Foliage object created by 3ds Max Design. It should be noted that this is a very common usage of mr Proxy objects, since trees are often generated with very dense meshes, often exceeding 100,000 faces. You can, though, create a proxy for anything in your scene that is slowing graphics performance.

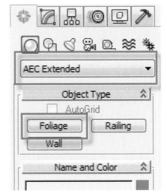

AEC Extended objects

Japanese Flowering Cherry, Spring object

1. Open 3ds Max Design or reset 3ds Max Design.
2. Set up your units as described in section 1.2 to establish the system and display units to millimeters.
3. In the Create tab of the Command panel, select the Geometry button.
4. Select AEC Extended from the Geometry pulldown list.
5. Click on the Foliage button.
6. In the Favorite Plants rollout, scroll down until you see the Japanese Flowering Cherry, Spring object.
7. Click on the image, and then click in the viewports to place the Foliage object.
8. Click on the Zoom Extents button.
9. Right click in the viewport and select Object Properties on the Quad menu.

Japanese Flowering Cherry, object in the scene

Quad menu

Object Properties dialog

10. In the Object Properties dialog, note the number of faces that was generated by that object.

This object generates about 40,000 faces, which in itself is considerable. If you wish to duplicate this tree 10 to 20 times in a scene, it will create considerable lag in the scene. A way to avoid the lag is to create an mr Proxy object from this object.

11. In the Modify panel, change the Height of the tree to 4500 mm.

Changing the Tree Height

Instancing the Tree

12. Switch to a four-viewport configuration, and Zoom Extents on all viewports.

13. While the tree is still selected, create an instance of the object by pressing Ctrl + V.

14. In the Clone Options dialog, select the instance option.

Tree in four viewports

15. Enlarge the Top View, and move Foliage02 away from Foliage01.
16. Open the Material Editor and select an unused material slot.
17. Select the Diffuse Color Map button.
18. Select Bitmap in the Material/Map browser.
19. Navigate to your Project files and open IMG_0192.jpg.
20. In the Bitmap Parameters rollout in the Cropping/Placement area, click on Apply.
21. Click on the View Image button.
22. Select the handles of the Crop area and move it to an area of the image where there are primarily only tree leaves. Close the dialog.
23. Click on the Go to Parent button to get to the top of the material.
24. Name the material Tree1.

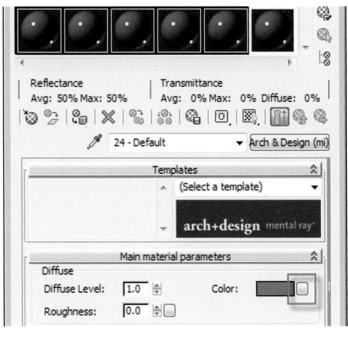

Selecting the Diffuse Color Map button

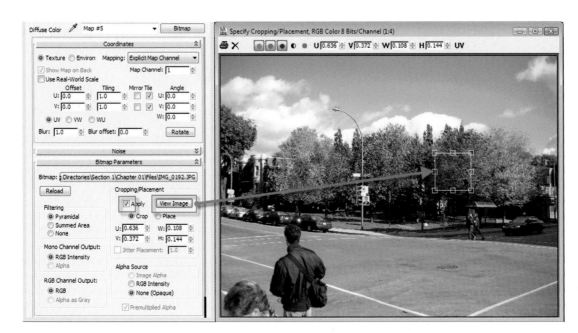

Cropping the map

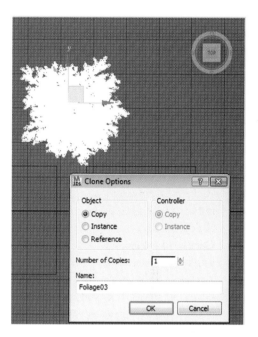

Reflectance
Avg: 40% Max: 86%

Transmittance
Avg: 0% Max: 0% Diffuse: 0%

Tree1 ▾ Arch & Design (mi)

Templates

Creates soft blurry
reflections without
affecting colors or maps.

Pearl Finish

{Appearance & Attributes}
. Matte Finish
. Pearl Finish
. Glossy Finish
Main materia {Finishes}

Selecting a template

Clone Options

Object
⦿ Copy
○ Instance
○ Reference

Controller
⦿ Copy
○ Instance

Number of Copies: 1

Name:
Foliage03

OK Cancel

Copy Clone the Third Tree

25. Select a Pearl Finish from the Templates list.
26. Assign the material to the Foliage01 and the Foliage02 object.
27. Click and Drag the Tree1 material into a unused Material Slot.
28. Rename the Material Tree2.
29. Create a third tree as a copied object.
30. Assign the Material Tree2 to the Foliage03 object.

At this point you have a group of trees, two of which are identical and a third that can be adjusted, in size, shape, and material. Since this group of trees is over 120,000 faces, it is a good time to convert it into a mr Proxy object. You will need to consolidate the three trees into one object:

31. With the Foliage03 object selected, go to the Modify panel.
32. Click on the New button in the Parameters rollout to change the seed value and thereby change the shape of the tree.
33. Change the height of the tree to 6000 mm.
34. In the Viewport Canopy Mode area, select Never.

Note: You need to switch the Viewport Canopy Mode to Never so that the display of the trees will not interfere with the integrity of the mesh when rendering. To be on the safe side, it is important to make all instanced objects unique prior to attaching them; otherwise there is the potential for critical errors within the mesh.

Parameters

Height: 6000.0mm

Density: 1.0

Pruning: 0.0

New Seed: 7490325

☑ Generate Mapping Coords.

Show

☑ Leaves ☑ Trunk
☑ Fruit ☑ Branches
☑ Flowers ☑ Roots

Viewport Canopy Mode
○ When Not Selected
○ Always ⦿ Never

Modifications to the Third Tree

35. Select one of the other two trees and switch the Viewport Canopy Mode to Never.
36. Click on the Make Unique button.
37. Select the Foliage03 object, and in the Modify panel, add an Edit Mesh modifier.

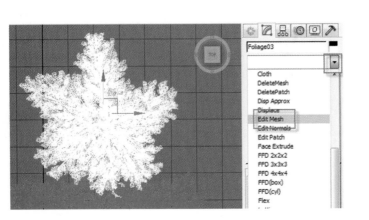

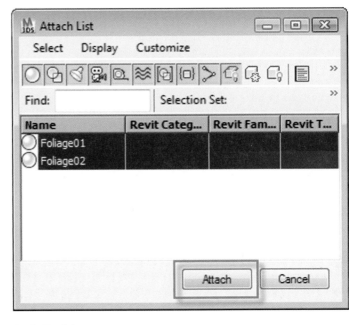

Edit Mesh modifier added

Make Unique button

38. In the Edit Geometry rollout, click on the Attach List button.

Note: If the Edit Mesh modifier is in Sub-Object mode (i.e., highlighted in yellow), the Attach List button will not be available.

39. In the Attach List dialog, select the Foliage01 and Foliage02 objects and select Attach.

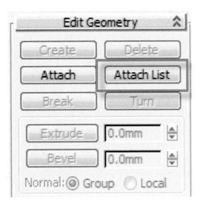

Attach List

Attach List dialog

40. In the Attach Options dialog, make sure the Match Material IDs to Material and Condense Material and IDs options are selected.

41. While the three attached trees are selected, select an unused material sample slot in the Material Editor.

42. Click on the Pick Material from Object button.

43. Bring the eyedropper cursor to the trees and select it.

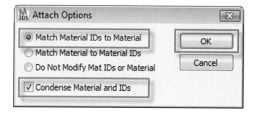

Attach Options dialog

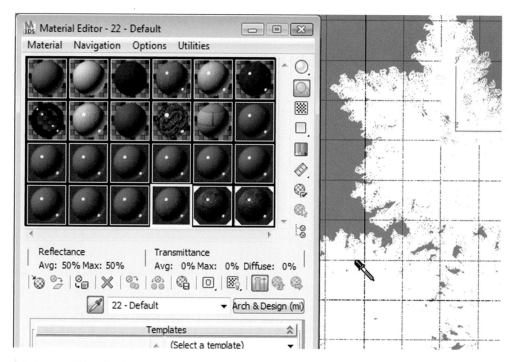

Pick the material from the object

The condensed materials created when the objects were attached are now in the Material Editor.

44. Name the newly acquired material Trees.

45. Switch to a four-viewport configuration, and Zoom Extents all viewports.

46. In the Create tab of the Command panel, with the Geometry button enabled, select mental ray from the Geometry list.

47. Select the mr Proxy object in the Object Type rollout. Then click and drag in the Top viewport to place the Proxy object near the center of the trees.

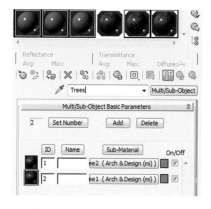

Pick the material from the object

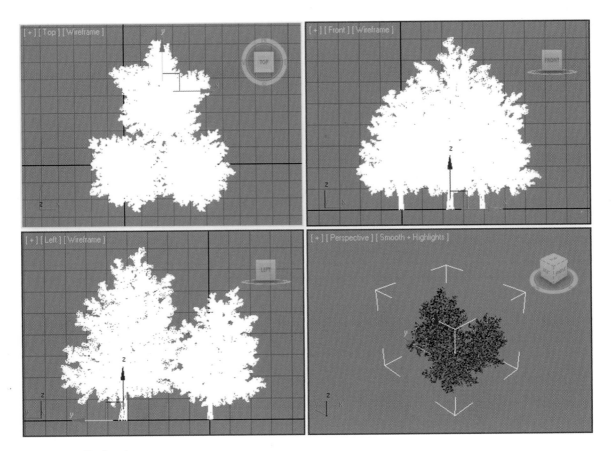

Four-viewport Configuration

Note: It is important that you place the mr Proxy object at the base of the object that you will be using to create the proxy. If you subsequently scale the object, scaling will occur about the pivot of the Proxy object.

48. While the Proxy object is still selected, click on the Modify tab of the Command panel.

49. In the Parameters rollout, select the None button in the Source object: area.

50. Select the trees that you created earlier. The None button will change to reflect the name of the object you selected.

51. Click on the Write Object to File... button

52. Select a file name in the Write mr Proxy file dialog—example: 3Trees .mib—and select Save.

Note: The file extension (.mib) that the mr Proxy file uses the default location of the file.

53. In the mr Proxy Creation dialog, click OK to accept the defaults.

Create panel

Creating the Proxy object

Selecting the Source object

Outputting the Proxy file

54. The mr Proxy tool will create a thumbnail of the proxy and place one occurrence of the proxy in the viewport.

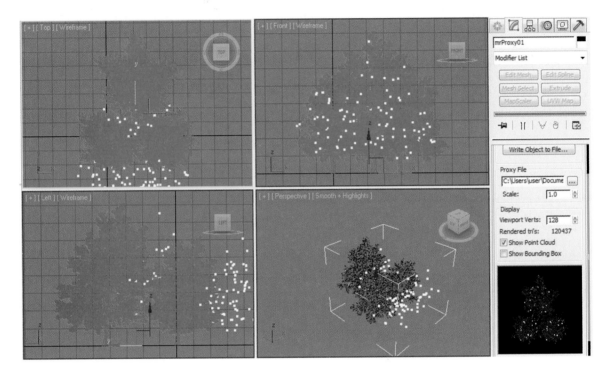

mr Proxy file created

55. Move the mr Proxy object away from the original foliage object.

56. Change the number of Viewport Verts to 1200 so that you can see the proxy more clearly.

57. Save the original max file as 3Trees.max with the Foliage objects included for references purposes and in case any further changes might be made to the original mesh.

You can move, rotate, and scale the Proxy object to provide some variety if you intend to have a series of trees of this type in your scene.

Note: You should avoid copy cloning proxies at all cost. Proxies should only be instanced. mental ray only loads the Proxy object once in the scene, when proxies are instances. When proxies are copies, mental ray will load the Proxy object every time it sees a new proxy. This will subsequently increase the rendering time dramatically. To individually Scale instanced objects, use the Scale tool from the main tool bar.

1. Delete the original Foliage objects from the scene.

2. Select the mr Proxy object and go to the Modifier panel.

3. Click on Show Bounding Box. This can give you a better idea of the extents of the mr Proxy object.

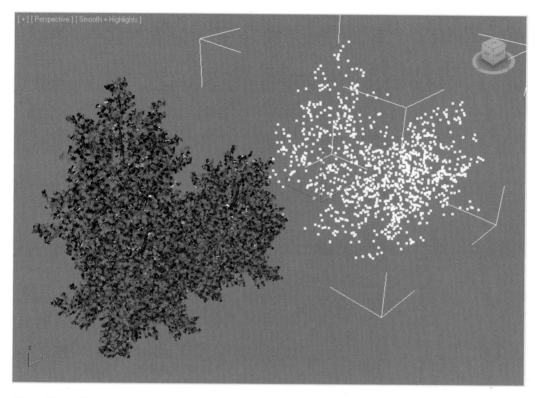

The mr Proxy object next to the original trees

4. Click on the Hierarchy tab of the Command panel.
5. Click on the Affect Pivot Only button and move the pivot in the Top view to the center of the bounding box.
6. Render the Perspective view. Note that the Proxy object does not have a material attached to it by default.

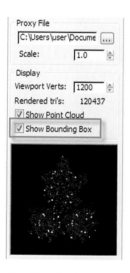

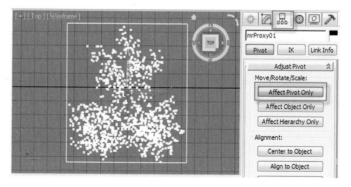

Show Bounding box

Move the pivot point of the Proxy object

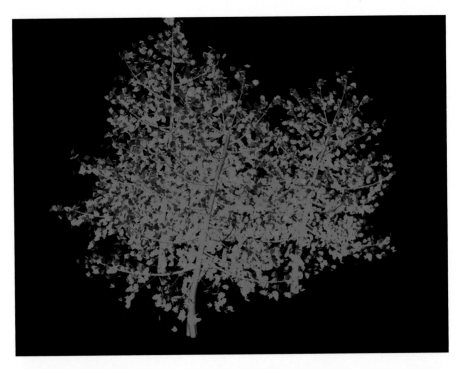

Render of the mr Proxy object

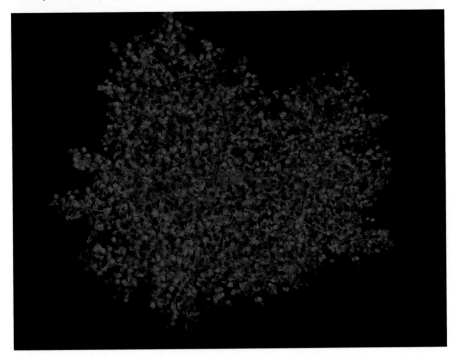

Render of the mr Proxy object with material applied

7. In the Material Editor, assign the Trees material to the mr Proxy object.
8. Render the Perspective view again.

Note: The Material Ids and UVW map are retained in the mr Proxy object. If you reuse the proxy objects in other scenes, you need to create a material library to transfer the material to the proxy in the destination scene. Also, to use proxy objects from a different Max project, simply merge in the relevant object/s in your current Max scene.

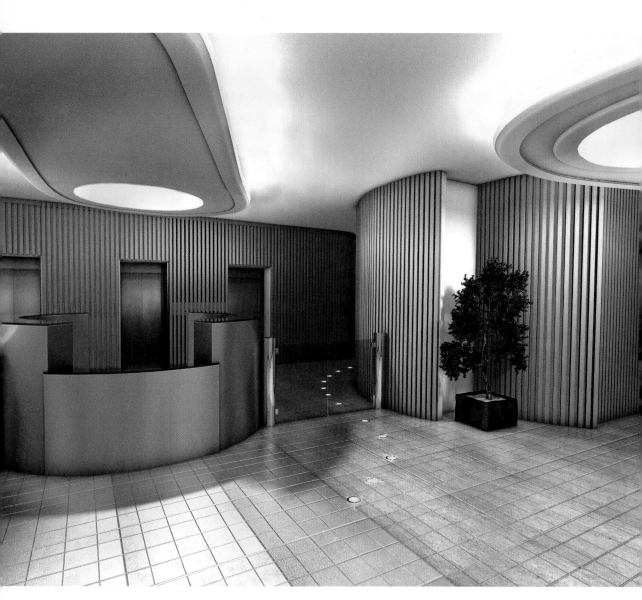

Lobby rendering

Chapter 2
Materials in mental ray

2.1 Introduction

In this chapter, you will learn about materials used with mental ray. Specifically, you will learn how to:

- Distinguish when to use ProMaterials and Arch & Design materials.
- Use specific ProMaterials.
- Search the predefined ProMaterial libraries.
- Create your own specific ProMaterials.
- Work with Templates in the Arch & Design material.
- Adjust important parameters in the Arch & Design material.
- Use Self Illumination to substitute for lights.
- Describe the use of the Utility Bump Combiner.
- Get familiar with the potential of the Ambient/Reflective Occlusion Map.
- Apply the Composite Map.

2.2 ProMaterials and Arch & Design Materials

When you begin working on applying materials to a scene in mental ray, you will note that there is a significant increase in the number of material types available to you.

Materials types available with the Scanline renderer

Materials types available with the mental ray renderer

Which materials you choose will depend on your workflow. The two main types of materials used in architectural rendering with mental ray are the Arch & Design material and the series of ProMaterials. The Arch & Design material is the more versatile of the two materials and is favored in the tutorial section of this book.

The series of ProMaterials have a unique material type for several surfaces and therefore have a simpler interface, narrowing your setting choices to those that are most important to that specific material. ProMaterials also come with an extensive predefined series of material libraries that can be used by novice 3D architectural artists. Finally, ProMaterials are created in 3ds Max Design when transferring a project from Autodesk Revit to 3ds Max Design using the FBX file format. If materials are created and assigned to objects in Revit, they will be automatically assigned to objects in 3ds Max Design using a ProMaterial type most suitable to the object.

In this chapter, you will see the types of ProMaterials available and how to work with the Arch & Design material.

2.3 ProMaterial Ceramic

The ProMaterial Ceramic is—as its name suggests—used for ceramic surfaces. Ceramic surfaces include objects like ceramic vases and ceramic tiled floors. Here are a few sample ceramic surfaces from the ProMaterial Ceramic Material Library:

ProMaterials Ceramic Material Library

Ceramic Tile Circular Mosaic

Ceramic Tile Square Slate Blue

UI Interface for Ceramic Material

Some of the important settings found in the Ceramic Material Parameters rollout:

- **Type:** Ceramic or Porcelain determines the surface characteristics of the material.
- **Surface Finish:** Choice between high-gloss, satin and matte finishes.
- **Surface Bumps and Tiling Pattern:** Two different bump maps available to control surface irregularities. The tiling pattern is typically used to control the indentations between tiles, the surface bumps are for surface indentation in the tiles themselves or in the absence of a tiling pattern over the entire material surface.

2.4 ProMaterial Concrete

The ProMaterial Concrete is for surfaces made with concrete, concrete blocks, and concrete with exposed aggregate. A few samples of materials from the ProMaterial Concrete Material Library:

Concrete with Stone 1

Concrete Formwork Holes

ProMaterials Concrete Material Library

UI of Concrete Material

Some of the settings to note in the Concrete Material Parameters rollout:

- **Surface Finish:** Allows you to select the surface finish of the concrete surface. Options include Straight Broom, Curved Broom, Smooth, Polished, and Custom Map.
- **Sealant:** Determines surface shininess of the concrete. Options are None, Epoxy, and Acrylic.
- **Brightness Variations:** Will provide a variation to the color of the concrete, according to either an automatic procedural map or a custom map.

2.5 ProMaterial Glazing

The ProMaterial Glazing material is primarily for exterior and interior glass for windows, doors, storefronts, and curtain walls. In the ProMaterial Glazing Material Library, there are several predefined material. Here are some samples:

Glazing Dark Bronze Reflective (Refraction Levels = 2)

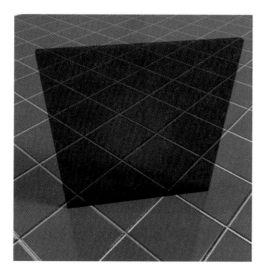

ProMaterials Glazing Material Library

Glazing Clear

Some of the settings to note in the Glazing Material Parameters rollout:

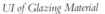

- **Color (Transmittance):** Set to one of six standard glazing colors or a custom color or map.
- **Refraction Levels:** Number of reflections and refractions permitted through the glazing. A value of 1 will produce only reflection; a value of 2 will produce reflection and refraction.
- **Reflectance:** The amount of reflection produced by the surface; 1 equals 100 percent reflective surface.

UI of Glazing Material

2.6 ProMaterial Hardwood

The ProMaterial Hardwood materials are wood materials for flooring and furnishings. In the ProMaterial Hardwood Material Library, there are materials for both applications:

Glazing Dark Bronze Reflective (Refraction Levels = 1)

ProMaterials Hardwood Material Library

Hardwood Flooring Beechwood Wild Berries

Wood Cherry Natural Low Gloss

Some of the settings to note in the Hardwood Material Parameters rollout:

UI of Hardwood Material

ProMaterials Masonry/CMU Material Library

- **Stain Application:** Tints the color of the base hardwood bitmap.

Wood Cherry, no stain applied

2.7 ProMaterial Masonry/CMU

The ProMaterial Masonry/CMU is a material designed for bricks, concrete masonry units (CMU), and stone walls and flooring. Some sample materials from the ProMaterial Masonry/CMU Material Library include:

Brick Yellow Uniform Running *Brick Red Herringbone*

The Masonry/CMU Material Parameters are fairly self-explanatory. Most masonry/CMU type materials will use a bitmap in the Color (Reflectance) map slot combined with a bitmap in the Custom pattern map slot.

UI of Masonry/CMU Material

2.8 ProMaterial Metal

The ProMaterial Metal is a material type in which you can choose a metal type and then adjust the material finish and surface pattern. Some sample materials from the ProMaterial Metal Material Library include:

ProMaterials Metal Material Library

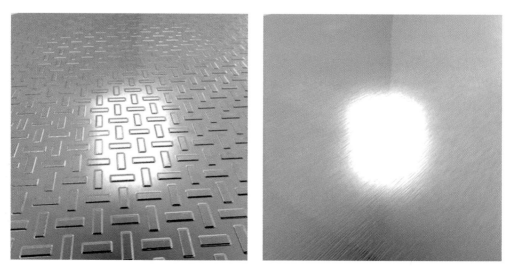

Steel Checker Plate *Chrome Polished Brushed*

Some of the settings to note in the Metal Material Parameters rollout:

- **Type:** Where you choose the metal type.
- **Patina:** Metals typically oxidize over time; the patina value is a control where you can adjust the appearance of the metal based on its age. You will note this most dramatically with the copper type.

UI Metal Material Parameters

- **Relief Pattern:** Specifies the bump surface pattern. Three patterns are built into the material: knurl, diamond plate, and checker plate. Custom Map files can be specified as well.
- **Cutouts/Perforations:** This value allows you to create openings in your metal material. Two standard patterns for round and square holes are in the list.

2.9 ProMaterial Metallic Paint

The ProMaterial Metallic Paint is a material for painted metallic surfaces. The UI and the samples available in the material library are fairly straightforward. One thing to note is the flakes option, which will turn on procedural flakes.

ProMaterials Metallic Material Library

UI for Metallic Paint Material Parameters

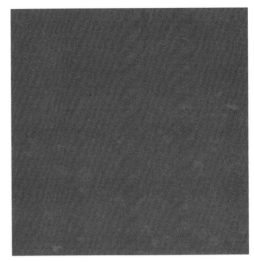

2.10 ProMaterial Mirror

The ProMaterial Mirror is—as its name suggests—for mirrored surfaces. The Mirror Material Parameters rollout offers a single value, which can adjust the tinting of the reflection.

Blowup render of Metallic Paint Magenta with Yellow Flakes added

UI for Mirror Material Parameters

2.11 ProMaterial Plastic/Vinyl

The ProMaterial Plastic/Vinyl Material is for surface applications that use plastic and/or vinyl. Some sample materials from the ProMaterial Plastic/Vinyl Material Library include:

Vinyl Flooring Dots Pattern

ProMaterials Plastic/Vinyl Material Library

Some of the settings to note in the Plastic/Vinyl Material Parameters rollout:

Plastic Light Red Transparent

UI for Plastic/Vinyl Material Parameters

- **Type:** You can choose from Plastic (Solid), Plastic Transparent, and Vinyl.
- **Surface Bumps and Pattern:** Two separate bump map channels allow you to create complex bump patterns with different strengths. This is useful for vinyl flooring systems where there is a tile pattern and another pattern for the tiles themselves.

2.12 ProMaterial Solid Glass

The ProMaterial Solid Glass Material is for objects made of glass that have a thickness, as opposed to glazing, where the surface can be a single plane. Some sample materials from the ProMaterial Solid Glass Material Library include:

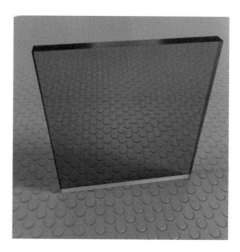

ProMaterials Solid Glass Material Library

Glass Amber

Some of the settings to note in the Solid Glass Material Parameters rollout:

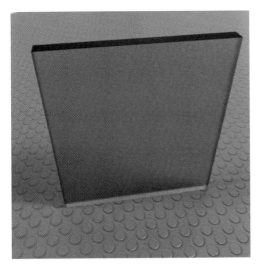

Glass Clear Frosted

UI for Solid Glass Material Parameters

- **Reflectance:** Affects the amount of reflectivity in the solid glass surface. The maximum value of 0.5 will produce an opaque surface with the maximum amount of reflection.
- **Index of Refraction (IOR):** This value will vary based on the density of various materials with typical glasses varying from 1.52 to 1.62. Water = 1.33, Sapphire = 1.77, Diamond = 2.417. IOR will affect refraction and reflection.
- **Reference Thickness:** This value is the thickness used to calculate transmittance, refraction, and reflection.
- **Surface Roughness:** A value to introduce surface imperfections in the surface of the glass.
- **Surface Imperfections:** A bump map with two built-in bump patterns, rippled and wavy, and the ability to specify a custom map.

2.13 ProMaterial Stone

The ProMaterial Stone Material is for wall, floor, roof and other surfaces where stone is used. Some sample materials from the ProMaterial Stone Material Library include:

ProMaterials Stone Material Library

Flagstone Flooring

Marble Square Large Veins

Stone Wall Jagged Rock

Some of the settings to note in the Stone Material Parameters rollout:

UI for Stone Material Parameters

- **Surface Bumps and Pattern:** Two separate bump map channels allow you to create complex bump patterns with different strengths. This is useful for stone flooring systems where there is a tile pattern and another pattern for the tiles themselves.

2.14 ProMaterial Wall Paint

The ProMaterial Wall Paint Material is for painted wall surfaces. The UI of the Wall Paint Material parameters is fairly straightforward, as are the samples found in the Wall Paint Material Library.

UI for Wall Paint Materials Parameters

2.15 ProMaterial Water

The ProMaterial Water Material is for water surfaces. Rendering samples by themselves does not produce interesting results, whereas combining the water material in an environment will produce reflective and refractive results.

UI for the Water Material Parameters

Water surface with a wave height of 10, over a herringbone brick surface reflecting a yellow brick wall

2.16 ProMaterial Generic

The ProMaterial Generic Material is a multiuse material that can be used for almost any type of surface. It not only covers materials that are not found in other ProMaterials but will also allow additional parameters to adjust, should the values found in the other ProMaterials be insufficient to obtain the results you require.

Some sample materials from the ProMaterial Generic Material Library include:

ProMaterials Generic Material Library

Grass Light Rye

Wallpaper Floral Blue

Glass Translucent White Luminous Sphere on Asphalt Wet Plane

Some of the settings to note in the ProMaterial Generic Material Parameters rollout:

Rollouts in the ProMaterial Generic Material

White Generic ProMaterial with both reflectivity values set to 0.0, no reflection occurs

Generic Material Parameters rollout:

- **Reflectivity Perpendicular to Surface:** This value determines the reflectivity of the surface when the viewer's angle to the surface is perpendicular to the surface (i.e., looking directly at it).
- **Reflectivity Parallel to Surface:** This value determines the reflectivity of the surface when the viewer's angle to the surface is parallel to the surface (i.e., looking at as sharp an angle to the surface as possible approaching parallel).

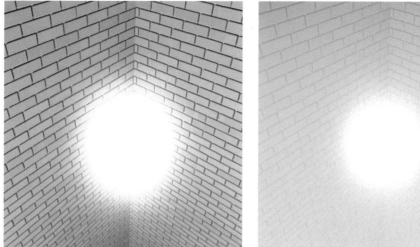

White Generic ProMaterial with both reflectivity values set to 1.0, mirror-like reflection occurs, mirroring a yellow brick wall

White Generic ProMaterial with Reflectivity (Perpendicular) set to 0.15 and Reflectivity (Parallel) set to 1.0, a gradient reflection occurs, mirroring a yellow brick wall

Transparency rollout:

- **Transparency:** Amount of transparency in the material: 0.0 = opaque, 1.0 = clear.
- **Translucency:** Amount of light that is scattered by the material, will make transparent objects look more opaque.
- **Index of Refraction:** The Index of Refraction (IOR) is a measurement of how much light will bend when it enters or exits a material. This value will vary based on the density of various materials, with typical glasses varying from 1.52 to 1.62: Water = 1.33, Sapphire = 1.77, Diamond = 2.417.
- **Cutout Opacity:** This value allows you to create openings in your material based on a grayscale bitmap.

Cutout Opacity with a Checker Map Applied to a Sphere

Cutout Opacity with a Checker Map Applied to a Sphere, Backface Cull Enabled

- **Backface Cull:** Accelerates rendering of objects, as it does not render inside faces of objects. Must be used with caution, as it can lead to some objects not rendering properly.

Self Illumination rollout:

Luminance (cd/m^2): When set to values higher than 0.0, the material will "self illuminate"—i.e., not require lights in the scene to become illuminated. The higher the value, the brighter the material will become.

- **Color Temperature (Kelvin):** By specifying the temperature of the artificial light in degrees, this value will adjust to provide the corresponding color of light emitted from that light.
- **Filter Color:** Adjusts the color of the illuminated material.

Self Illumination Applied to Lettering, default values for Color Temperature and Filter Color

Reduction of Color Temperature to 2000 Kelvin

Color Temperature = 6500 Kelvin, filter color = Aqua Blue

Ambient Occlusion rollout:

- **Ambient Occlusion:** Creates shadows that exist between = objects, increasing the depth of a rendered view.
- **Samples:** Controls the quality of the Ambient Occlusion Shadows; as you increase the value, the shadows become more refined.
- **Max Distance:** Distance that the Ambient Occlusion searches for connecting objects. Objects beyond the Max Distance value do not contribute to the shadows. Is dependent on the units and size determined in the scene.

- **Use Color from Other Materials (Exact AO):** Affects the accuracy of the AO solution and the amount of color bleed.

Ambient Occlusion (AO) off

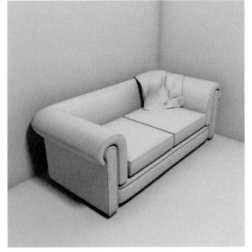

AO on with Max Distance Value of 10.0

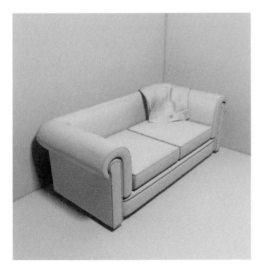

AO on with Max Distance Value of 2.0

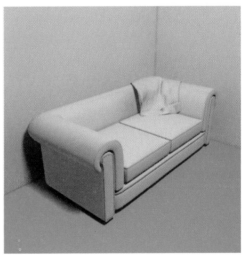

AO with a Colored Floor Surface illustrating Color Bleed

Round Corners rollout:

Objects in real life rarely have razor sharp edges, as are typically created in CG programs. The Round Corners feature takes geometry that is angular and rounds off the edges providing more realistic renderings.

- **Fillet Radius:** Value of the fillet to be applied to the geometry. For realistic results, measure the distance of the corners on the viewport with the help of the tape tool or the distance tool.

Note: Using a fillet radius value bigger than the overall object size will generate inaccurate results, artifacts, and/or errors in the render.

- **Blend with Other Materials:** By default, Round Corners only works on the same material. This option will apply rounded corners to objects with different materials. This function is great to emulate a joined plastered wall, welded surfaces, and so on. The final appearance is dependent on the fillet radius values.

Round Corners off (i.e., Fillet Radius = 0.0) *Round Corners on (Fillet Radius = 0.15, Depends on Geometry)*

2.17 Arch & Design Material

The Arch & Design Material is the most flexible of the materials used in architectural design with mental ray. The ProMaterial Generic was designed to be similar to the Arch & Design Material while simplifying the User Interface. Additional controls are exposed in the Arch & Design Material that many artists find essential in creating their own photorealistic materials. A good approach is to use as much of the ProMaterials as possible while learning how to use the Arch & Design Material for special situations.

You will find many similar concepts and controls in the Arch & Design Material as there are in the ProMaterials.

Templates

Directly at the top of the Arch & Design Material is the Templates rollout. The Templates list allow you to select from many predefined material setups. Templates are good starting points from which you will normally need to make further adjustments to obtain the material you require.

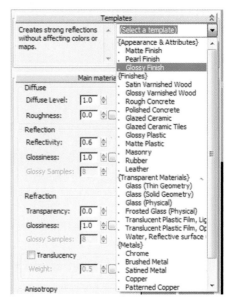

Templates List and corresponding explanations in the left panel in the Templates rollout

As you select different templates, you should note the left panel, where a brief description of the template appears. Recommended practice is to name your material with the template you used in the name of the material—for example, Dining Room Floor (Satin Varnished Wood).

Main Material Parameters

The first area of the main rollout is the most recognizable: Diffuse parameters. The diffuse color specified with a color swatch and a Diffuse Map can be accessed by clicking on the button adjacent to the color swatch.

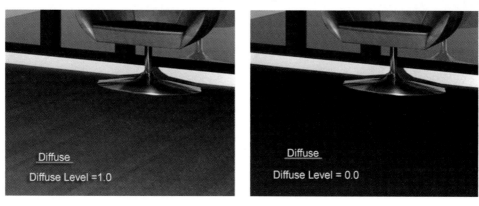

Diffuse area of the Main Material Parameters

- **Diffuse Level:** Controls the intensity of either the diffuse color or the diffuse map values range between 0 (no diffuse) and 1 (full intensity).

Note: With the satined metal and a few other templates, the diffuse level value is low, which will subsequently have an effect on the intensity of the diffuse color as well as the bitmaps assigned to it. The rule of thumb is to have it at the value of 1.0 when adjusting bitmaps and colors. Also, the satined metal template has the diffuse bitmap toggle switched off by default. To enable it, simply go to the general maps rollout, and check the diffuse color function.

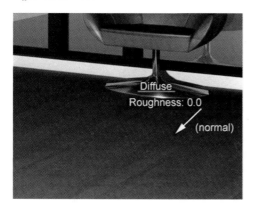

Diffuse Level = 1.0

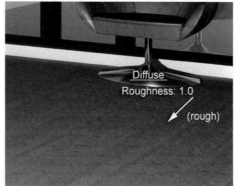

Diffuse Level = 0.0

Roughness = 0.0

Roughness = 1.0

- **Diffuse Roughness:** If you select the Templates list and choose a Matte Finish, you should note the roughness changes to 0.2. Go to a Glossy Finish and the Roughness is back to 0.0. The higher the value, the more powdery the appearance of the surface will be.

The next section of the Main Material Parameters to discuss is the Reflection area. There are several parameters that control the reflection on a material's surface.

Reflection area of the Main Material Parameters

- **Reflectivity:** The amount of reflection present on the material surface. Higher values produce more reflection.

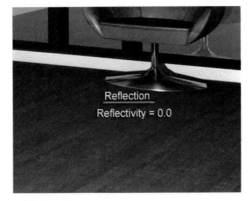

Reflectivity = 0.0

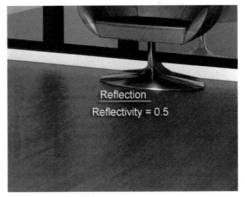

Reflectivity = 0.5

- **Reflection Glossiness:** The blurriness or sharpness of reflections. Low values will produce a blurry reflection; a high value will produce a mirror-like appearance.

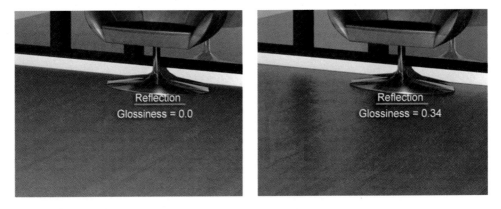

Reflection Glossiness = 0.0 *Reflection Glossiness = 0.34*

- **Reflection Color:** The color of the reflection, generally kept as white.

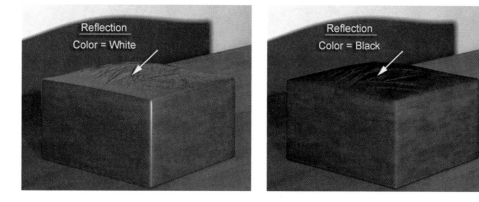

Reflection Color = White *Reflection Color = Black*

- **Glossy Samples:** Defines the maximum number of samples (rays) that mental ray will shoot to create glossy reflections. Higher values produce a smoother result. The Glossy Samples value is available only when Glossiness is less than 1.

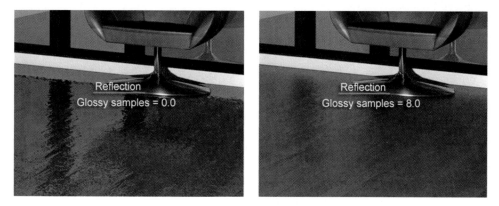

 Glossy Samples = 0.0 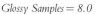 *Glossy Samples = 8.0*

- **Highlight & FG Only:** When this option is on, mental ray does not trace any reflection rays for that material. The material does not reflect the environment and only produces highlights. For objects that are not highly reflective, this will often produce adequate results and reduce render time.
- **Metal Material:** A metal object reflection's color is affected by the color of the metal object. Enabling this checkbox turns on this feature. On a dark metal surface, the reflections will remain dark.

Note: The Metal Material is ideal to achieve accurate colors on reflective surfaces, not only metallic materials (i.e., reflective sofas, floors). Often, reflective surfaces change colors when reflecting strong environments; this function will help you retain the original color(s). Because this function uses mainly the diffuse color for the reflections, professionals often use this function in conjunction with the composite map for best results.

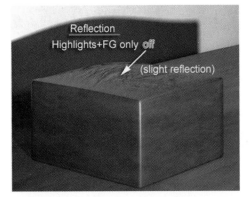

Highlights and FG only off

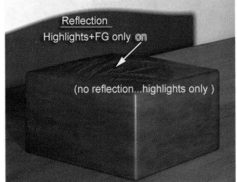

Highlights and FG only on

Metal Material off

Metal Material on

The next section of the Main Material parameters to discuss is the Refraction area. There are several parameters that control the refraction of light through a surface.

Refraction area of the Main Material Parameters

- **Refraction Transparency:** Defines the level of refraction; if a surface is completely transparent ($= 1.0$), you can see right through it.

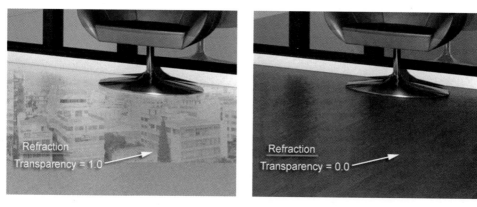

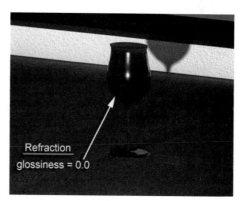

Refraction Transparency = 1.0

Refraction Transparency = 0.0

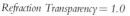

- **Refraction Glossiness:** Defines the sharpness of the refraction. High values produce clear transparency; low values produce blurry or diffuse transparency.

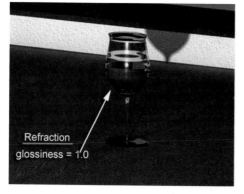

Refraction Glossiness = 1.0

Refraction Glossiness = 0.0

- **Refraction Color:** Defines the color of the refraction. Refraction provides a quick way to create colored glass.

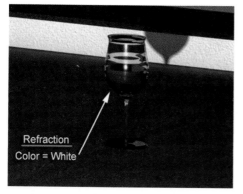

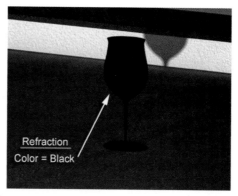

Refraction Color = White

Refraction Color = Black

- **Refraction IOR:** The Index of Refraction (IOR) is a measurement of how much light will bend when it enters or exits a material. This value will vary based on the density of various materials, with typical glasses varying from 1.52 to 1.62. Water 1.33, Sapphire = 1.77, Diamond = 2.417.

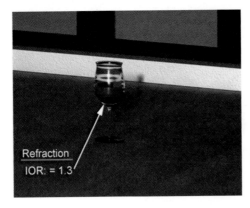

IOR = 1.3

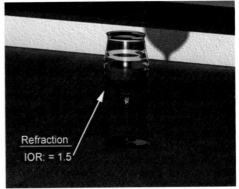

IOR = 1.5

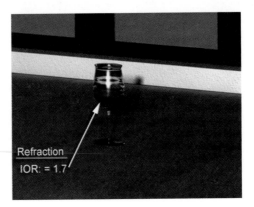

IOR = 1.7

BRDF

The BRDF (bidirectional reflectance distribution function) rollout controls a material's reflectivity based on the angle from which the surface is viewed. Like the Reflectivity Perpendicular to Surface and Reflectivity Parallel to Surface values found in the Generic ProMaterial, the 0 Degree Reflection and the 90 Degree Reflection serve a similar function.

When using the Custom Reflectivity Function, the value in the 0 degree reflectivity defines the intensity of reflections when the camera is looking directly at the reflective surface. If the value is 0, there will be no reflection. The 90 degree reflectivity value defines the reflection of surfaces that are at a 90-degree angle to the direction of the camera.

The graph curve represents the transition from one reflectivity value to another.

BRDF curve

Curve Shape value adjusts the default transition curve

BRDF 0 Deg Refl: = 1.0

Self Illumination (Glow)

This rollout in the Arch & Design Material is similar to the Self Illumination rollout of the Generic ProMaterial. In addition to the parameters found in the Generic ProMaterial are the Glow options found at the bottom of the rollout.

BRDF 0 Deg Refl: = 0.45

- **Visible in Reflections:** When a large object is used to provide diffuse lighting in the scene using the Glow Option, you may wish that the object does not appear in reflections. Default = on.

Self Illumination (Glow) rollout

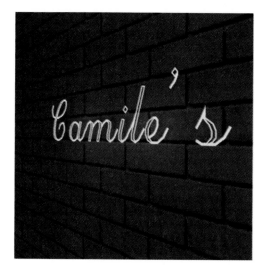

- **Illuminates the Scene (When Using FG):** This option will project light in the scene based on the luminance values in the rollout. Accuracy is mainly dependent on the value of interpolate over num. FG points, in the final gather options.

Advanced Rendering Options

A final series of parameters are found in the Advanced Rendering Options rollout. Although there are numerous parameters in this rollout, only a few will be looked at.

Self Illuminated Material with Glow activated

- **Reflection Color at Maximum Distance:** This group of parameters allows you to control the color of transparent glass according to a distance. The Max Distance checkbox must be enabled so that the Color at Maximum Distance feature is available. Once selected, you can choose a color for the transparent material.

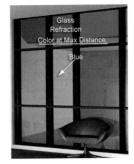

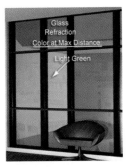

Advanced Rendering Options Reflections

Color at Max Distance = Blue

Color at Max Distance = Light Green

- **Indirect Illumination FG/GI Multiplier:** This value allows you to control how strongly a material responds to indirect light, and affects only surface areas lit by indirect light. The directly lit areas can be tweaked with the help of the composite map for ultimate control.

Note: Although the Indirect Illumination FG/GI Multiplier function is not often used by novice CG artists, it is one of the most important functions of the Arch & Design Material, especially when fine-tuning photorealistic scenes. This function, in conjunction with the metal material function and the composite map, lets you emulate any photorealistic material. Through the tutorials ahead in Sections 2 to 6, you will be able to further understand its benefits.

FG/GI multiplier = 0.0

Indirect Illumination Options

FG/GI multiplier = 1.0

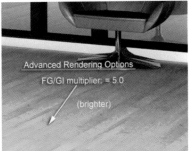

FG/GI multiplier = 5.0

Indirect Illumination FG Quality: A multiplier to enhance Final Gather at the material level, thereby enhancing the rendering of certain objects.

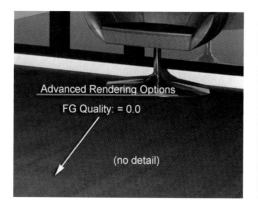

FG Quality = 0.0

FG Quality = 1.0

Fast Glossy Interpolation

- **Interpolation Grid Density:** This function controls the accuracy of glossy effects in the render. It is recommended that the interpolation grid density is set to 1 (same as rendering) for good results. Higher values will increase render times, with little impact on the final result. Lower values will decrease the render times and create artifacts on glossy surfaces.

Special-Purpose Maps

- **Bump:** This map allows you to insert a bitmap or procedural map in its map channel to create the illusion of 3D displacement or bump. Its spinner value sets the visibility of the map assigned.

Note: For best results you should use grayscale maps. Unlike displacement, this function only creates an illusion of a bump; therefore, it doesn't cast shadows and is quick to render.

- **Displacement:** This map allows you to insert a bitmap or procedural map in its map channel and will create displaced geometry. It is only visible at render time. It is worth mentioning that the displacement works differently to bump as it creates real geometry from the information contained on the bitmap; therefore, it casts shadows but is slower to render. Its value sets the visibility of the displacement bitmap applied to the map slot on the right.

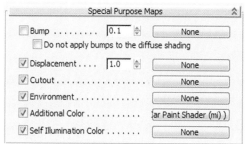

FG Quality = 20.0

Special Purpose Maps rollout

Note: For best results you should use grayscale maps. Displacement works best with subdivided surfaces. To subdivide a surface, one of the best tools to use is the Tessellate tool. Use the face-center option to avoid artifacts and maintain the integrity of the mesh. This tool can be accessed from the modifier dropdown list in the Modifier panel.

- **Cutout:** This function works as an opacity mask. It works best with black and white colors only. Black represents the invisible area (cutout areas), and the white represents the visible area. Cutout is accurate and powerful to create perforated surfaces and the like. It casts shadows through the perforations accurately.
- **Environment:** This map allows you to add a bitmap or a procedural map to the environment map channel. A powerful combination is mixing and matching the Environment map, the main diffuse properties, and the Additional Color map. Example: create a satined metal material as the main template, mixed with car paint (mi) map applied to the additional color map, and a high dynamic range image (HDRI) applied to the environment map.

Additional Color: This map allows you to add a bitmap or procedural map to the Additional Color map channel. A powerful combination is mixing and matching the Environment map, the main diffuse properties, and the Additional Color map.

- **Self Illumination Color:** This map allows you to add a bitmap or procedural map to the Self Illumination Color map channel (Filter color). When the Self Illumination (glow) function is on and a bitmap or procedural map is applied to the filter color map, the Self Illumination Color toggle is automatically connected as an instance to the Self Illumination (glow).

2.18 Utility Bump Combiner

The Utility Bump Combiner is a special shader in mental ray that combines an existing mental ray material with three independent bump map channels that can have their own maps and strengths. The Utility Bump Combiner is added at the top level of a material, and the existing material is kept as a submaterial. This material utility is important in creating surfaces with floor tiles in addition to overall general floor irregularities. Its unique functionality is best highlighted in the atrium tutorial.

Note: A similar Utility Displace Combiner can be used for displacement maps.

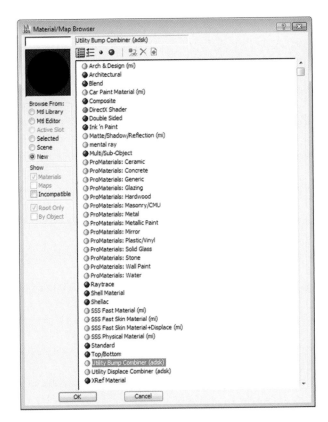

Selecting the Utility Bump Combiner in the Material/Map Browser

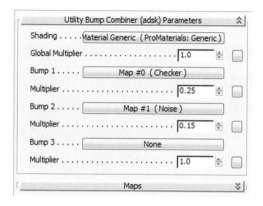

UI of the Utility Bump Combiner

2.19 Ambient/Reflective Occlusion Map

This map replaces a standard map or color with an Ambient/Reflective Occlusion Map while retaining the existing map as a submap. This map provides more control over the Ambient Occlusion features found in other mental ray materials. In addition, it adds details on overexposed areas. This map is often used on external scenes that are usually flattened by the direct light(s), but also helps bring out lost details from objects in any scene, interior or exterior. Render times are not increased significantly with its use.

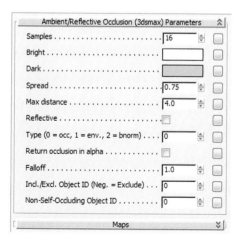

UI of the Ambient/Reflective Occlusion Map

Example of a Checker and Noise Bump combined

Selecting the Ambient/Reflective Occlusion Map in the Material/ Map browser

Some of the settings to note in the Ambient/Reflective Occlusion (3dsmax) Parameters rollout:

- **Samples:** Controls the quality of the shadows; higher values produce better-quality shadows.
- **Bright:** The Diffuse Color or Map.
- **Dark:** The Shadow Color or Map.
- **Spread:** Controls the radius value of the limit of the shadows.
- **Max Distance:** Controls the fading distance of the spread values.

Ambient/Reflective Occlusion Map

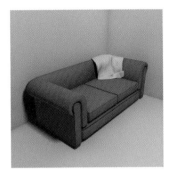

Ambient/Reflective Occlusion Map with Bright and Dark Values changed to medium and dark brown for the sofa object

2.20 Composite Map

The Composite Map provides you with the ability to layer two or more images to produce a more complex image. In the tutorials section, the Composite Map is used to perform color corrections on map files.

- You add to the complexity of the composite by adding layers to the Composite Map.
- The map slot on the left of each layer is the primary bitmap in the layer; the map slot on the right is for a mask bitmap.
- Each map can be color-corrected by clicking on the button to the left or right of the map slot.

UI of the Composite Map

- Each layer is combined with the others by one of the following methods:
 - An opacity value
 - Different blending methods that can be chosen in the Blending list
 - A mask file
 - An alpha channel built into the original bitmap texture

Composite Map used to composite a sign onto a map of a brick wall

Spiral Staircase with various materials

Chapter 3

Lighting in mental ray

3.1 Introduction

In this chapter, you will learn about lighting in mental ray. Specifically, you will learn about:

- Interior lighting with mental ray
- Parameters in Final Gather
- Creating Final Gather Maps
- Parameters in Global Illumination
- Hardware Shading
- The mr Sky Portal
- Exterior lighting with mental ray
- mr Sun Parameters
- mr Sky Parameters

3.2 Interior Lighting Concepts with mental ray

When a scene is rendered without indirect illumination, only light rays that strike the surfaces directly affect its illumination. In scanline rendering, you could use fill lights to simulate indirect lights or go to an advanced lighting solution like radiosity to obtain more realistic results. In mental ray, you use indirect lighting controls to provide your images with realistic illumination.

Whenever you work on an interior scene, there will be a number of potential adjustments that you can make to the way mental ray calculates light distribution in a 3D scene that will make the scene look more realistic. Initially, without lights and the controls provided by mental ray, an image will look flat and lifeless. Using these controls will provide you with a more realistic image, but it will take longer for 3ds Max and mental ray to generate a final image.

Note: In general, the best settings of Final Gather (FG) alone will not be sufficient to have a "photo real" image. It is a combination of good FG settings; good shaders with parameters at the best settings; the scene composition (i.e., many detailed objects, good camera position, objects randomly and naturally placed around the

scene, good choice of material colors, designer objects); great contrast in the scene between brighter and darker areas; reflective objects with highlights; lively objects in the scene (i.e., plants/vegetation, people, animals); great position of the lights in the scene; and a wise choice of their colors. The Atrium and the Photomontage tutorials are good examples of the above-mentioned elements. It is also common practice to use real photography as reference to emulate reality.

The controls you will use in mental ray will fall under two areas of indirect lighting: Final Gather and Global Illumination. As you work with values in indirect illumination, you will clearly see the trade-off between rendering speed and quality. In the images that follow, you can see how Final Gather (FG) and Global Illumination (GI) affect the indirect light in the scene.

As a reference, the living room scene has been rendered with a sample light behind the camera and with no indirect illumination.

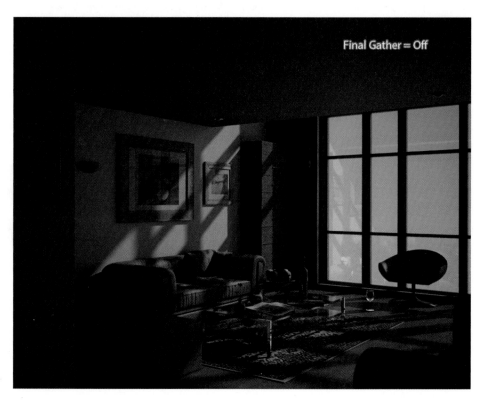

Final Gather off

Final Gather is usually the first step in using indirect illumination in mental ray. When you turn on Final Gather, you will begin to see indirect illumination in areas previously only in dark shadows.

Global Illumination is used in mental ray to contribute to the overall bounce of light. GI will provide more color appeal to an image, as light will pick up colors from reflected surfaces. It is not necessary to use GI, but it adds that extra quality that will turn a nice image into a very nice one.

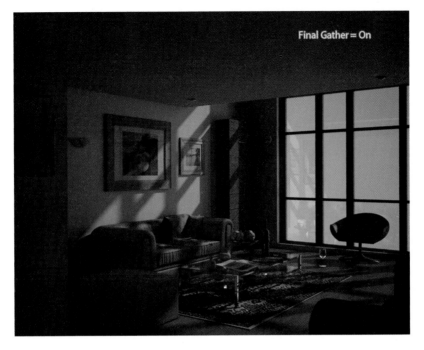

Final Gather on

Note: In 3ds Max Design 2010, you should use either FG or GI. FG is clearly more prominent in the UI and appears to be favored by the developers. Some settings of FG and GI will be ignored if both are used simultaneously.

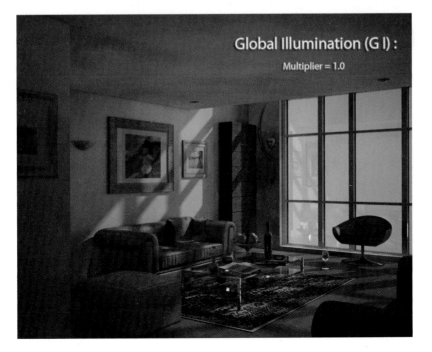

FG off and GI on

3.3 Parameters in Final Gather

There are numerous parameters in Final Gather and Global Illumination that control the quality of the indirect illumination in a scene.

Basic Group

- **Enable Final Gather:** This check box is turned on by default. When it's on, all Final Gather parameters are enabled. When it's off, all Final Gather parameters are grayed out.
- **Multiplier:** Sets the amount of brightness in the scene by multiplying the indirect light and its color stored in the Final Gather solution. Default value is 1.0. Good practice is to try to keep the default value of 1.0, and adjust the light and material properties instead, as higher multiplier values may increase the rendering times somewhat.

Final Gather rollout in the Indirect Illumination tab of the Render Setup dialog

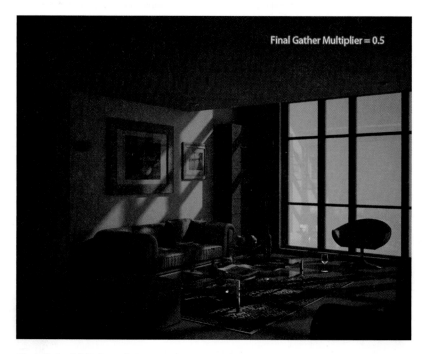

Final Gather Multiplier = 0.5

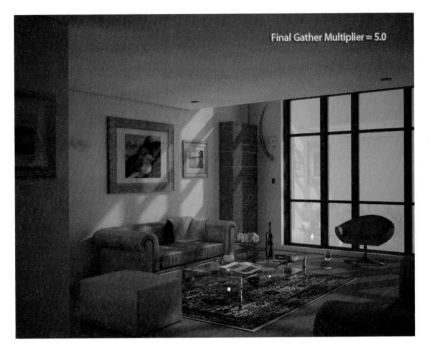

Final Gather Multiplier = 5.0

- **Preset:** This slider sets the accuracy with which mental ray will interpret the basic parameters values of Final Gather. By sliding it either to the left or right, you will ultimately determine the rendering time (Draft = fast; Very High = very slow). It is strongly advised to keep the preset as custom, as generally you may only require adjustment of 1 or 2 values of the Final Gather parameters.

- **Project FG points from camera position (best for stills):** This Final Gather preset is designed to work very well with still cameras only, as FG points are computed from scratch per frame. If you were to use this preset for animated cameras, lights, or objects, you could encounter flickering FG artifacts on the render. This FG preset is designed to process one frame at time as opposed to sequenced frames.

- **Project FG points from positions along camera path:** This Final Gather preset is designed to reduce FG artifacts encountered on animated cameras, objects, or some complex materials. It incrementally adds FG points along the camera positions with consistency, eliminating any possibility of FG flickering. When you have an animation where only the camera is moving, you can set the 3ds Max Design range function to render the FG every 10/20 frames only, from the Common tab, Time Output group.

- **Divide camera path by num segments:** This function is only available when "Project FG points from positions along camera path" is selected. Its number of segments rollout determines the accuracy at which the FG will be computed along the positions; high values on this rollout will have to be coordinated with high values of the initial FG point density. The default value is often sufficient.

- **Initial FG point density:** This value reduces the amount of noise and other FG artifacts generated by the Final Gather points. High values will dramatically increase the rendering time but produce smoother and more prominent results. The default value is 0.1. The rule of thumb is to keep this function at its default parameter of 0.1 and compensate it with high values of "Interpolate over num. fg points," which takes relatively less or no time to compute for the same/similar results.

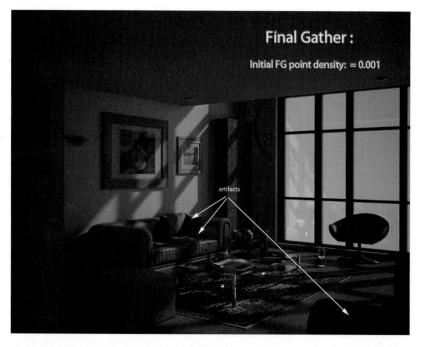

Initial FG Point Density = 0.001

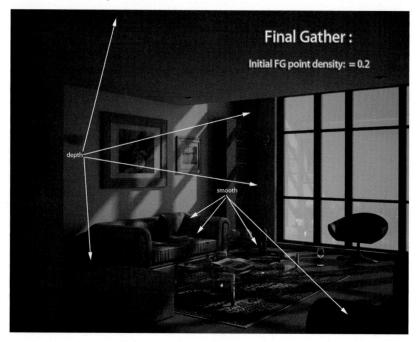

Initial FG Point Density = 0.2

- **Rays per FG point:** Sets the number of rays used to compute indirect illumination. High values will increase the rendering time. The default value of 30 may be good for some simple exterior scenes, however; some

complex exterior or interior scenes may require values as high as 150. The of thumb is to start test rendering always with lower values; should you encounter any artifacts, then start increasing the values.

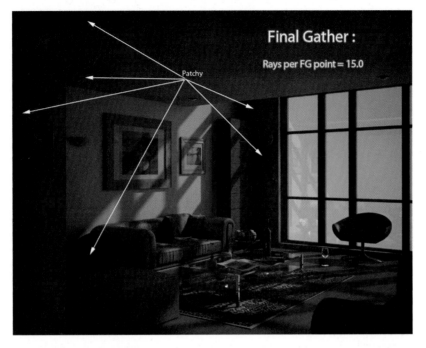

Rays per FG Point = 15.0

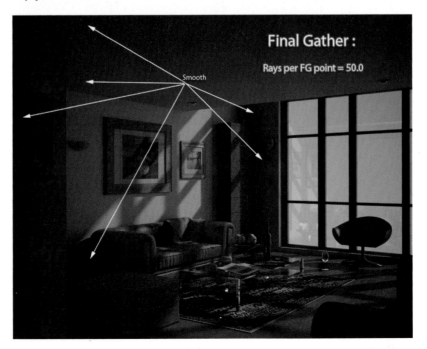

Rays per FG Point = 50.0

- **Interpolate over num. FG points:** This function adds (by interpolating) more FG points over the rays per FG points (this interpolation will result in a smooth transition between FG points). This function is critical for eliminating any FG artifacts in the scene. The self-illumination (glow) using FG is dependent on this function to correct its artifacts or to help create specific self-illuminated patterns. These self-illuminated patterns can only be corrected accurately when the cameras in the viewport are not distorted or at an odd angle. Finally, high values for the "Interpolate over num. FG points" setting will not contribute a great deal to the rendering times; however, it may eliminate some depth in the scene. Also, when its value is set to 0.0, it would automatically enable the Brute Force render, which essentially bypasses any of the FG settings and starts rendering immediately. For this reason, the Brute Force rendering system takes a considerable amount of time, as the bucket frames are computed in a raw manner without any precalculations.

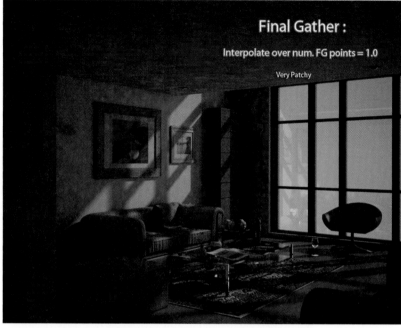

Interpolate Over Num. FG Points = 1.0

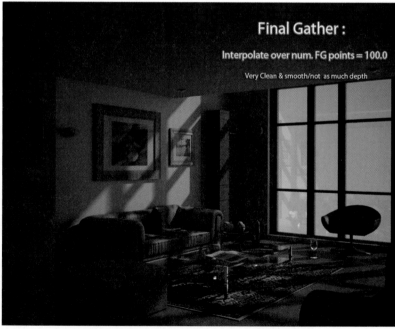

Interpolate Over Num. FG Points = 100.0

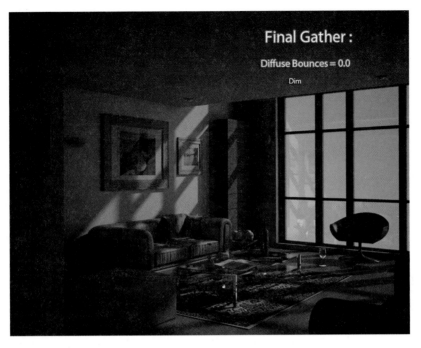

Diffuse Bounces = 0, Weight = 1.0

- **Diffuse Bounces:** Sets the amount of contribution each object in the scene will have when calculating the light bounces from one surface to another nearby surface. Default value is 0.0. Note that values higher than 1.0 will dramatically increase the rendering times.
- **Weight:** Invigorates the "Diffuse Bounces" prominence. Default value is 1.0.

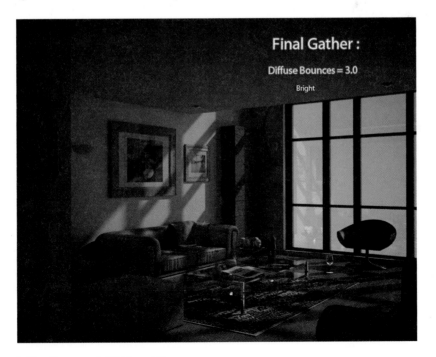

Diffuse Bounces = 3, Weight = 1.0

3.4 Reuse Final Gather Maps

In the Reuse (FG and GI Disk Caching) rollout, there are several tools that allow you to generate and reuse a Final Gather Map file (.fgm). Generating a Final Gather Map file is a time- and memory-saving operation that can have a number of applications.

- When you are creating still image test renders and your scene is almost final—there are no changes to lights, objects (moved, modified, or replaced), and there are no significant changes to materials (i.e., self-illumination glow material using FG, or displacement map)—generating a FG Map file will save time, as 3ds Max Design will bypass the FG calculation step to render the image.

Reuse (FG and GI Disk Caching) rollout

- If you run out of memory while computing the Final Gather process of a high-resolution image (300 dpi), the best way to overcome that problem is to save the Final Gather map into a low-resolution image such as 320×240 pixels and reuse it on your final high-resolution image.

- When saving the FG at a lower resolution, ensure that only one machine is being used, or there could be artifacts when using the final rendering. Only when the presaved FG file is being used one should use multiple machines—if available.

- **Mode:** Two modes are available: Single File Only (best for walkthough and stills) and One File per Frame (best for animated objects).

- **Calculate FG/GI and Skip Final Rendering:** When this setting is on, 3ds Max Design will calculate the FG Map and save it to the file specified. This is great when previous test renders had been carried out; no complete renders are required, only the FG process. The render stops at the completion of the FG process.

- **Final Gather Map Mode:** Three modes are available:
 - **Off:** No caching of FG Map Data to disk.
 - **Incrementally Add FG Points to Map Files:** When you are saving your FG Map file, this mode needs to be on.
 - **Read FG Points Only from Existing Map Files:** When you wish to reuse the presaved-only Map file you generated, this mode needs to be on. Also, Calculate FG/GI and Skip Final Rendering mode must be off.

- **(…) Browse:** This button allows you to click and choose a location to save your Final Gather Map file.

- **Generate Final Gather Map File Now:** This button tells 3ds Max to calculate the FG Map and save it to the file specified.

3.5 Parameters in Global Illumination

The following are the main parameters in the Global Illumination (GI) area of the Caustics and Global Illumination (GI) rollout:

- **Enable:** When on, calculates global illumination. Default = off.
- **Multiplier:** Sets the brightness of the photons. Default = 1.0.

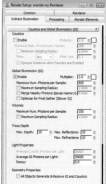

Caustics and Global Illumination (GI) rollout

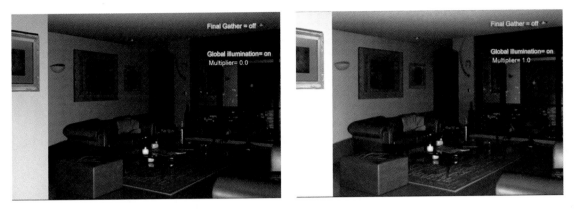

Multiplier = 0.0 *Multiplier = 1.0*

- **Maximum Num. Photons per Sample:** Sets the number of photons to be used when processing the intensity of the global illumination. Increasing its values reduces the noise; however, it also blurs the image. Higher values will increase the rendering time. Default = 500.

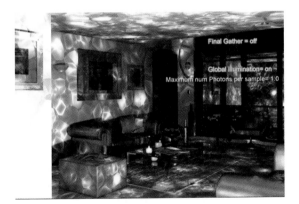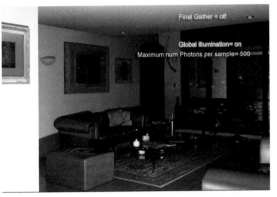

Maximum Number of Photons per Sample = 1 *Maximum Number of Photons per Sample = 500*

- **Maximum Sampling Radius:** When on, sets the size of photons. Default = off; value = 1.0.

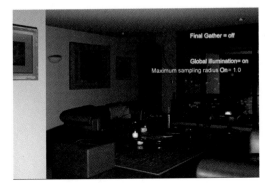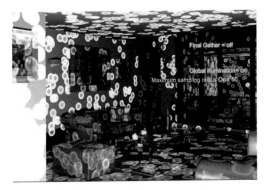

Maximum Sampling Radius = on, Value = 1.0 *Maximum Sampling Radius = on, Value = 50.0*

- **Merge Nearby Photons (Saves Memory):** When checked, prevents the mental ray renderer from releasing more photons by merging the nearby ones (no need to use high "Maximum Num. Photons per Sample" values), subsequently saving memory usage.
- **Optimize for Final Gather (Slower GI):** When this is on, it works in conjunction with the Final Gather settings by optimizing its samples; however, it may increase the global illumination calculation.

3.6 Hardware Shading

Hardware Shading is the ability to preview Shadows, Ambient Occlusion, and Exposure Control in the 3ds Max Design viewport. This will allow you to place lights more accurately in your scene without having to create test renders.

In the Shading Viewport Label Menu, you will find a selection called Lighting and Shadows. Within this menu, you will find the option Enable Hardware Shading. Typically, you will choose to Illuminate with Scene Lights and Enable Shadows.

Shading Viewport Label menu

Smooth and Highlights Shading mode, no Hardware Shading

3.7 mr Sky Portal

The mr Sky Portal is a light object that you can place into a scene to boost the light coming into an interior space through transparent materials or openings in walls. The mr Sky Portal by default draws color from the mr Sky object, which is part of the Daylight System. The mr Sky Portal object can be found in the Create tab of the Command panel under Lights > Photometric.

Hardware Shading enabled

mr Sky Portal

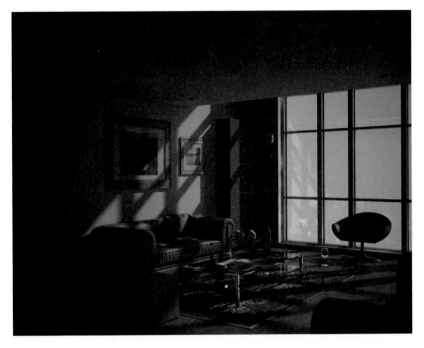

Light entering an interior space with no mr Sky Portal

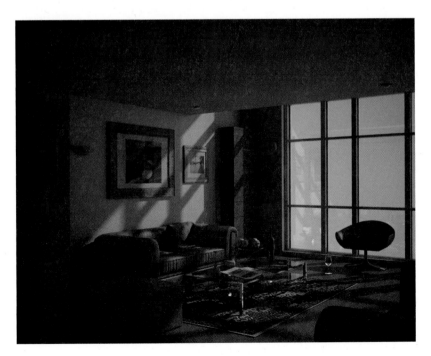

*Light entering an interior space with a mr Sky Portal placed at the plane of the window glass,
multiplier = 5.0*

Note: When using a mr Sky Portal, you can use an hdr image to add realism to the light being emitted by the portal. To do so, go to the mr Sky Portal Advanced Parameters, in the color source area; choose the custom function and add the relevant image from its adjacent map button.

3.8 Exterior Lighting Concepts with mental ray

Exterior lighting with 3ds Max Design and mental ray has the potential to be a quick and easy process. Inserting a daylight system in an external scene can quickly establish three components for your exterior lighting: the sun, the sky, and the sky environment.

While the daylight system provides this quick ease of use, it also provides an incredible amount of control over how the three components interact with one another to provide you with the lighting you want in your scene. The following section will describe many of the parameters of the daylight system.

When you have mental ray as the default renderer and create a daylight system in a scene, 3ds Max Design will create the daylight system with a mr Sun and a mr Sky and will also prompt you to use a mr Physical Sky environment map. While you may choose to not use all three of these components, the following section will use all three so that you can appreciate how they interact together.

Create a daylight system through the Create pull-down menu on the Main toolbar.

When you expand the rollout of the daylight system you created, you will see the number of parameters that can be adjusted.

Quickly placing a daylight system in a scene like this harbor scene will show you what can be easily

Accessing the Daylight System

Daylight System rollouts

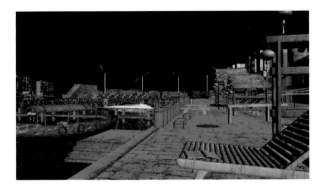

Scene with default lighting

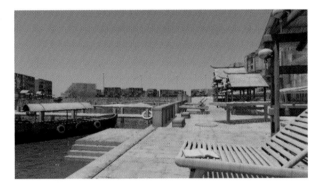

Scene with Daylight System

Scene with Daylight System and matte material

attained. The first image is only default lighting. The second image has the materials with a daylight system inserted. The third image has the materials overridden with a matte material. It's easier to see the effect of the lighting on the scene with the matte material.

Although the scene lighting with a default Daylight System is not bad, there is considerable room for improvement. Once you understand the parameters in mr Sun, mr Sky, and mr Physical Sky, you will be able to produce much more interesting lighting for your exterior scenes.

3.9 mr Sun Parameters

In the Daylight System parameters, you can adjust several parameters that will allow you to create different effects for the sun. The parameters discussed here are in the mr Sun Parameters rollout.

- **Multiplier:** The multiplier affects the overall intensity of the light from a given source.

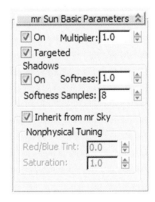

mr Sun Basic Parameters

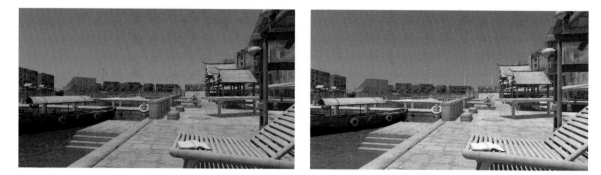

mr Sun Multiplier = 1.0 mr Sun Multiplier = 2.0

When you remove the check in the "Inherit from mr Sky" option, you will have access to a few additional options that allow further control over the lighting.

- **Red/Blue Tint:** Sets the color (tint) of the sun; negative values start from −0.1, which is equivalent to light tones of blue, down to darker tones of blue, which is equivalent to −1.0. Positive values start from 0.1, which is equivalent to light tones of yellow, down to darker tones of yellow, which is equivalent to 1.0.

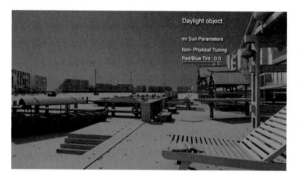

Red/Blue Tint = 0.0 Red/Blue Tint = −1.0

Red/Blue Tint = 1.0

- **Saturation:** Sets the Saturation of the Red/Blue Tint. This option is very useful to tone down strong colors like dark blue (−1.0) or dark yellow (1.0).

Saturation = 0.0

Saturation = −1.0

3.10 mr Sky Parameters

In the Daylight System parameters, you can adjust several values that will allow you to create different effects for the sky. The parameters discussed here are in the mr Sky Parameters rollouts:

- **Multiplier:** The multiplier affects the overall intensity of the light from a given source.
- **Sky Model:** Choices range between Haze (default), Perez All Weather, and CIE. Perez and CIE are physically accurate sky models, whereas the Haze model provides you a range of values to control the number of particles in the air and therefore affects the intensity of color in the scene.

Saturation = 2.0

- **Haze:** The Haze value can vary between 0.0 (clear) and 15.0 (extremely overcast).
- **Horizon Height:** Allows you to control the height of the horizon of the mr Physical Sky background.

mr Sky Multiplier = 1.0

Haze = 1.0

Haze = 5.0 *Haze = 10.0*

- **Blur:** Allows you to blur the ground/sky transition at the horizon.

Height = 0.0, Blur = 0.0 *Height = −0.5, Blur = 0.5*

- **Red/Blue Tint:** Sets the color (tint) of the sun; negative values start from −0.1, which is equivalent to light tones of blue, down to darker tones of blue, which is equivalent to −1.0. Positive values start from 0.1, which is equivalent to light tones of yellow, down to darker tones of yellow, which is equivalent to 1.0.

Red/Blue Tint = 0.0 *Red/Blue Tint = 1.0*

Red/Blue Tint = −0.2

Red/Blue Tint = −1.0

- **Saturation:** Sets the saturation of the Red/Blue Tint. This option is very useful to tone down strong colors like dark blue (−1.0) or dark yellow (1.0).

Saturation = 1.0

Saturation = 0.0

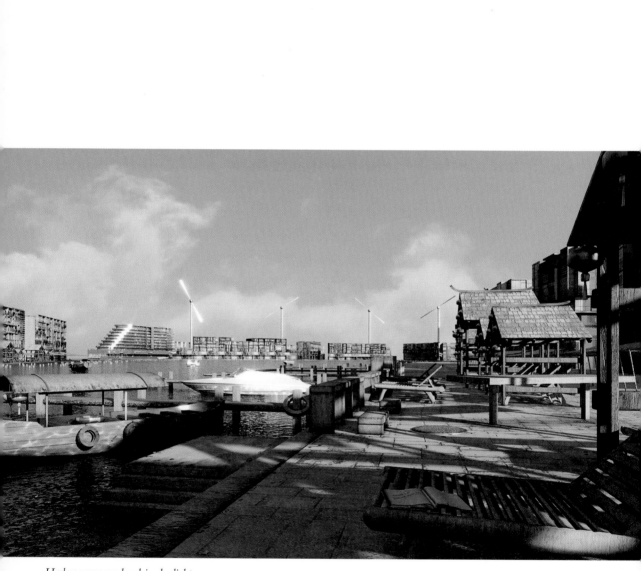

Harbor scene rendered in daylight

Chapter 4

Rendering in mental ray

4.1 Introduction

In this chapter, you will learn about rendering in mental ray. Specifically, you will learn about:

- Specific controls related to the mental ray renderer in the Rendered Frame window and Render Setup dialog
- Material Overrides
- mr Photographic Exposure Controls
- Network and Distributed Bucket Rendering
- Batch Rendering and Using Scene States and Presets

4.2 Rendering

Rendering is a process that you will go through several—if not hundreds—of times while developing an image. Renders are typically performed:

- During the modeling process to check model accuracy and integrity
- While developing and applying materials
- As you add lights to the scene
- To refine materials once scene lights have been applied
- To create final renders of the highest quality

3ds Max Design provides a number of places from which you can initiate a render of your scene:

- The Rendered Frame window
- The Render Setting dialog
- The Main toolbar
- By pressing the F9 function button (renders the last rendered view)

mental ray makes use of the Rendered Frame window, and changes the layout of the Render Setting dialog. The mental ray elements will be the primary focus of the next sections.

4.3 Rendered Frame Window

The Rendered Frame window is nothing unique to mental ray, although the entire lower section of the window appears only when the mental ray renderer is active. This area is typically referred to as the "mental ray settings area."

Rendered Frame window when mental ray is active

Here are some of the settings that are of most importance:

- **Image Precision:** This slider controls the antialiasing of the image; as the value of the slider is reduced, you will notice jagged edges along diagonal lines in the image and some artifacts. Higher values produce better images but will increase render times. This slider adjusts the Samples per Pixel values found in the Render Setup dialog under the Sampling Quality rollout.

- **Final Gather:** This slider controls the level of Final Gather settings to one of six default settings (Off to Very High). The usefulness of the slider is mostly limited to the lower levels (Off, Draft, and Low), as the higher settings will increase render times considerably. Refining Final Gather beyond Draft is best done through settings found in the Render Setup dialog, the Indirect Illumination tab, and the Final Gather rollout.

- **Soft Shadows Precision:** Controls the quality of Soft Shadows globally and whether soft shadows are on. Soft shadows are produced when light is being emitted from an object that is something other than just a point. The feathered effect of the shadows produced from these lights can be improved with this value. While you are performing test renders, you may decide to turn off this slider completely to save on render time. Soft Shadows Precision can also be adjusted in the Render Setup dialog, the Renderer tab, and the Global Tuning Parameters.

- **Glossy Reflections/Refractions Precision:** These two sliders control the precision of reflections globally or refractions in reflective or refractive objects. Lower values lead to artifacts and jagged edges, while higher values lead to better images but longer render times.

- **Max Reflections:** This value controls the number of reflections that can occur in a scene. For scenes that have numerous reflective objects, the default value of 4 may be ideal or not high enough. For scenes that have objects with low reflectivity, rendering time can be saved by reducing this value.

- **Max Refractions:** This value controls the refractions that occur through transparent objects in a scene. Light gets refracted at each surface of a transparent object. When there are transparent objects in the scene, you need to calculate the number of refractions based on the maximum number of surfaces the light will pass through. For a glass window with a thickness, this value would be 2; for a glass vase, it would be 4; and so on. If the value is too low, the transparent object will render opaque.

- **FG Bounces:** Controls the number of times mental ray will calculate diffuse light bounces in the scene. Switching from 0 bounces to 1 will have a dramatic effect on the scene, whereas increasing the value past 3 will have a minimal effect on the scene.

- **Reuse Geometry:** This lock is useful for renders after the geometry in the scene no longer changes. The mental ray renderer will be quicker to compute the geometry translation process.

- **Reuse Final Gather:** This lock is useful for test renders when geometry, lighting, and major material changes (i.e., displacement and self-illumination [glow] using FG) are finalized. You can save the FG at a lower resolution (300×) and reuse it for larger final renders (5000×), provided the camera angle and the image ratio remain intact. The Initial Final Gather is computed on one computer only to avoid artifacts. Later, the FG Map file can be used with the Reuse Final Gather function, on multiple machines, if available.

4.4 Render Setup Dialog

The Render Setup dialog is both an alternative to the Rendered Frame window for establishing mental ray settings and also offers many more settings that you can control. In this section, you will see some of the more important settings that you can control here that are specific to mental ray:

- **Caustics:** In the Indirect Illumination tab, Caustics and Global Illumination (GI) rollout, you can enable and control the reflective or refractive caustics effects in your scene. Caustics are discussed in detail in the appendices.

Note: It is advised to avoid using caustics in external scenes, as this can take too long to compute.

Material Override tool

Caustics and Global Illumination (GI) rollout

- **Sampling Quality Filter:** Five different sampling types are available; recommended widths and heights are dependent on the filter type chosen. This filter works similarly to the filter samples of renderer parameters: Box produces draft results, Cone produces better results, and Gauss has more precision and accuracy when representing caustics.

- **Material Overrides:** In the Processing tab of the Render Setup dialog is a Material Override tool that will temporarily replace all materials in a scene with a material designated in the adjacent material slot. By default, it uses the objects' color; to replace it with one completely new material, simply drag and drop a new material from the Material Editor onto the Material Override toggle. This tool is extremely useful when you have applied materials in your scene and would like to go back and adjust lighting. Rendering the scene with materials that contain maps, reflections, and refractions can slow down a test render. If you choose a matte white material as the material override, it will give you a clear idea of how the lighting is contributing color to the scene.

4.5 Exposure Control

Exposure Control is a tool that allows you to adjust your image brightness, contrast, and color without adjusting the lighting. It is used once you have finalized your lighting setup and wish to make some final

Material Override tool

adjustments to the image. When you work in 3ds Max Design and use either a Daylight System or photometric lights if Exposure Control is not on, it will prompt you to turn it on. When mental ray is active, mr Photographic Exposure control is used.

Once you activate Exposure Control and/or it is activated for you, you will see the mr Photographic Exposure Control rollout displayed in the Environment tab of the Environment and Effects dialog:

- **Exposure Presets:** This list allows you to select from several preset values for exterior and interior conditions. Each preset will adjust the Exposure Value and Photographic Exposure.
- **Exposure Value (EV):** The Exposure Value is a numerical value used to represent the exposure in the scene. Exterior day light scenes typically have an EV = 15.0, whereas an interior scene lit by artificial lights will have an EV = 2.0. The lower the value, the greater the exposure and the brighter the scene will appear.

Scene rendered with default Exposure Value of 15.0

Scene rendered with Exposure Value of 16.0

- **Photographic Exposure:** The three controls of Shutter Speed, Aperture (f-stop), and Film Speed (ISO) combine to adjust exposure of the image:
 - The slower the shutter speed (1/64 is slower than 1/512), the more light is let into the camera and therefore the brighter the image will be.
 - The smaller the aperture value, the more open the shutter of the camera will be, thereby letting in more light, making the image brighter.
 - Film Speed refers to the speed that a film will absorb light, 100 being typically the slowest. Doubling the value ISO setting will increase the EV value by 1.0.
- **Image Control:** Highlights (Burn), Midtones, and Shadows can be controlled here to adjust the contrast of the image:
 - Increasing the Highlights value makes the bright areas brighter (default = 0.25).
 - Midtones can be made brighter or darker by raising or lowering the value (default = 1.0).

Increasing the Shadows value will make the shadows darker (default = 0.2). This tool is also very useful to increase the contrast of a scene.

Scene rendered with Exposure Value of 15.0, Highlights = 0.75, Shadows = 0.5; image has more contrast

- **Color Saturation:** Allows you to increase or decrease the color saturation of the image much in the same way you do in a color selector (Hue, Luminance, Saturation).
- **Whitepoint:** Defines the temperature value of white light in an image. Similar to color-adjusted film or white balance controls on digital cameras. Typically, exterior scenes with a Daylight System would be set to 6500. If you wish to correct the yellow/orange quality of an interior image that is lit with primarily incandescent lights, a value of 3700 would be more appropriate.
- **Vignetting:** Controls the darkness at the corners of the image and to balance the brightness of a scene.

Scene Rendered with Vignetting = 10.0

4.6 Network and Distributed Bucket Rendering

These two methods of rendering were designed to help you cope with large renders and/or animations. Usually you would require multiple machines to be able to utilize any of these two methods of rendering. The following discussion will take you through the steps of setting them up and help you understand the advantages and restrictions of each method.

Note: You can use Net Render *or* Distributed Bucket Rendering but not both at the same time. In addition, Distributed Bucket Rendering should not be used for rendering animations—only still images.

4.7 Net Render

Ensure that all your files (FG Map, bitmaps, file output path, and so on) are in a shared drive (not local drives like C:). Ensure that the Net Render toggle is checked and click Render. The Network Job Assignment dialog will appear. Click Connect to see all the available machines in the server. Select the machines desired from the server field name.

On the Server Usage group, choose Use Selected to enable only the selected machines to be used. In the Options group, choose the Split Scan Lines option, and then click on the Define button.

The strips setup dialog will appear; set it to Pixels, the Overlap value to 2, and the number of strips to 10 and strip height to 48. Click OK to close the dialog. Click Submit.

The Dependencies Toggle in the Priority group is very useful when setting up FG files and final renders. For example, submit the first Max file to compute the final FG only on the network. Good practice is to submit this to one computer, as opposed to several computers. Resubmit the same Max file (i.e., the second Max file)—not to compute the FG, but to read the FG and compute the final render. This time, use multiple machines to do this. Before submitting the second Max file to render on the network, open the Job Dependencies dialog box. On the Existing Jobs Name field, select the first Max file submitted to

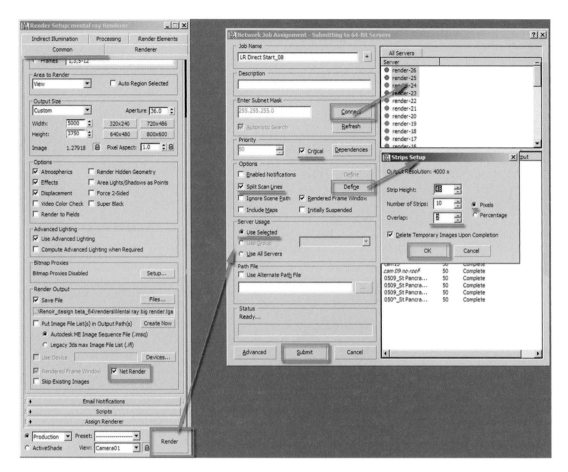

Submitting a Net Render

compute the FG file only. Once selected, add it to the Jobs Your Job Depends On name field. Click OK to close the dialog.

Note: Name each Max file according to its tasks (i.e., "photomontage_FG" when the task is to compute FG only and "photomontage_FINAL RENDER" when the task is to compute the final render only). This way it is easier to pick, add, and edit jobs from the list.

To follow the progress of your renders, double-click the Monitor icon from your desktop or from your Windows Start menu.

Monitor icon

Job Dependencies dialog

The Backburner Queue Monitor dialog will display. Click the Connect to Manager button; its dialog will appear. Click OK to close it.

Note: If most of its toggles are grayed out, it is an indication that you are not in control of the Backburner Queue Monitor. To control the Backburner Queue Monitor, click the Manager menu and select Request Queue Control.

Backburner Queue Monitor

Requesting Queue Control

Next, choose any job from the list and click the Refresh button several times until buttons such as Delete Job and Suspend Job become available. Once on, this indicates that you have full control of the Backburner Queue Monitor.

Once in control, you can then select a job from the list, right-click, choose, and edit any of the available settings. For example, if you select Edit settings from the menu, a common setting to change would be the Wait to Render setting. With a large render, which might take a long time to complete, you would often change the default of 600 to 10000, so that the render does not time out.

Refresh the Queue Monitor

Full Control

z7cam1ppl	7		Critical	Complete	(100%) 0...	jcheung
z7cam1ppl - Second Pass	8		Critical	Complete	(100%) Si...	jcheung
cam07irr	9		Critical	Complete	(100%) 0...	simonec
cam10irr	10		Critical	Complete	(100%) 0...	simonec
cam13irr	11		Critical	Complete	(100%) 0...	simonec
cam09 no roof IRR	12		Critical	Complete	(100%) 0...	simonec
cam07			50	Active	(099%) 1...	simonec
cam10			50	Complete	(100%) 0...	simonec
cam13			50	Complete	(100%) 0...	simonec
cam 09 no roof			50	Complete	(100%) 0...	simonec
0509_St Pancras			50	Complete	(100%) 0...	zpancheva
0509_St Pancras			50	Complete	(100%) Si...	zpancheva
0509_St Pancras			50	Complete	(100%) 0...	zpancheva
0509_St Pancras			50	Complete	(100%) Si...	zpancheva

Edit Settings...	Ctrl+J
Change Priority	Ctrl+P
Clone Job	
Dependencies...	
Report...	
Column Chooser...	
Activate	Ctrl+A
Suspend	Ctrl+S
Restart Job	
Archive Job	
Job Archives	
Delete	Del

Right-Click menu

Job Settings

Compute Advanced Lighting	No
Field Order	Odd
Outputs	
Output 0 Path	\\Glass-fs-01\Data2\0571_FRS\090206\cam07\cam07\
Output 0 Gamma	2.2000
Alternate Paths	
Alternate Bitmap Path	
Alternate Xref Path	
Alternate Path Configuration File	
Alternate Project Folder	C:\Documents and Settings\simonec\My Documents\3
Timeouts	
Wait to load	20
Wait to unload	10
Wait to render	600
Notifications	
Enable Notifications	No
Notify Failures	Yes
Notify Progress	Yes
Notify Completion	Yes
Notify Progress Every Nth Task	10
Send Emails	No
Alert Email From	

OK Cancel

Job Settings

Another couple of useful tools are the Assign to Selected Jobs selection and the Remove From Selected Jobs selection in the Show All Servers list.

cam09 no roof 1RR	12		Critical	Complete	(100%) 0...	simonec
cam07	13		50	Active	(099%) 1...	simonec
cam10	14		50	Complete	(100%) 0...	simonec
cam13	15		50	Complete	(100%) 0...	simonec
cam 09 no roof	16		50	Complete	(100%) 0...	simonec
0509_St Pancras_Elevations_cam2	17		50	Complete	(100%) 0...	zpancheva
0509_St Pancras_Elevations_ca...	18		50	Complete	(100%) 0...	zpancheva
0509_St Pancras_Elevations_cam1	19		50	Complete	(100%) Si...	zpancheva

All Servers
— Selected Job
— Global Groups
— Local Groups
— Plugins

Show All

All Servers

Server	▲ ☐	Status	☐	Current Job	☐	Last Message	☐
glass-pc10		Idle		None		None	
glass-pc11		Absent		None		N/A	
glass-pc12		Absent		None		N/A	
glass-pc12		Idle		None		None	
glass-pc13		Idle		None		None	
glass-pc14		Idle		None		None	
glass-pc15		Idle		None		None	
glass-pc16		Idle		None		None	
glass-pc17		Absent		None		N/A	
glass-pc9		Idle		Nor			
render-01		Idle		Nor			
render-02		Idle		Nor			
render-03		Idle		Nor			

Assign to Selected Jobs
Remove From Selected Jobs
Remove From Selected Group

Servers list

Common Errors

At times, on the Backburner Queue Monitor, you may see an error message like, "Unexpected error has occurred." This is often due to memory problems. To solve most memory problems, you should turn most of the heavy geometry into proxies.

Another common reason for this type of error is missing plug-ins. You may have some plug-ins being used in the render that are installed on one machine but not in the others. All computers being used in the render should have the same plug-ins and applications running.

Errors can be caused by missing bitmaps and/or the missing map coordinates. Ensure that bitmaps and paths are pointing to a shared location "visible" by all the rendering machines (network/server) and that they have mapping coordinates applied.

When rendering in strips, you may get different strip colors, ending up with "zebra"-type renders. This is mainly to do with different gamma settings from some of the machines rendering. All machines should have the same gamma values—or, alternatively, don't use gamma at all. Gamma settings can be accessed from the Preference Settings dialog.

4.8 Distributed Bucket Rendering

Ensure that all your files (FG Map, bitmaps, file output path, and so on) are in a shared drive (not local drives like C:). In the Backburner Queue Monitor, under Server, select any server from the list and right-click. On

the dropdown list, choose the Column Chooser selection. The Server Columns dialog will appear. Select and drag the IP Address from the Server Columns dialog and drop it into the Backburner Queue Monitor under Server. This will allow you to see all IP address numbers that will be later typed in the name field. It is worth

Accessing the Column Chooser

Placing the IP Address into the Server Columns

mentioning that in this occasion the Backburner Queue monitor is being used solely to find out the IP address names. Distributed Bucket Rendering does not use the Backburner Queue monitor and/or the Net Render.

In the Render Setup dialog, in the Processing tab, go to the Distributed Bucket Rendering rollout and enable the Distributed Render option. Click the Add button to add the IP address. The Add/Edit DBR Host dialog will appear. Type the IP address number as indicated on the Backburner Queue Monitor and click OK to close the dialog.

Distributed Bucket Rendering

Server IP Address added

Multiple IP Addresses added

Keep adding as many as available and allowed.

If you need to edit, select one machine in the Distributed Bucket Rendering rollout list and click the Edit button.

To monitor the rendering process, go to the Rendering menu on the main menu and choose the mental ray Message window. In the dialog, check all its options (Information, Progress, Debug (Output to File), Open on Error).

mental ray Message window

Rendering menu

Common Errors

When using the Distributed Bucket Rendering service, it is very common to have the following error or something similar:

An exception occurred: A connection attempt failed because the connected party did not properly respond after a period of time, or established connection failed because connected host has failed to respond.

This occurs mainly because the firewall protection system from the other computers are blocking the "host" (i.e., your computer) from connecting to them.

To correct this error, do the following in the machines being used: Open the Control Panel > Security/Security Center > Windows Firewall > Change Settings > Exceptions tab. In the dialog, click on the Add program... button. Add the list of

Adding program exceptions in the Windows Firewall

raysat files for all Max versions, one at the time. These files can be found in: C:\Program Files\Autodesk\3ds Max ...\mentalray\satellite.

While the Distributed Bucket Rendering service is being used, all the machines being used have to remain on. If any of the machines is switched off by another user or any of the machines crashes while computing the buckets, it will crash the render. Some low-specification machines may not cope well with large renders and will crash. Network strip render is by far more efficient and intelligent when dealing with these issues. Strip renders are described in section 4.7. Batch render and strip render can be used simultaneously by simply checking the net render function on the batch render dialog box.

Rendering menu

4.9 Batch Rendering

When rendering multiple camera views in the same 3ds Max Design scene, which require different FG settings and some changes to objects (i.e., turned off or moved), there is a very useful tool named Batch Render. To access this tool, simply go the Rendering menu on the Menu bar. In the menu, select Batch Render.

Batch Render dialog

To start adding cameras, click the Add button. By default, the first camera name will be named view01. To edit this, go to the name field and type in the camera name according to the camera name in scene desired (i.e., camera01).

Note: By simply typing, the camera name will not change; you have to type and press Enter in order for the name to change. Also, the output path button allows you to set the output image name of the rendered camera view; this function overrides the save file name button from the Render Setup dialog box, under the Render Output area on Common tab.

The next step is to assign a camera from the scene to correspond to the named camera. To do so, click on the camera bar and select the desired camera from the list.

Entering a camera name

Next, you would set the scene state. Generally, when sending a variety of views to render, you might require different light settings, change some material parameters, and perhaps move/hide some objects. To save a scene state, go to the Tools menu on the Menu bar. In the menu, choose Manage Scene States.

Tools menu

Linking to a camera in the scene

In the Manage Scene States dialog, click Save. In the Save Scene State dialog, name the scene state according to your camera and choose the parts of the scene you want to save from the Select Parts list. Then click Save.

In the Manage Scene States dialog, you can choose to Restore, Rename, or Delete the saved highlighted scene state. Repeat the previous steps to save additional camera views.

Note: The Restore button is also useful to check parts of the Scene State saved, without having to actually restore the state.

Note: You may not require to save the number of parts for each scene (such as if only lighting has changed).

In the Batch Render dialog, select and choose the saved Scene State from the list.

Saving a Scene State

Manage Scene States dialog

Linking to Scene State

The preset option is very useful when saving numerous FG settings for different views. To save a preset, first open the Render Setup dialog. Click on the Presets list at the bottom of the dialog and choose Save Preset.

Render Setup dialog

Naming your Render Preset file

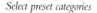

Select preset categories

In the Render Presets Save dialog, name the file after the camera name (i.e., camera01). Click Save.

The Select Preset Categories dialog should open; choose all categories required and click Save.

Now that is has been stored, you can load it in the Batch Renderer.

The Override Preset function needs to be checked, in case you need to override some of the default presets.

Note: If you have about five final views to render, and need to save FG settings for each view, it is worth sending the first batch of renders dedicated only to creating the FG files. Name the cameras accordingly in the name field of the batch render (i.e., camera01_FG). Then the second batch of final renders can be set up to be dependent on the first batch of FG renders in the Network Render dialog. Also, it is utterly important to check the override preset function to ensure that all files are included in the render.

Loading the preset into the Batch Renderer

Batch render is the name used to describe this tool; it is also written on its dialog box. Batch rendering is the process of using this tool/rendering method.

As things can easily become complex when setting up these presets and states, it is worth writing down the tasks required.

Batch Render setup for FG renders

Batch Render setup for final renders

Artificial lighting in an interior space

Section 2

The Living Room

Introduction

In this section, you will learn about creating materials and lighting an interior scene during the daytime and at night. Specifically, you will learn how to:

- Create realistic materials for an interior space
- Use daylighting techniques to visualize the space during the day
- Use photometric lights to simulate artificial lighting to illuminate the space at night.

Working on materials

Chapter 5

Preparing Materials for an Interior Space

5.1 Introduction

In this chapter, you will see how to prepare materials for an interior scene. This chapter discusses material creation in a light-free environment. Working with both lighting and materials simultaneously increases rendering time and therefore reduces efficiency. Though either lighting or materials could be worked on first, the choice was made to work on materials first, as it is easy to disable the materials when working on the lighting.

Specifically, you will learn how to:

- Use a proper workflow when creating materials
- Use reference images when designing materials
- Use templates in the Arch & Design material effectively
- Render parts of the scene to create test renders more efficiently
- Adjust Reflectivity

5.2 Preparing the Units in the Scene

Before beginning on a new 3ds Max Design scene, it is imperative that you ensure that the units are properly set up in your scene. Otherwise you will later encounter a number of undesirable results. Please refer to the appropriate section in Chapter 1 of this book to properly set up the units in your scene.

5.3 Examining the Scene

To get started, we are going to open the version of the living room scene, where only grayscale materials have been applied.

File Load: Units Mismatch

The Unit Scale of the file does not match the System Unit Scale.

File Unit Scale: 1 Unit = 1.0000 Millimeters

System Unit Scale: 1 Unit = 1.0000 Centimeters

Do You Want To:

○ Rescale the File Objects to the System Unit Scale?

◉ Adopt the File's Unit Scale?

OK

File Units Mismatch dialog

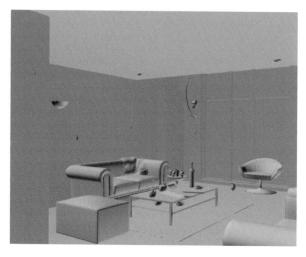

Establishing settings for the render

Initial render

1. Open the file "LR materials Start. max" from the files folder.

2. If the Units Mismatch Dialog appears, make sure that Adopt the Files's Unit Scale is selected and click OK.

3. Once the scene is loaded, open the Render Setup dialog by clicking on the Render Setup dialog button on the Main toolbar.

4. In the Render Setup dialog, click on the Common tab.

5. Set the Output Size Width to 450 and the Height to 352.

Note: These values worked well for this scene, but you could enter different image sizes if desired.

6. Click on the Lock button next to the Image Aspect value to enable it.

7. Select the View list at the bottom of the dialog and change the View to Camera01.

8. Click on the Lock button next to the Viewport list at the bottom of the dialog. This will lock the Camera01 view to be rendered until it is unlocked.

Locking the Render View: Render the file by clicking the Render button in the Render Setup dialog

The scene is rendered with its default grayscale materials.

9. Close the Render Frame window and the Render Setup dialog.

5.4 Working on the First Material

Whenever you create a material, it is always a good idea to have a reference from which to observe when you recreate the material in the scene. In the next few steps, you will recreate a Cloth material for the living room scene and apply it to the cloth model draped over the sofa.

1. In the Rendering menu, select View Image File and open the image "cloth_small.jpg" from the files directory.

Note in the photo the folds in the cloth and how they create an undulating shadow pattern. The material itself is rough; the cloth surface has a pattern of woven fibers producing this appearance.

2. Dismiss the View Image window.
3. Open the Material Editor and select an unassigned material slot.
4. In the Templates rollout, choose Matte Finish from the pulldown list.

The Cloth Reference image

Material Editor

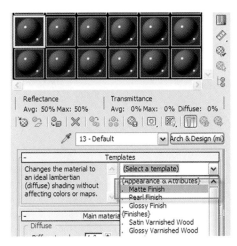

Selecting the Matte Finish template

Note: A description of the properties of the material template appears to the left of the pulldown list as you scroll down the list of templates. This will give you an idea of the settings and best use of an individual template:

5. Name the material Cloth (Matte Finish) by typing it in the edit box to the left of the Material/Map browser button.

Note: It is always a good idea to name the material after the template that was used to create it. In this case, you used the Matte Finish template and also included it in its name. If you work on this file sometime in the future, you will know that the base settings were derived from the selected template. Once you continue working on the material, the Matte Finish template is no longer displayed at the top of the list.

6. Click on the button next to the Color Swatch in the Diffuse section of the Main material parameters.
7. In the Material/Map Browser dialog, choose Bitmap and click OK to exit the dialog.
8. Choose "cloth.jpg" from the files folder and click Open to close the Select Bitmap Image File dialog box.

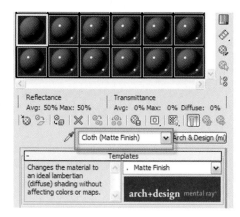

Naming the Material

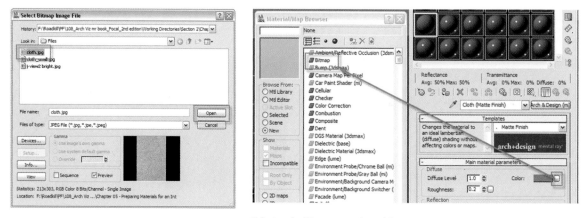

Selecting the Bitmap file

Selecting the Bitmap map channel button

9. In the Material Editor, under the Coordinates rollout, remove the check from Use Real-World Scale.
10. Set the Blur value to 0.1.

Note: Lowering the Blur value sharpens the bitmap display in the material. In this case, the number of pixels the material uses in the image is quite small, so sharpening of the bitmap is necessary in order to see the material clearly. The effect of a change in the Blur value can be seen more clearly at render time and is sometimes difficult to see in the sample spheres.

Adjusting Bitmap coordinate values

Comparative images with Blur at 5.0 and 0.1

11. Click on the Go to Parent button.
12. At the root of the Arch & Design parameters, go to the Special Purpose Maps rollout.
13. Click on the button labeled None on the right side of the Bump map.
14. Select Bitmap from the Materials/Map browser.
15. Select "cloth bump.jpg" from the files folder.
16. Under the Coordinates rollout, remove the check from Use Real-World Scale.

Note the difference adding a bump map to the material has on the sample sphere.

Bump Map button

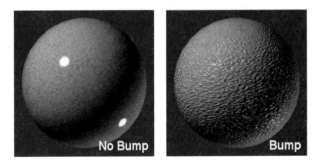

Sample spheres with bump or no bump

17. At the bitmap level of the material, adjust the Blur value in the Coordinates rollout to 0.2.
18. Click the Go to Parent button to get back to the root parameters of the material.
19. Select the Cloth Main object in the scene.
20. Assign the Cloth (Matte Finish) material to it.

Adjusting coordinates of the Bump map

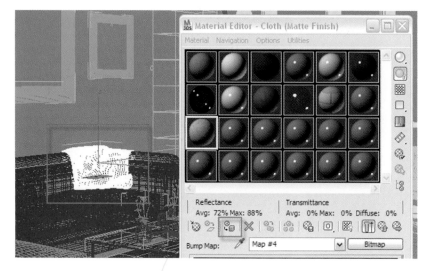

Assigning the material to the cloth object

Resizing the Blowup area

24. In the Rendered Frame Window dialog, click the Render button.

3ds Max Design will render an enlarged view of this area of the viewport, so you can see some of the detail in the Cloth material.

The Cloth material looks good, but it could look better by increasing the bump map value.

To see how this material will appear in some detail, render a blowup of that area of the image where the Cloth main is located:

21. Click on the Rendered Frame Window dialog button.

22. In Area to Render, select Blowup from the pulldown list. The Edit Region will appear in the Camera01 viewport.

23. In the Camera01 viewport, resize the rectangle to enclose the sofa.

You may need to rearrange some dialogs so you can see the viewport.

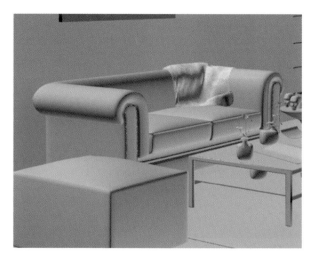

Selecting the Blowup area

Rendered image with the Cloth material assigned

25. In the Material Editor, go back to the Cloth Matte Finish material's main parameters and find the Special Purpose Maps rollout.

26. In the value field in the bump map, increase the value to 2.0.

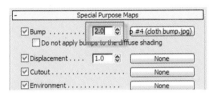

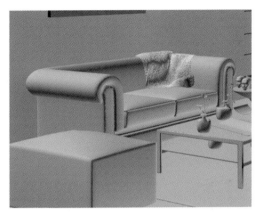

Adjusting the Bump value

27. In the Render Frame Window dialog, click on the Render button.

28. The cloth material now looks fluffier and softer.

Cloth material with increased Bump value

5.5 Working on the Sofa Material

The next material to work on is the sofa. Here you will simulate leather for this object in the scene.

1. Continue working on the 3ds Max Design scene from the previous section, or, if you prefer, open the file "LR materials cloth done.max."

2. In the Rendering menu, select View Image File and open the image "leather sofa 01.jpg" from the files directory.

Note in the photo how the leather in the sofa is slightly creased, and in addition, creates dispersed specular highlights.

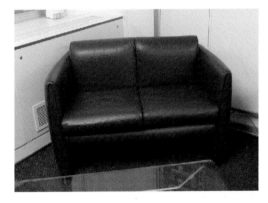

Leather reference image

3. Dismiss the View Image window.

4. In the Rendering menu, select View Image File and open the image "leather sofa 02.jpg" from the files directory.

This image shows a leather couch with a different leather treatment. The leather itself appears shinier and the leather surface is more creased and crinkled.

5. Dismiss the View Image window.

6. Open the Material Editor and choose an unassigned material slot.

7. Choose the Pearl Finish template by selecting it from the Templates pulldown list.

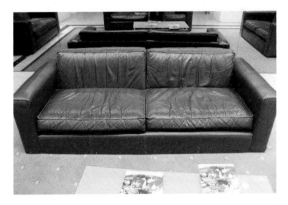

Leather reference image

8. Name the material "sofa (Pearl Finish)" by typing it in the edit field to the left of the Material/Map Browser button.

9. Click on the button next to the Color swatch in the Diffuse section of the Main material parameters.

10. In the Material/Map Browser dialog, choose Bitmap and click OK to exit the dialog.

Naming the Sofa material

Selecting a Bitmap for the Diffuse map channel

11. Choose the leather material "Ranch.jpg" and click Open to dismiss the Select Bitmap Image File dialog.

12. In the Bitmap Parameters, Coordinates rollout, change the Blur value to 0.2.

13. Click on the Go to Parent button.

14. Go to the Special Purpose Maps rollout at the root of the sofa (Pearl Finish) material.

15. Click on the button labeled None in the Bump Map area.

16. Select Bitmap in the Material/MapBrowser.

17. Select the "file 7.jpg" from the file directory.

18. In the Bitmap parameters, Coordinates rollout, change the Blur value to 0.2.

19. Click on the Go to Parent button.

Adjusting the Blur value

Assigning a Bitmap to the Bump map channel

20. In the Camera viewport, select the mesh, Back Sofa seat L.

Selecting the sofa seat

21. Assign the sofa (Pearl Finish) material to this object.

22. Render a blowup of the same area of the camera viewport as you did before.

Note how much longer it took to render with the materials applied to these two objects.

23. Increase the Bump value in the Special Purpose Maps rollout to 1.3.

Increasing the Bump value

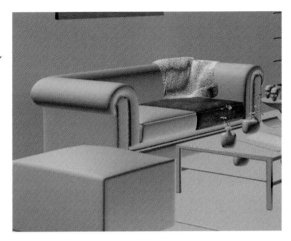

Sofa seat cushion rendered with material applied

Next, you will change some of the Pearl Finish template settings to get a better leather look for the sofa.

24. In the Main material parameters rollout in the Reflection section, uncheck the Fast (interpolate) option. This will provide you with more accurate glossiness calculations and appearance.

25. Change the Glossiness value to 0.3 to make the material slightly more glossy.

Note: For lower glossiness, check the Highlights + FG only option.

26. Decrease the Reflectivity value to 0.2.

27. Open the Fast Glossy Interpolation rollout.

28. Change the Interpolation grid density to be 1 (same as rendering) by selecting it from the pulldown list.

Adjusting Main material parameters

Adjusting Fast Glossy Interpolation

This is done to ensure that all bitmaps are accurately rendered:

29. Go to the BRDF Parameters rollout.

30. In the Custom Reflectivity Function, change the 0 deg. refl: value to 1.0.

Adjusting the BDRF Curve

Changing this value creates wider highlights, and the material sample looks much more like the image of the sofa at the beginning of this section.

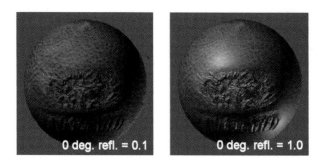

Changing the BRDF Reflectivity function

31. Render a blowup of the back sofa as you did before.

The sofa seat is starting to look leather-like, but you can hardly see the bump and glossiness due to the fact that there are no lights in the scene yet. Once all the materials have been applied, you will work with the materials and lights together. This will be the time to further adjust the bump and glossiness values. Even though you have to wait to see the quality of the final materials, it is the fastest way of getting good results and minimizing test render times.

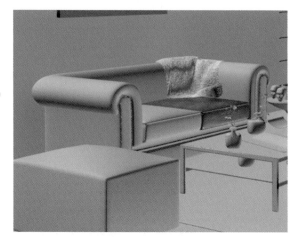

5.6 Working on the Floor Material

The sofa, with material improvements

The next material to work on is the floor. Here you are trying to simulate a semi-polished wood for this object in the scene:

1. Continue working on the 3ds Max Design scene from the previous section, or, if you prefer, open the file "LR materials sofa done.max."
2. In the Rendering menu, select View Image File and open the image "Floor Image.jpg" from the files directory. Open the image "Floor Image 01.jpg" as well.

Wood floor reference material

Wood floor reference material

Note in the photos how the pattern and grain of the wood are only two of the distinctive elements of the material. The wood pictured here is fairly dull and does not have an enhanced reflective quality. You can see a clear reflection in the image only where the camera is near the floor. In this photo, you can also see that the reflection of the sofa in the floor fades as the distance from the sofa and floor becomes greater. Lastly, note the specular highlights created by the light coming in through the windows. They create patches of reflective light that are mostly fuzzy around the edges. The specular reflection only enhances the appearance of the material.

3. Dismiss the View Image windows.

4. Open the Material Editor and choose an unassigned material slot.

5. Choose the Glossy Varnished Wood template by selecting it from the Templates pulldown list.

6. Name the Material "floor (Glossy Varnished Wood)" by typing in the edit field to the left of the Material/Map Browser button.

Wood Main material parameters

7. In the Main material parameters rollout, make sure that the Fast (interpolate) checkbox is unchecked.

8. Set the Glossiness value to 0.34. This will blur the circular highlights in the material.

9. Make sure that the Glossy Samples value is set to 8. This will make reflections in the material blurrier.

10. Click on the button to the right of the Diffuse Color swatch. The Bitmap parameters of an already assigned bitmap will pop up.

11. Change the tiling values to U: 30 and V: 7.

12. Adjust the Blur value to 0.1.

13. Go to the Main parameters by selecting the Go to Parent button.

14. Go to the Special Purpose Maps rollout.

Adjusting the Wood Bitmap coordinates

Adding a Bump map

Note that there is already a bitmap in the Bump map slot.

15. Click on the map slot to access the parameters of the map.

The map used in the Arch & Design glossy varnished wood is a Mix map combining a noise and the same bitmap as the diffuse map.

16. Click on the map slot next to Color #2.

Adjusting Mix Parameters for the Bump map

You will now be brought down another level in this material. Note here that the bitmap's tiling coordinates are the same as the adjusted coordinates you changed in the diffuse map. This is due to the fact that the maps were instanced when the template was created. This is standard behavior in the Arch & Design templates.

17. Go up one level by selecting the Go to Parent button.

You are going to make a major adjustment to the Bump map in this material, which will require replacing the entire mix map with a bitmap:

18. Click on the Material/Map Browser button that is currently labeled Mix.

19. Select Bitmap from the Material/Map Browser and click OK.

Adjusting Bitmap coordinates

Replacing the Mix Map with a Bitmap

20. Open the file "large oakglasgow life2 bump.bmp."
21. Remove the check from Use Real-World Scale.
22. Change the tiling values to U: 30 and V: 7.
23. Click on Go to Parent.
24. In the Special Purpose Maps rollout, change the Bump value to 0.2.
25. In the BRDF rollout, change the 0 deg. refl: value to 0.68.

Adjusting the Bitmap coordinates

26. Go to the Fast Glossy Interpolation rollout and verify that the Interpolation grid density is set to 1 (same as rendering).

Adjusting the BDRF Curve

Adjusting the Fast Glossy Interpolation

Note: In the Arch & Design material, you can hover the cursor over a parameter and a tooltip-like box will appear. The tooltip will display additional information on the parameter where appropriate.

Sometimes this tooltip will display when you point to different areas of the control.

Tooltips in the Arch & Design material

27. Select the Main floor object in the scene, and apply the Floor (glossy varnished wood) material to it.

28. Render a blowup of your camera view, but expand the rectangular area to be rendered slightly to see more of the floor area in the rendering.

Once again, the final quality of this material will not be apparent until we bring the scene into a lit environment.

5.7 Working on the Glass Material

The next material to work on is the Glass material. Here you are trying to simulate transparent glass for this object in the scene:

Rendered image with Floor material applied

1. Continue working on the 3ds Max scene from the previous section, or, if you prefer, open the file "LR materials floor done.max."

Glass material reference image

In this photo reference, several attributes of the glass produce an enhanced reflection. The darker background of the carpet and the sharper angle of the camera to the surface of the glass contribute to the increased reflective quality.

2. In the Rendering menu, select View Image File and open the image "Glass Image.jpg" from the files directory.

Glass is an interesting material that may require some tweaking, depending on your lighting conditions. In the photo reference, you are looking from inside to outside, where there is a considerable difference in the intensity of light outside. Under these conditions, the glass is very transparent and little or no reflection of the interior exists. Under nighttime conditions, the light conditions are reversed; the interior is generally illuminated and there is little or no light outside. Under these conditions, the glass will reflect the interior environment and make it very difficult to see outdoors:

3. Dismiss the View Image window.
4. In the Rendering menu, select View Image File and open the image "glass Image 01.jpg" from the files directory.

Glass material reference image

5. Dismiss the View Image window.
6. Open the Material Editor and choose an unassigned material slot.
7. Choose the Glass (solid Geometry) template by selecting it from the Templates pulldown list; this shader is ideal for objects with thickness, as it brings out the edge of the glass surfaces.
8. Name the material "PframeGlass (physical)" by typing in the edit field to the left of the Material/Map Browser button.
9. Go to the BRDF rollout and verify that the By IOR (fresnel reflections) is currently enabled.
10. Type H to go to the Select from Scene dialog.
11. In the Display menu of the Select from Scene dialog, turn on Display Children.
12. Select the Glass Mesh object in the scene that is part of the rectangle picture frame group.

BDRF rollout

13. Assign the PframeGlass (physical) material to it.
14. Render a blowup of the area including the picture frame above the rear sofa.

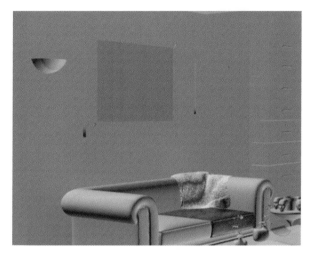

Picture frame glass rendered with IOR enabled

Selecting the glass on the picture frame

Although there is some change to the appearance of the glass, there is some improvement to be made here. The IOR fresnel reflection is a good option and often works for most scenes. In this case, due to the current camera angle, the reflections are not all that apparent. This might be accurate, but if you desire better control of the reflections, change the BRDF settings to a Custom Reflectivity Function:

15. Select the Custom Reflectivity Function option.
16. Change the 0 deg. refl: value to 0.45.
17. Render a blowup of the same area to see the difference.

BRDF rollout

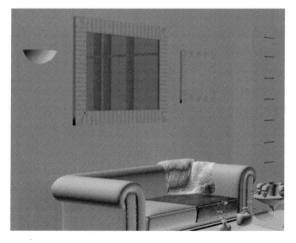

Picture frame glass rendered a Custom Reflectivity function

You can see the reflections of the curtain wall frame in the picture frame glass more clearly now. You can experiment with different values of the 0-degree reflection and see the results you get.

Another attribute of the Glass material you should note is the slightly bluish color. This is due to the Color at Max Distance setting.

18. In the Advanced Rendering Options rollout, click on the Color swatch next to the Color at Max Distance.

19. Change the color to a very pale green; possible RBG values are R: 0.88, G: 0.9, B: 0.89.

20. In the Advanced Transparency Options area of the Advanced Rendering Options rollout, click on the Use Transparent Shadows option.

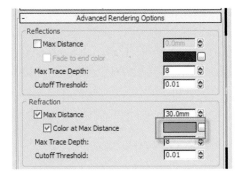

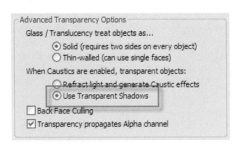

Advanced Transparency options

Changing the Refraction color

As noted in the tooltip, this option allows light to pass through a plain window and use standard transparent shadows. Caustics can cause a large amount of calculations to occur, slowing down rendering time. This option allows you to control whether these calculations will occur for each transparent material you create:

21. In the Fast Glossy Interpolation rollout, change the Interpolation grid density to 1 (same as rendering).

22. Apply this Glass material to the following objects, some of which are contained in the groups indicated in brackets []:
 - window glass
 - table glass [table glass]
 - table glass01 [table glass]
 - glass [picture frame R]
 - glass [picture frame L]

23. Render the blowup of the scene that includes some of the curtain wall, table, and picture frames.

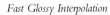

Fast Glossy Interpolation

Note the number of reflections that are occurring in the scene. The slight bluish tint of the window glass is due to the background, which is beginning to show through. It may not be necessary to use the custom reflectivity function in all occurrences of glass in this scene. You could experiment with some of the glass objects using the Custom Reflectivity functions in the BRDF rollout.

Image rendered with Glass material

5.8 Working on the Metal Material

The next material to work on is the Metal material for the base of the chair near the window. Here you are trying to simulate a brushed metal for the object in this scene.

Metal material reference material

1. Continue working on the 3ds Max scene from the previous section, or, if you prefer, open the file "LR materials glass done.max."
2. In the Rendering menu, select View Image File and open the image "Metal Image.jpg" from the files directory.

In the photo reference, note the highly reflective nature of the metal surface. The surface reflects the surrounding environment and has a highly polished surface that creates sharp and intense specular highlights.

3. Dismiss the View Image window.
4. Open the Material Editor and choose an unassigned material slot.
5. Choose the Brushed Metal template by selecting it from the Templates pulldown list.
6. Name the Material "chair leg (brushed metal)."
7. In the Main material parameters, make sure that the Fast (interpolate) option is not checked.

Creating the material for the chair leg

8. In the Fast Glossy Interpolation rollout, change the Interpolation grid density to 1 (same as rendering).

The next thing you are going to do with this material is look at its Ambient Occlusion values. This template has Ambient Occlusion turned off. Ambient Occlusion (sometimes simply referred to as AO) is the effect of

shadows appearing in crevices of objects. Note in the following illustration the darker shadows in the crevices of the sofa and diffuse shadow that appears at the corner of the wall.

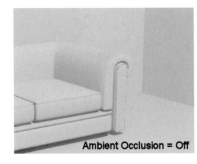

Ambient Occlusion

There are two ways to enable Ambient Occlusion.

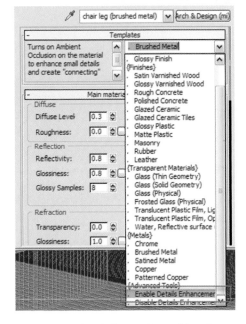

9. The simplest way of enabling Ambient Occlusion is through the Templates pulldown list. Select Enable Details Enhancements at the bottom of the Templates list.

Note that there is a Disable Details Enhancements option in the list as well. Enabling Details Enhancements turns on Ambient Occlusion with some preset values.

10. Another way to enable Ambient Occlusion is to do so in the Special Effects Rollout. Open the Special Effects rollout.

11. If Ambient Occlusion is not enabled, check this box to turn it on.

12. Make sure that the samples are set to 8. The higher the number of samples, the better results you will get with the Ambient Occlusion shadows.

13. Adjust the Max Distance to approximately 100.

Enabling AO through the Templates pulldown list

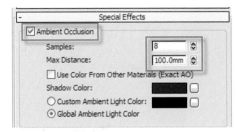

Enabling Ambient Occlusion manually

Image rendered and several materials applied

This distance refers to the maximum distance that should be used in looking for objects that will create occluded shadows. A smaller number will reduce the effect on large areas. Large numbers can adversely affect render times. Ambient Occlusion is assigned on a per-material basis:

14. Assign this material to the leg object in the Contemporary Chair group.
15. Render the entire Camera view to see your progress so far.

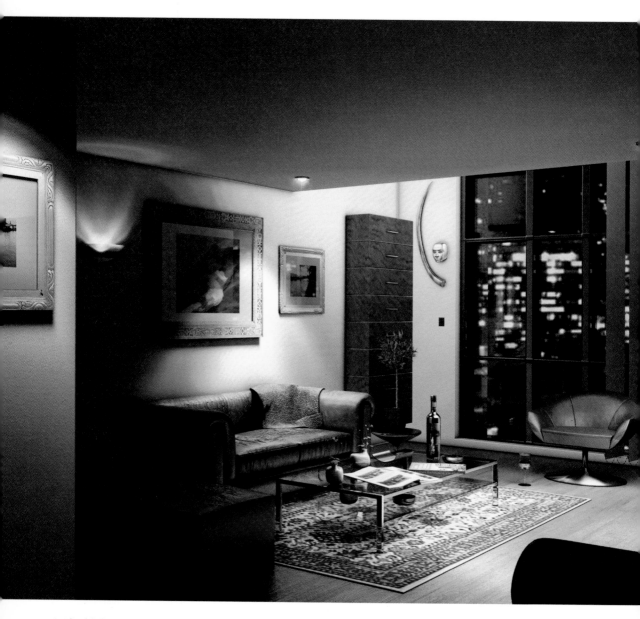

Artificial lighting in an interior space

Chapter 6
Artificial Lighting in an Interior Space

6.1 Introduction

In this chapter, you will learn about lighting an interior scene at night with artificial lights. Specifically, you will learn how to:

- Use Photometric Web Lights in an interior space
- Use Material Override to quickly analyze lighting
- Create a Glow material to illuminate a scene
- Adjust the affect of indirect illumination on a material
- Create a material for ceiling lights
- Create a final render of the scene

6.2 Preparing the Units in the Scene

Before beginning on a new 3ds Max Design scene, it is imperative that you ensure that the units are properly set up in your scene. Otherwise, you will later encounter a number of undesirable results. Please refer to the appropriate section in Chapter 1 of this book to properly set up the units in your scene.

6.3 Adding Lights to the Night Scene

To get started, you are going to open the version of the living room scene from where you left off in the daylight scene. Please see the online appendices for this chapter. The Daylight object has been deleted from the scene.

1. Open the file "LR Night Start.max" from the Files folder.
2. If the Units Mismatch dialog appears, make sure that Adopt the File's Unit Scale is selected and click OK.
3. Start by first test-rendering the scene.
4. The scene is dark.

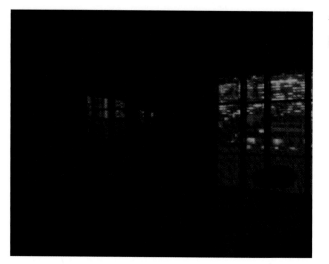

Artificial lighting in an interior space

Add some lights to begin illuminating the scene:

5. In the Create tab of the Command panel, in Lights, under Photometric, choose Target Light.

Photometric Target Light

6. Click and drag to position the light and its target in the Front viewport in the approximate position shown.

7. With the light selected, Click on the Modify tab.

8. In the General Parameters, change Shadows to Ray Traced Shadows.

Placing the light

Changing Shadows to Ray Traced Shadows

In this scene, you will use Photometric Web Lights to produce appealing lighting to the space and produce better results than what is possible with normal lights. A web distribution file controls the distribution of light emanating from a photometric light. Lighting manufacturers produce these files for their specific lights, so that you can accurately simulate light from their specific lights. There are a number of web lights that one can choose from the list of templates; however, for the purpose of this exercise, you will choose a specific one with special characteristics:

9. In the Light Distribution area, choose Photometric Web.

10. In the Distribution (Photometric Web) rollout, click on the Choose Photometric File button.

Photometric Web

Accessing the Photometric Web files

11. Navigate to your Files folder and click on the "Nice recessed.IES" and open it.

Opening the Photometric Web file

12. Test-render your scene again.

The new light is hardly visible on the render. The light has insufficient intensity. The next steps will be to correct this and to move it to its proper location. In order to move the light easier, you will disable the target.

13. With the light selected, in the Modify tab, remove the Targeted option in the General Parameters of the light.

14. In the Top viewport, move the light near the draped cloth on the sofa. Alternatively, you can use the following coordinates: (X: 128, Y: 0, Z: 1030).

Effect of the Photometric Web light

Removing the Target

15. In the Intensity/Color/Attenuation rollout, change the Resulting Intensity to 1670%.

6.4 Using Material Override to Quickly Analyze Lighting

Prior to test-rendering, make some changes for faster rendering feedback:

1. Open the Render Setup dialog box and select the Processing tab.
2. In the Material Override group, click on the Enable toggle.

A material named Ambient Occlusion was previously created and dragged into the material slot. This material is a plain material with Ambient Occlusion enabled. The entire scene will now be rendered using this material.

3. Test-render the scene.

Resulting Intensity

Enabling Material Override

Light in the scene

There is light illuminating the couch from the recessed ceiling light over it. Note the pattern of the light on the wall; this is produced by the Web Distribution file. Next you will copy the light to illuminate the entire scene and soften the shadows.

4. While the TPhotometricLight01 is still selected, in the Shape/Area Shadows rollout, change the Emit light from (Shape) type to disc.
5. Change the radius to about 160.0 mm.

Note that although the shadows will be slightly feathered, it will take a few seconds longer to render. The larger the disc radius, the softer the shadows will be.

Change in the light shape

6. In the Intensity/Color/Attenuation rollout, choose HID Quartz Metal Halide (cool) from the color group dropdown list.

7. On the Filter Color swatch, choose a medium yellow tint from the Color Selector dialog box (R: 248, G: 220, B: 109).

Filter Color

Change in light color

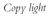

Copy light

8. Make a clone (copy) of the light TPhoto-metricLight01 and move it to the following location: X: 1180.0 mm, Y: −2175.0 mm, Z: 985.0 mm.

9. In order to randomize the color and shape of the light, change the following parameters:

 • In the Dimming group, change the Resulting Intensity to 550%.

 • Change the Disc Radius to 85.0.

 • Set the color to HID Phosphor Mercury.
 • Set the Filter Color to light yellow: R: 245, G: 245, B: 220.

10. Create the next light by copying it to where the other recess light object is: X: 1700.0, Y: 0.0, Z: 1065.0.

11. In order to randomize the color and shape of the light, change the following parameters.

 • In the Dimming group, change the Resulting Intensity to 5520%.
 • Change the Disc Radius to 695.0.
 • Set the color to D65 Illuminant (Reference White).
 • Set the Filter Color to medium yellow: R: 240, G: 210, B: 92.

Adjust light parameters

12. Test-render the scene.

The scene is starting to look much better now. Next, you will create the light in the wall washer:

13. Clone (copy) the last light you created and move it to the following location: X: −188.0, Y: −912.0, Z: 688.0.

14. Rotate the light 180 degrees so that it points toward the ceiling.

15. Change the color and shape of the light by modifying the following parameters:

 • In the Dimming group, change the Resulting Intensity to 50%.

 • Change the Disc Radius to 140.0.

 • Set the color to HID Phosphor Mercury.

Rendering with new lights

Wall washer light location

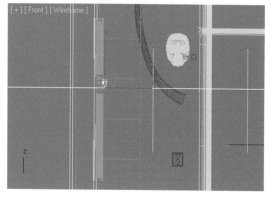

Rotated wall washer

 • Set the Filter Color to a pale yellow: R: 251, G: 244, B: 224.

 • Enable the Incandescent Lamp Color Shift When Dimming option for this light and all the other lights in the scene.

Incandescent Lamp Color Shift

Note: This option changes the light's color when its intensity is decreased, just as would occur in the real world.

16. Test-render the scene.

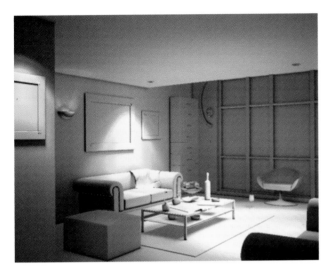

Effect of new light

3. Open the Material Editor.
4. Drag and drop the Ambient Occlusion material (third row, first column) to the sample area directly below it.

Creating a new material

6.5 Creating a Glow Material to Illuminate the Scene

The scene is looking well lit; however, the floor upstairs could benefit from a bit more of light. In this exercise, you will use an object as a light source, as opposed to a physical light object. This method takes less time to render and produces good results:

1. Open the Render Setup dialog box.
2. In the Processing tab, under the Material Override group, uncheck the Enable toggle.

Removing the Material Override

5. Name the material Light Box. This material will form the basis of our self-illuminating material, which will help light the scene.
6. Change the Material template to Matte Finish. Note the description of the Material properties to the left of the templates list.
7. Add the name of the Material template to the material name so you can easily remember where the material started from. Rename the material Light Box_(matte finish).
8. Since we want a plain material, delete the map in the Diffuse Color.
9. Change the following values in the Main material parameter rollout to 0:

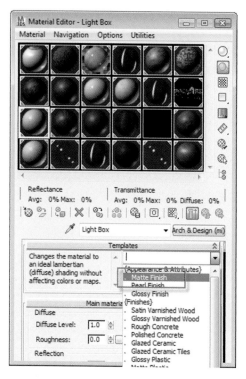

Changing the Material Template

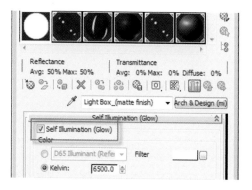

Enabling the Glow parameter

This option will allow the material to affect the indirect illumination in the scene. Next, you will create an object in the scene to attach this material to.

- Diffuse Roughness
- Reflection Reflectivity and Glossiness
- Refraction Transparency and Glossiness

Main material parameters adjustments

10. In the Self Illumination (Glow) rollout, enable the Self Illumination (Glow) toggle. Note how the material color changes automatically.

11. In the Luminance group, choose the Physical units: (cd/m^2) option.

12. In the Glow Options group, enable the Illuminates the Scene (when using FG) toggle.

Enabling Indirect Illumination

13. Create a Box object in the approximate position shown above the couch and coffee table.

Creating the box

14. In the Modify tab of the Command panel, adjust the size of the box to the following:
 - Length: 1060.0
 - Width: 1240.0
 - Height: 140.0

15. Rename the object Light Box.

16. Move the box to sit between the lower floor ceiling and the upper floor ceiling. Use the following coordinates if required: X: 680.0, Y: 420.0, Z: 1590.0.

17. Change the wireframe color of the box object to yellow, so it's easier to identify as a light.

18. Assign the Light Box_(matte finish) material to the Light Box object.

Adjusting the box

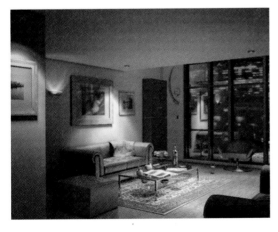

Test-render to see the effects of the illuminated box

19. Assign the Light Box (matte finish) material to the Light Box object.

20. Test-render the scene.

Currently, the illumination from the box is not affecting the scene that much. Its value will need to be increased. At the same time, you will apply a bitmap to the glow material.

21. In the Material Editor, in Self Illumination (Glow) parameters, click on the Filter Map button.

22. Select bitmap in the Material/Map Browser.

23. Navigate to your Files folder and choose j-view2 nigh copy.jpg.

At the bitmap level of the material, you will specify coordinates in the image so that you only use a portion of the bitmap to emit light from.

24. In the Bitmap Parameters rollout, Cropping/Placement group, click on the Apply toggle to enable it.

25. Select the View Image button.

Displaying the image

Cropping the image

26. In the dialog that appears, enter the following coordinates at the top: U: 0.343, V: 0.652, W: 0.051, H: 0.077.

27. Close the dialog.

28. Click on the Go to Parent icon to go back to the main level of the material.

29. In the Self Illumination (Glow) parameters, change the Luminance value to 30000.

Increasing the Luminance value

30. Back in the scene, make sure the Light Box object is still selected, and right-click to display the Quad menu.

31. Select Object Properties.

32. In the Object Properties dialog, click on the By Layer button in the Rendering Control group.

33. Toggle off the following parameters:
 • Visible to Camera
 • Visible to Reflection/Refraction
 • Receive Shadows
 • Cast Shadows

34. Click OK to exit the dialog.

35. Test-render the scene.

Controlling the rendering of the Light Box

The scene is much brighter now, as the effect of light from the Light Box illuminates the curtain wall. There are some artifacts that need to be taken care of.

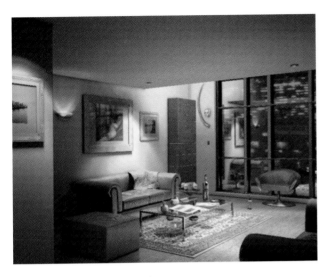

Effects of the light box on the render

36. In the Self Illumination (Glow) rollout, remove the check in the Visible in Reflection toggle.

Removing the Glow in Reflections

37. In the Render Setup dialog, make the Indirect Illumination tab active.
38. In the Final Gather rollout, change the Rays per FG Point to 150. This parameter change will solve most FG problems with little cost to rendering times.
39. Test-render the scene.

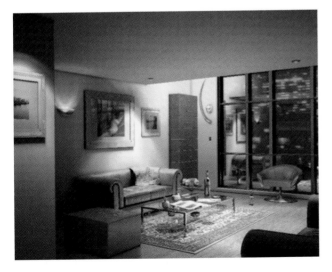

Effects on rendering

Increasing Rays per FG Point

The FG artifacts are better now. The technique of using an object to emulate lights is common for distance camera shots or close-up shots where the lit area is not directly in front of the camera.

6.6 Adjusting the Effect of Indirect Illumination on a Material

In the next few steps, you will improve the brightness of the wall in the foreground:

1. In the Material Editor, choose a sample area.
2. Click on the Pick Material from Object button.
3. Click on the wall in the foreground, on the left (wall02).
4. Click and drag the material to a new sample area and rename it "ambient occlusion 2 indirect illumination."
5. In the Advanced Rendering options, Indirect Illumination Options group, change the FG/GI multiplier to 2.0.

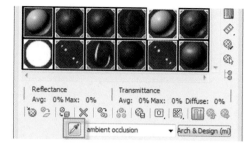

Pick Material

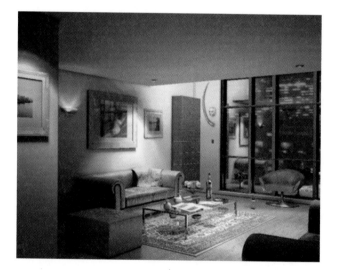

Increasing Indirect Illumination

6. Assign the new material to wall02.
7. Test-render the scene.

Effect on the rendered image

6.7 Creating a Material for the Ceiling Lights

1. Select the Light Box_(matte finish) material in the Material Editor.
2. Drag and drop the light box material onto an adjacent slot in the material editor.
3. Rename the material Light Bulb_(matte finish).
4. Decrease its physical units values to 10000.0.
5. Uncheck the Illuminate the Scene (Using FG) toggle.

6. Enable the Visible in Reflections toggle.

7. Assign the material to two objects in the scene that represent the ceiling lights (bulb, bulb01).

8. Test-render the scene.

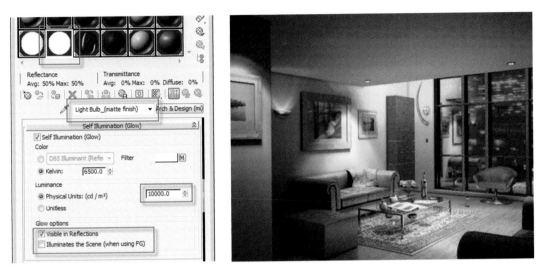

Creating the Light Bulb material *Rendering with the Light Bulb material applied*

6.8 Creating a Final Render of the Scene

Next, you will save the FG settings, lock it, and send the final render at a higher resolution:

1. Open the Render Setup dialog box.

2. In the Indirect Illumination tab, Reuse (FG and GI Disk Caching) rollout, choose the Single File Only (Best for Walkthrough and Stills) from the Mode group.

3. Check the Calculate FG/GI and Skip Final Rendering toggle.

4. In the Final Gather Map group, choose the Incrementally Add Points to Map Files toggle.

5. Click on the Files button and give your Final Gather Map file an appropriate name.

6. Click on the Generate Final Gather Map File Now button to create the FG file.

7. Once the FG file has been generated, under the Final Gather Map group, choose Read FG Points Only from Existing Map Files from the list.

8. Remove the check in the Calculate FG/GI and Skip Final Rendering toggle.

Preparing the FG Map file

Using the FG Map file

10. In the Renderer tab, Global Tuning Parameters rollout, change the following parameters:
 - Soft Shadows Precision (Multiplier) to 4
 - Glossy Reflections Precision (Multiplier) to 2.0
 - Glossy Refractions Precision (Multiplier) to 2.0

11. In the Sampling Quality rollout, Samples per Pixel group, change the Minimum to 1 and the Maximum to 16.

12. In the Filter group, change the Type to Mitchell, and make sure the Width and Height are 5.0 each.

Sampling Quality settings

13. In the Common Parameters tab, Output Size group, set the Width to 3000 and the Height to 2350.

9. In the Render Setup dialog, Processing tab, click on the lock icon in the Geometry Caching Group.

Locking Geometry Caching

Global Rendering Tuning

Setting the Output Size

Note: When rendering images of 2 K pixels or larger, you will most likely wish to use network rendering. For more information, please see Chapter 4, where this process is described in detail.

14. Render the scene.

Photomontage

Section 3

The Photomontage

Introduction

In this section, you will learn about creating materials, lighting, and the process of bringing together a rendered image with a photographed background. Specifically, you will learn how to:

- Create realistic materials for a stone and glass office building
- Add daylighting and adjust materials to the intensity of the background image
- Photoshop a rendered image into a background photo
- Create verified views

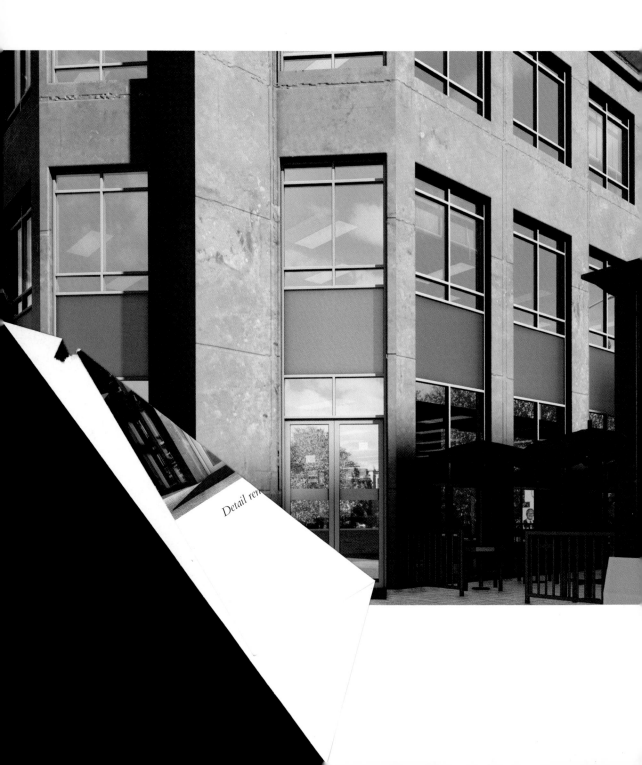

Detail ren

Chapter 7

Photomontage Materials

7.1 Introduction

In this chapter, you will see how to prepare an office building to be photomontaged into a background photo. Photomontages can often prove to be a challenge. Often, you do not have survey points or correct camera information. In addition, the building itself can represent a mammoth task when integrating it with the background photo. The material properties and the building detail are crucial to integrating the building with the background photo. The following tutorial comes with most of the challenges you may face when working with photomontages:

- Simple building without much detail
- The original photograph doesn't frame the whole building
- The background photograph is weak
- There are no camera information and no survey points

In this tutorial, you will learn how to:

- Create materials for the office building exterior
- Create materials for glass surfaces
- Create materials for reflecting planes
- Create materials for the interior ceiling lights

Note: Unless otherwise indicated, this tutorial assumes that you develop materials using the Arch & Design material.

7.2 Units in the Scene

In this scene, the selected units are meters. Previous projects in this book have used millimeters. When you open the files in this chapter, you will most likely encounter the File Units Mismatch dialog. Just click OK to accept the default options and proceed. For further explanation, please refer to Chapter 1.

7.3 Enhancing the Initial File

Often a 3D model of a building is created by someone other than the 3D artist whose responsibility it is to create the final renderings. It is commonly the case that additions need to be made to the scene to help the artist portray it realistically. In this scene, the following has been done:

- The office ceiling lights have been modeled and placed inside the building.
- Some window blinds have been added for further detail and realism in the scene. The blinds were randomly placed with different lengths. Window blinds often help weak scenes look more realistic.
- Door mats and door labels have been added. These small items, randomly placed in the scene, often help boost the realism of a scene.
- Proxied trees have been placed in the scene to further help the building integrate with the background photography. A material has already been applied to the trees; however, it may require enhancing in order to fit with the background photography.

Note: The office ceiling lights are crucial to any photomontage, especially when the camera is looking through the glass window. It adds extra realism to a building.

In addition, the following has been completed in the scene to begin the photomontage process:

- The camera position has been matched with the background photo.
- Box planes have been modeled and placed around the building to be used later for reflection maps. Good and detailed reflections are crucial to achieving realistic renders, especially when working on glass facades.

Note: Generally, reflections can be created using a spherical bitmap in the environment map. However, at times you may require specific things to be reflected on certain areas of the building. Placing images on surfaces around the building give you this control.

7.4 The Main Marble Material

Begin by creating a material for the marble surfaces of the building.

1. Open the file "Photomontage Materials_Start.max."
2. Click on the Select by Name button.
3. In the Find value, type Layer:ExWall U, and click OK. This will select the 32 objects in the scene named Layer:ExWall Upper Building.
4. Right-click and choose Isolation Selection from the Quad menu.

Select from Scene dialog

5. In the Shading Viewport Label menu, select Smooth + Highlight.

6. Open the Material Editor and choose an unassigned
 sample slot.

7. Name the material "Stone" and assign it to the selection.

8. Set the Glossiness to 0.35 and the Reflectivity to 0.6.

9. Select the Diffuse Color Map button.

10. Select the Ambient/Reflective Occlusion (3ds Max) map. This
 shader, when placed in the Diffuse map, helps to bring out details
 on the façade, especially on the areas directly lit by light.

Material main parameters

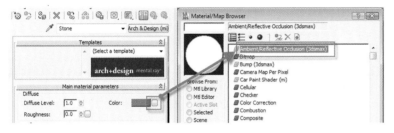

Selecting the Ambient/Reflective Occlusion (3ds Max) map

11. In the Ambient/Reflective Occlusion (3ds Max) Parameters
 rollout, enter the following parameters:

 • Samples = 45

 • Spread = 3.0

 • Max distance = 0.2

Note: Keep in mind that this scene has been set up in meters and
that the previous values have been adjusted proportionally.

12. Click on the Bright Map button.

13. In the Material/Map Browser, choose Bitmap.

Ambient/Reflective Occlusion (3ds Max) parameters

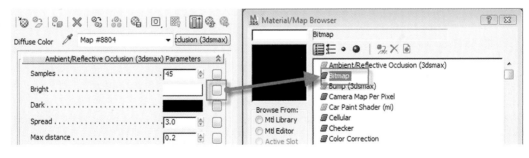

Selecting a bitmap for the Bright map

14. Choose "marble big.jpg" from the list of maps in your project files folder.

The Marble bitmap

Note: When you use the Ambient/Reflective Occlusion (3ds Max) map, you will always place any required bitmaps in the bright map channel.

Note: This bitmap has been worked in Photoshop to the point that it does not tile evenly on extensive areas of a surface. The image has lots of realistic details if you zoom into the bitmap. The bitmap is 4859 × 4184 pixels large and was nearly 100 MB in size before it was compressed in Photoshop with the Save for Web and Devices tool. Using bitmaps of this size should be done only when absolutely necessary, as large maps will slow down renderings.

15. In the Coordinates rollout of the Bitmap, disable Use Real-World Scale.
16. Lower the Blur value to 0.01 to sharpen the image.
17. Click on the Show Standard Map in Viewport button.
18. Click on the Go to Parent button twice to get to the Main material parameters.

19. Enable the Metal material option to retain the Main Diffuse color when the surface is reflecting.

Metal material

Bitmap coordinates

20. Press the F4 function button to enable edge faces.

In the next few steps, you will MapScale the exterior wall objects individually. MapScaler often works best with objects of this type when UVW mapping is not wrapping around the surface realistically.

21. Make sure all of the exterior walls are still selected.

Exterior Walls Selected

MapScaler (OSM)

22. In the Modify tab of the Command panel, select the MapScaler modifier from the Object Space Modifiers (OSM) in the Modifiers list.

23. In the MapScaler Parameters rollout, change the
 following values:

 - Scale = 1.858
 - U Offset = − 0.18
 - V Offset = 2.15

MapScaler Parameters

24. Make sure the Wrap Texture option is enabled.

25. In the Material Editor, Special Purpose Maps rollout,
 set the Bump value to 0.1.

26. Click on the Bump map slot and select bitmap from
 the Material/Map Browser.

27. Select "Tiles.jpg" from the Project folder.

28. Disable the Use Real-World Scale option.

29. Change the following Offset and Tiling Options:

 - U Offset = − 0.02
 - V Offset = 0.042
 - U Tiling = 2.0
 - V Tiling = 4.0

Adjusting the Bump map

Note: The Blur value is left at 1.0; having sharp bump bitmaps
causes the surface to look unrealistic.

30. Click Go to Parent to get to the Main material
 parameters.

31. In the Fast Glossy Interpolation rollout, change the
 Interpolation grid density to 1 (same as rendering) to
 provide more accurate results.

32. In the Special Effects rollout, enable the Round Corners
 option.

33. Set the Fillet Radius to 0.04.

Bitmap coordinates

Note: Round Corners provides realistic details in the scene by
rounding off sharp edges of objects. For good results, you may
have to measure the size of the objects in your scene. In this case,
you will need to specify a radius smaller than half the thickness of
the walls; otherwise, the wall openings will appear rounded and
produce rendering artifacts. Another way is to create a chamfer
box from the extended primitives tools; and use it as a reference
to determine the desired fillet radius.

34. Exit Isolation mode.

35. Apply this material to objects that are named Layer:ExWall
 Lower Building.

36. Render the view.

Rounded Corners

7.5 Creating a Satined Metal Material for the Window and Door Frames

The next material to be created will be applied to all the Window, Door, and Curtain Wall Frames.

1. Select the objects named Layer:Storefront Frame and isolate the objects.

Note: A series of objects like this one are associated with a layer in the Layer toolbar. In this case, if you make the Layer Storefront Frame the current layer and select the Select Objects in Current Layer button, it will select all objects on that layer.

2. Open the Material Editor and select an unassigned sample slot.
3. Name the material "Metal (satined metal)."
4. In the Template list, select the Satined Metal template.
5. Set the Diffuse Level to 1.0. By default, the Diffuse Level is 0.3; however, since you will be using the diffuse color extensively, increasing the value will help to reinforce the diffuse component.
6. Go to the General Maps rollout and enable the Diffuse Color Map.

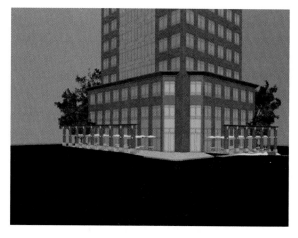

Rendered view with Marble material

Layer toolbar

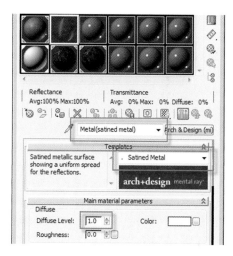

Diffuse Color Map enabled

Satined Metal

7. In the Main Material parameters, change the diffuse color to a Light Gray (Value = .722).
8. Assign this material to the Storefront Frame objects.
9. Right-click on the Diffuse Color swatch and select Copy from the menu.
10. Click on the Diffuse Color Map button.

Copy the Diffuse Color

11. Select the Ambient/Reflective Occlusion (3ds Max) Map from the Material/Map Browser.

12. Right-click in the Bright color swatch and select Paste from the menu.

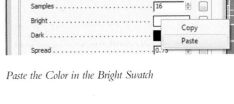

Paste the Color in the Bright Swatch

13. Change the values in the Ambient/Reflective Occlusion (3ds Max) Map Parameters as you did with the Marble material.

14. In the Fast Glossy Interpolation rollout, change the Interpolation grid density to 1 (same as rendering).

15. In the Special Effects rollout, enable the Round Corners option.

16. Set the Fillet Radius to 0.01.

17. Exit Isolation Mode.

18. Assign this material to the following objects:
 - Layer:Window Frame
 - Layer:Curtain Wall Frame

19. In the Material Editor, create a duplicate of this material and name it "Metal Panel (satined metal)."

20. Change the Diffuse Color to be a slightly darker gray (Value = 0.65).

21. Copy this color into the Bright color swatch of the Ambient/Reflective Occlusion (3ds Max) map.

22. Assign the Metal Panel (satined metal) to objects named Layer:Storefront Glass02.

23. Render the Camera01 view.

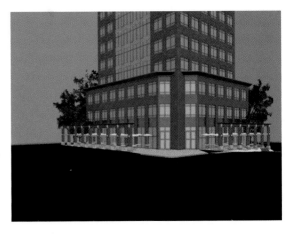

Satined Metal material applied to the building

7.6 Creating a Glass Material for Windows and Doors

The next material to be created is a Glass material for the windows and doors.

1. In the Material Editor, select another unused sample slot.

2. Name the material "Glass (thin geometry)."

3. In the Templates list, choose the Glass Thin Geometry template.

4. Apply this material to the following objects:
 - Layer:Window Glass
 - Layer:Curtain Wall Glass01
 - Layer:Curtain Wall Glass02
 - Layer:Curtain Wall Glass03
 - Layer:Storefront Glass01

5. In the Fast Glossy Interpolation rollout, change the Interpolation grid density to 1 (same as rendering).

6. Render the Camera01 view.

Glass material applied to the building

7.7 Creating a Sky Material for Reflective Planes

The next material is the Sky material, which will be applied to several planes that surround the building. This material applied to the planes is to provide a reflection for the glass surfaces of the building.

1. In the Material Editor, select an unused sample slot.
2. Name the material "building reflection (matte finish)."
3. From the Template list, select the Matte Finish template.
4. Set its Roughness to 0.0 and Glossiness to 0.0.
5. Click on the Diffuse Color Map toggle and select the Composite Map in the Material/Map Browser.
6. In the Composite Layers rollout, click on the Color Correct this Texture button.
7. In the Color Correction Basic Parameters, click on the Map button.

Building reflection material

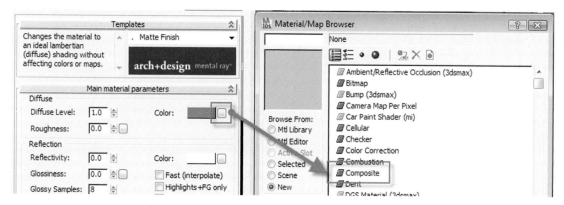

Selecting the Composite map

Color Correction

Selecting Color Correction

Cropping the sky bitmap

8. Select bitmap from the Material/Map Browser, and open "tall sky.jpg" from the project folder.

9. Once the bitmap is loaded, in the Bitmap Parameters rollout, select the Apply option in the Cropping Placement area.

10. Click on the View Image button and move the Crop Region so that the street is cropped out of the image.

11. In the Coordinates rollout, change the following values:
 • Disable the Use Real-World Scale option
 • Set the U Offset to 0.31
 • Reduce the Blur value to 0.01

Establishing bitmap coordinates

Adjusting Lightness

12. Click on the Go to Parent button to get back to the Color Correction Map.

13. In the Lightness rollout, chose the Advanced option.

14. Set the RGB Gamma Contrast to 3.0.

15. In the scene, select the object named "building reflection01" and assign the material to it.

16. Assign similar materials to the five other objects in the scene that start with "building reflection." Vary crop placements and offset values for some variety.

17. Render the Camera view.

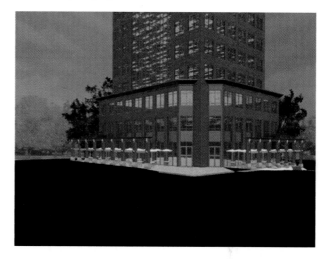

Effect of the sky reflection

7.8 Creating a Material for the Ceiling Lights in the Office Building

The next material is for the ceiling lights in the office building: ·

1. Switch to the Top viewport.

2. In the scene, select an object named "Metal Panel Frame24."

3. On the Main menu bar, select Close in the Group menu.

4. Isolate the selection.

5. While the Group is still selected, select Open in the Group menu.

6. Select one of the many objects named "Light fitting bigxxxx."

Light fitting in the ceiling grid

7. Open the Material Editor and select an unassigned sample slot.

8. Name the material "ceiling light (matte finish)."

9. Choose Matte Finish from the Templates list.

10. Set the roughness, glossiness, and glossiness samples values to 0.0.

11. Click on the Diffuse Color Map button and select Bitmap from the Material/Map Browser.

12. Open the file "uplight.jpg" from your project folder.

13. In the Output rollout of the bitmap, click on the Enable Color Map option.

14. In the Color Map area, select the RGB option.

15. Turn off the R, G, and B buttons.

16. Select the R button to turn it on; the R curve in the graph will become selectable.

17. Select the graph handle on the right side.

18. In the graph value fields at the bottom of the graph, enter 1.95.

Main material parameters

RGB buttons off

Editing the red graph

19. Repeat this process for the G and B color graphs, using the following values for the right-hand point:
 - G = 1.181
 - B = 0.562

This has adjusted the bitmap to a more yellowish tint.

20. Click on the Go to Parent button to get to the Main Material Parameters.

End result of editing the RGB Color Map

21. Right-click on the Diffuse Color Map button and select Copy from the menu.

22. In the Self Illumination (Glow) rollout, enable the Self Illumination option.

23. In the Luminance area, click on the Physical Units (cd/m^2) option.

24. Right-click on the Color Filter Map button and select Paste (Instance) from the resulting menu.

25. Assign this material to all objects that begin with "Light Fitting Big."

26. For the Metal frames holding the lights, create a Satined Metal Material as previously described.

27. Close the Ceiling Lights group.

28. Assign these materials to all ceiling levels. You can do this quickly by selecting all Ceiling light groups, closing them, then isolating the selection. Open the groups, and select all objects named "Light Fitting Big" and assign the ceiling lights material to them. Close the groups afterward.

29. Render the Camera view.

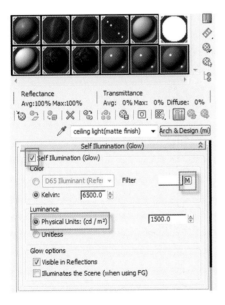

Creating Self Illumination for the lights

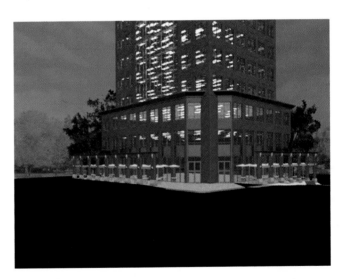

Effect of ceiling lights

7.9 Creating a Metallic Material for the Stone Wall Details

The next material to create is for some elements in the stone walls between the curb and terrace surrounding the building:

1. In the scene, select the objects named "Layer:ExWall Stone Elements."

2. In the Material Editor, select another unassigned material sample slot.

3. Click on the Material Type button, and in the Material/Map Browser, select the Car Paint material (mi).

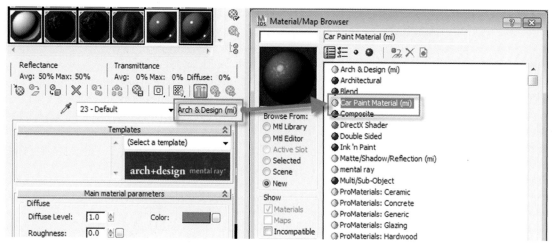

Selecting the Car Paint material

4. Name the material "car paint."
5. In the Diffuse Coloring rollout, change the Base Color to a dark blue: R: 0, G: 34, B: 57.
6. Change the Light Facing Color to a lighter blue: R: 152, G: 162, B: 168.

In this scene, the other values in the Diffuse Coloring rollout do not need to be adjusted, but it is worth noting what they do:

- **Ambient/Extra Light:** This color can be used to increase the overall brightness of the material.
- **Edge Color:** This color acts as a rim color, which appears on the edges of the object.
- **Edge Bias:** The falloff rate of the Edge Color, smoothes the transition between colors.
- **Light Facing Color:** The color that appears facing the light source; generally brings and extra color to the base color. Its prominence varies according to the light position.
- **Light Facing Color Bias:** Controls the falloff rate of the color that appears facing the light.
- **Diffuse Weight and Bias:** Works similar to adding self-illumination to the base color.

Rarely would you have to modify the flakes appearance in an architectural setting.

Modifying Diffuse Coloring

7. Apply the Car Paint material to the selected object.

8. Render the Camera view.

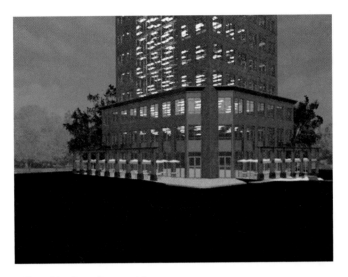

Effects of the Car Paint material

Note: The materials that you have applied so far look pretty good. In all likelihood, once you apply lighting to the scene, the materials will need to be adjusted.

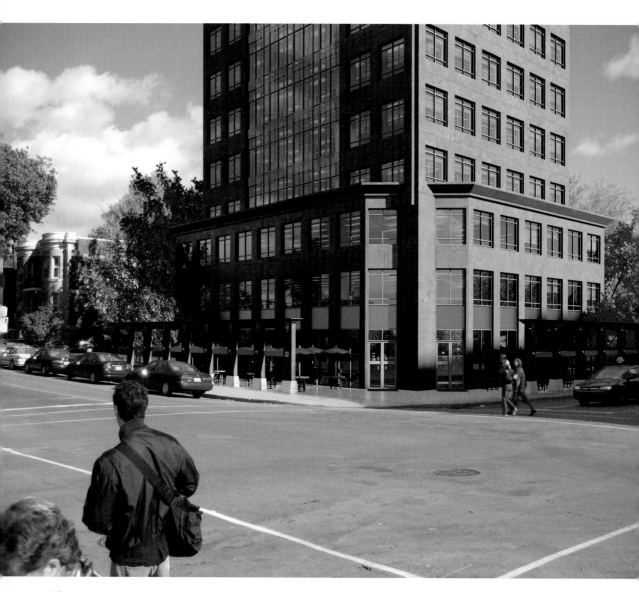

Photomontage

Chapter 8

Photomontage Lighting

8.1 Introduction

In this chapter, you see all the intricacies of lighting a photomontage scene. Once the scene is lit, you will then adjust the preapplied materials and their parameters.

In this tutorial, you will learn how to:

- Create a Daylight System in the scene
- Match the sun direction and intensity in the scene with the background
- Match material brightness with the background
- Photomontage the rendered image in Photoshop

8.2 Units in the Scene

In this scene, the units are set to meters. Some previous projects in this book have used millimeters. When you open the files in this chapter, you may encounter the File Units Mismatch dialog. Just click OK to accept the default options and proceed. For further explanation, please refer to Chapter 1.

8.3 Adding a Daylight System

First, you will add a Daylight System to the scene.

1. Open the scene Photomontage Light_Start.max.
2. In the Main toolbar, select Create menu > Lights > Daylight System.
3. In the Daylight System Creation dialog, click Yes.
4. In the Top viewport, click and drag out the compass from the approximate center of the building.
5. In the mental ray Sky dialog, click Yes.

Daylight System

Daylight System placed in the scene

6. Move your cursor away from the compass to establish the position of the Daylight object, and click to set it.

8.4 Adding the Viewport Background

The background image has already been added in the viewport and matched with camera01 in the scene. The aspect ratio and output size have been matched and locked. Generally, to load the background image in the viewport, you would need to follow these steps:

1. In the Camera viewport, click on the Shading Viewport Label menu, the Viewport Background submenu, and then the Viewport Background selection.

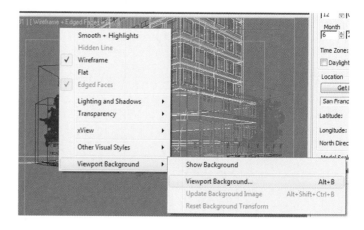

Viewport Background

2. In the Viewport Background dialog, click the File button and open the background image file.

3. Verify that the Match Rendering Output and Display Backgrounds are both selected.

Note: The original background image was 2592 × 1944; this was typed in the Render Setup dialog Common tab, Output size area, in order to match the background with the rendered image. The Image Aspect and Pixel Aspect were subsequently locked. Finally, the Width was adjusted to 500 to reduce the size of test renders.

Viewport Background dialog

Render Setup dialog

8.5 Matching the Sun Direction

Since the previous section had already been completed for you in this file, all you will need to do is to display the background image. Then you can proceed to match the sun angle.

1. In the Camera viewport, click on the Shading Viewport Label menu, select the Viewport Background submenu, and select Show Background.

2. In the scene, select the following objects:

 • **Ground:** Box covering the entire surface of the scene.

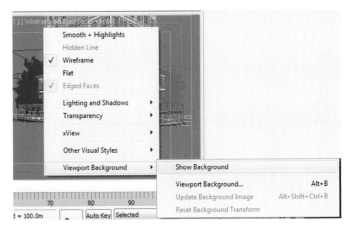

Displaying the background image

- **Layer: Landscape–slabs:** Sidewalks around the building where the shadows will be cast.
- **GIRLS:** Dummy objects in the scene to match the two girls crossing the street in the background image. These objects will be used as a reference for the shadow distance and scale of the whole scene.
- **Building Shadow:** This object will be used to emulate the building across the street, which is casting a shadow on the background image.
- **Layer: ExWall Stone Elements:** This element will be used to match the Daylight System multiplier intensity and highlights. It is especially useful in that it has a white material applied to it.
- **Daylight01:** It is necessary to have the Daylight System visible to adjust its values.

3. Isolate the objects.
4. In the Camera viewport, click on the Shading Viewport Label menu and select Smooth + Highlights.
5. Now Enable Hardware Shading by turning on the following options in the Shading Viewport Label menu, Lighting and Shadows submenu:
 - Illuminate with Scene Lights
 - Enable Hardware Shading
 - Enable Shadows

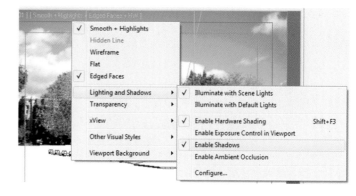

Enabling Hardware Shading

Note: You can also enable Hardware Shading through the Viewport Configuration dialog, Lighting and Shadows tab.

Viewport Configuration dialog

6. With the Daylight object selected, open the Modify tab of the Command panel.

7. In the Daylight Parameters rollout, in the position area, select the Manual option.

8. In the mr Sun Basic Parameters, reduce the Multiplier Value to about 0.1.

9. Select the Ground object, right-click and select Object Properties from the Quad menu.

10. In the General tab of the Object Properties dialog, select the See-Through option in the Display properties area. Close the dialog.

Daylight Parameters

11. In the Top viewport, move the Daylight object in the negative Y direction until you begin to see a shadow being produced from the building shadow object in the scene.

See-Through Property enabled

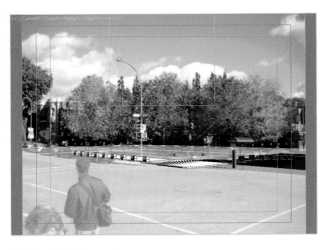

Shadows in the Camera viewport

13. Change the sun's Multiplier back to 1.0.
14. Test Render the Camera view.
15. Exit Isolation Mode.

The Shadow position now matches the background photo. The next task will be to match the sun's intensity with that of the background image.

12. To move the Daylight object to a precise location, use the following World Coordinate position: X: 223.29 m, Y: −1208.23 m, Z: 1005.551 m.

Test Rendering with the Sun in Position

8.6 Matching the Sun's Intensity

In the previous chapter, you created a material for surfaces to reflect onto the glass of the building. These surfaces are required in the final rendering only for reflections and should not affect the light in the scene. You will adjust the properties of these surfaces and then proceed to adjust the sun's multiplier.

1. In the Select from Scene dialog, select all the objects that begin with "building reflection."
2. Right-click and choose Object Properties from the Quad menu.
3. In the Rendering Control area of the General tab, disable the following options:
 - Visible to Camera
 - Receive Shadows
 - Cast Shadows

Object Properties of the building reflection objects

Note: The building reflection objects are in the scene solely for the purposes of reflections; therefore, they should not render or affect shadow casting.

4. Open the Rendered Frame window and set the Final Gather Precision to Draft.
5. Render the Camera view.
6. Open the original background photo. In the Rendering menu on the Main menu bar, choose View Image File.
7. Select img_192.jpg from the project folder. Compare the image with the rendering.

Building reflection objects invisible to Camera and Final Gather on

Adjusting the brightness of the rendering to the background image is generally accomplished with the use of a white object in the scene and matching it with white objects in the

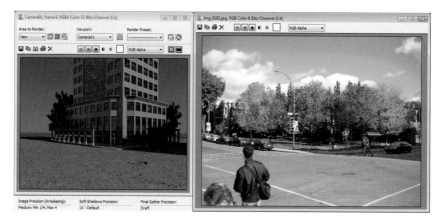

Original background image and rendering

photo background. You can see from the side-by-side comparison of the rendering and background what needs to be done:

- The directly lit areas need to be stronger to brighten white areas of the render.
- The shadow areas of the road need to be lighter.
- Areas of the building in shadow need to be darker.
- Tree leaves need to be lighter.
- The sky needs to be lighter.

Note: If viewport performance is slow on your system, consider disabling Hardware Shading and switching to Wireframe mode in the Camera view.

8. Select the Daylight object and go to the Modify panel.
9. Uncheck the Inherit from mr Sky option in the mr Sun Basic Parameters rollout. This will give you more control on the directly lit areas of the sun.
10. Increase the Multiplier to 3.0.
11. In the mr Sky Advanced Parameters, change the Horizon Height to −0.4 to lower it from its present location.

mr Sun Basic Parameters

Indirectly lit areas of the scene need to be brighter. One way of accomplishing this would be to change the multiplier in the mr Sky Parameters. However, we don't want to overpower the already increased values of the mr Sun Parameters. Instead, increase the Final Gather Bounces as a way of bringing more light into the indirectly lit areas.

12. In the Rendered Frame window, increase the Final Gather Bounces to 1.
13. Test render the Camera view.

mr Sky Advanced Parameters

The directly lit areas of the scene have improved greatly, as the white areas of the render now match the background. However, the indirectly lit areas of certain materials are not dark enough in comparison to the photo. You will have to modify their brightness at the material level.

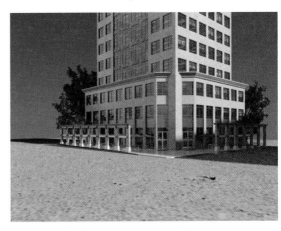

8.7 Matching Material Brightness

In the next few steps, you will use controls in the Material Editor to adjust the rendered appearance of objects in the scene to match the background image.

Effect of lighting changes

1. In the top viewport select the object "building shadow."
2. Access its Object Properties and disable the following options:
 - Visible to Camera
 - Visible to Reflection/Refraction

- Open the Material Editor

3. Select the material named "stone" (first row, first column). This material appears to be too bright in comparison to the background photo.

Material Map Navigator

4. Click on the Material/Map Navigator button. Select the Bright Map in the Navigator.

Choosing the Composite Map

5. Click on the Map Type button and select Composite.
6. In the Replace Map dialog, keep the old map as a submap.
7. In the Composite Layers rollout, click the Color Correct This Texture button.
8. In the Lightness rollout, select the Advanced option.

Color Correct This Texture button *Decreasing brightness*

9. Decrease the RGB Gamma/Contrast value to 0.5.

10. In the Material/Map Navigator, click on the upper level of the material.

11. In the Rendered Frame window, select the region from the Area to Render list.

12. Select a region that covers both sides of the building.

13. Render the region to compare the rendered results.

Material/Map Navigator

Adjusting the render region

Comparing the render region

The material looks much better now; however, the areas in shadow could be darker. Before working on this material some more, you will save a Final Gather Map file to speed up test renders.

8.8 Creating the FG Map File to Save Render Time

Since there will no longer be any changes to the lighting or modeling or materials that might affect the FG Map (like displacements or Self Illumination), it is a good time to create a FG Map file so that you can bypass the Final Gather stage of subsequent test renderings.

1. In the Rendered Frame window, in the Area to Render dropdown list, select View.

2. Open the Render Setup dialog and select the Indirect Illumination tab.

3. In the Final Gather rollout, Basic Parameters, change the following parameters:
 • Rays per FG Point to 150
 • Interpolate Over Num. FG Points to 50

Final Gather settings

Note: For the Rays per FG point value, exterior renderings rarely require values above 150 for good results—higher values will cause longer render times. For the Interpolate over Num. FG Points, this value is absolutely crucial to eliminating any FG artifacts, and it helps improve the visual aspect of self-illuminated objects using FG. Setting this option to a high value does not add much to the render time, but it is very useful to improve the image quality. It can also be used to enable the brute force render, when its value is set to 0.0. Brute force essentially by-passes any FG computation and starts rendering immediately. It is worth mentioning that brute force render takes longer to render, as everything is computed per bucket while rendering.

4. In the Processing tab in the Geometry Caching area, check the Enable option. This option will help speed up the translation process during rendering.

5. In the Indirect Illumination tab, go to the Reuse (FG and GI Disk caching) rollout.

6. In the Mode area, click on the Calculate FG/GI and Skip Final Rendering.

7. In the Final Gather Map area, choose the Incrementally Add FG Points to Map Files option from the list.

Geometry Caching

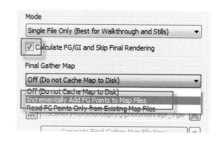

Reuse FG settings

8. Click on the Browse button, give your file an appropriate name, and then click Save to exit the dialog.

9. Click on the Generate Final Gather Map File Now button.

3ds Max Design will proceed to compute the FG Map but will stop at the point of rendering the file. At the same time it will store the FG Map information in the file specified.

Note: FG computations should always be carried out on one computer at a time; using distributed rendering or multiple machines will result in inaccurate results.

Creating the FG Map file

Final Gather calculation

10. In the Render Setup dialog, in the Processing tab, lock the Geometry Caching.

Geometry Caching locked

11. In the Indirect Illumination tab, Reuse (FG and GI Disk Caching) rollout, disable the Calculate FG/GI and Skip Final Render option.
12. In the Final Gather Map list, select Read FG Points Only from Existing Map Files.
13. Render the Camera view.

The Render proceeds much more quickly now, because it does not calculate the FG Map during render time.

Geometry Caching locked

8.9 Working on the Stone Material

The Stone material has improved with the adjustment made previously; however, the materials in shadow are still much too bright for the background photo.

1. In the Material Editor, select the Stone material, and make sure that you are at the top level of the material.
2. Go to the Advanced Rendering Options rollout, and in the Indirect Illumination Options, change the FG/GI Multiplier value to 0.08.

Note: Although you have changed the FG/GI Multiplier value in the Stone material, this does not require a computation of the FG Map file. This multiplier affects only how much of the Indirect Illumination the material uses; the Indirect Illumination is still present.

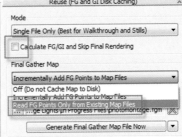

Material FG/GI Multiplier value

3. Open the Renderer Frame window and change the Area to Render to Region.

4. Render the same region in the Camera view.

5. Compare the Shadow areas of the Stone material to the darker areas of the photo.

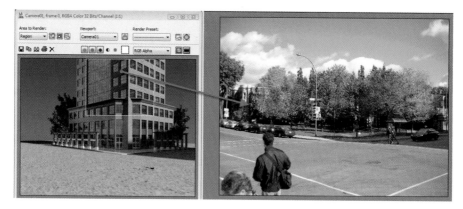

Material FG/GI Multiplier value

8.10 Changing the Material for the Door and Window Frames

The next material to be worked on is the Metal (satined metal). Because the material to be worked on is quite small in the rendering, you will increase the output size of the rendering to have a clear vision of the changes in the scene.

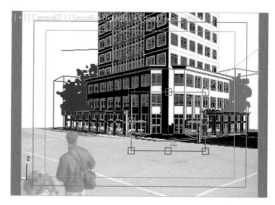

1. In the Render Setup dialog, go to the Common tab, and change the Output size to 1000 × 750.

2. In the Rendered Frame window, set the Area to Render to Crop.

3. In the Camera view, set the crop region to the entrance area of the building.

4. Render the crop region of the Camera view.

Selecting the crop region

Rendered crop region

The render looks pretty good; however, the shadows being cast on the metal are not as prominent as the shadow on the stone. This is due to its intense reflectivity and other internal properties of the Metal material.

5. In the Material Editor, select the Metal (satined metal) material slot (first row, third column).
6. In the Advanced Rendering Options rollout, Indirect Illumination Options, change the FG/GI Multiplier to 0.001.
7. Click on the Select by Material button, and in the Select Objects dialog, click the Select button.

Select Objects by Materials

8. In the Rendered Frame window, click on the Subset Pixel Rendering button to render only the selected objects.

Subset Pixel Rendering button

Note: This option works only when a previous full render is in the frame buffer and the Image Size/Ratio and Camera view are identical.

9. Click Render to test the results.

The shadows are a bit more prominent now; however, the intense reflections of the metal are preventing this from being seen more clearly.

10. In the Main Material Parameters, in the Reflection area, change the Reflectivity to 0.5.

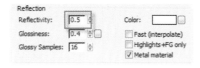

Reflectivity value

11. In the BRDF rollout, set the 0 deg. refl: to 0.4.

12. Test render the Camera view.

Use similar techniques to make other Metal materials in the scene have more prominent shadows.

13. Once complete, disable the Subset Pixel Rendering button.

14. Change the Area to Render to View, and render the Camera view.

Rendering the Metal material

Modifying the BRDF curve

The Metal materials look good now; however, the environment plane maps are not very evident in the reflections of the glass.

Effects on the rendering of the entrance

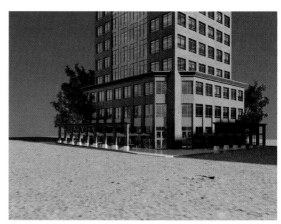

Rendering the entire view

8.11 Adjusting the Building Reflection Materials

1. In the Rendered Frame window, select the Area to Render as Crop.

2. Set the crop region to the windows in the upper left of the building.

3. In the Material Editor, select the material named building reflection01(matte finish) slot (third row, fourth column).

4. Click on the Diffuse Color Map button.

5. Click on the Map Type button, and choose Composite from the Material/Map browser.

6. Keep the old map as a submap.

7. In the Layer 1 rollout, click the Color Correct This Texture button.

8. In the Lightness rollout, select the Advanced option.

9. Decrease the RGB Gamma/Contrast to 0.3.

10. Render the region.

11. Select the material slot named building facade 33 (first row, fifth column). This reflection material is affecting the front façade glass planes.

12. Go to the Self Illumination rollout, and increase the Physical Units to 16000.0.

13. Render the region.

Setting the region to render

Composite map

Lightness parameters

Improved sky reflection

Self Illumination values increased

Effects of increasing the Self Illumination

8.12 Adjusting the Reflective Glass

The glass on the front façade are not reflecting very much. You will need to make modifications to the glass materials to change this.

1. In the Material Editor, select the material named front facade (Glass (Thin Geometry)) (first row, sixth column).

2. Go to the BDRF rollout and choose the Custom Reflectivity option.

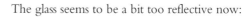

BDRF rollout

3. In the Advanced Rendering Options rollout, enable Transparency Propagates Alpha Channel.

Note: This option is very useful to save alpha channel information for reflective glass materials when saving to a TGA file or another file format that supports alpha information. It is also useful in that it allows you to insert or blend your own Sky material in Photoshop.

4. Enable these options in all Glass materials.

5. Test render a cropped region of the building in the Camera view, eliminating the foreground.

Transparency Propagates Alpha Channel option

The glass seems to be a bit too reflective now:

6. In the BRDF rollout, change the 0 deg. refl: value to 0.2 in all Glass materials.

Render with Glass material changes

BRDF changes

7. Test Render the building again.

Note: It is important to link the environment color and its reflections with the building in order to better incorporate the two.

The glass looks much better now; however, the ceiling lights are getting lost in the reflections in the glass.

8. In the Material Editor, select the material named ceiling light(matte finish) (fourth row, first column).

9. Go to the Self Illumination (Glow) rollout and change the Luminance value to 5000.

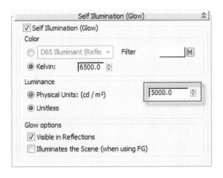

Changing the Luminance value

10. Test render a cropped region on the left side of the building.

The ceiling lights look fine now.

8.13 Adjusting the Tree Material

1. In the Material Editor, select the material named tree2 (first row, second column).
2. Select the submaterial named leaves.
3. Select the Color Diffuse Map button.
4. Click on the Map Type button and select the Composite Map in the Material/Map browser. Keep the old map.
5. Select the Color Correct This Texture button.
6. In the Color rollout, change the Saturation value to approximately 50.0. This will help to brighten up the color for the trees.
7. In the Lightness rollout, select the Advanced option.
8. Change the RGB Gamma/Contrast to 3.0.

Effect of BRDF changes on the render

Ceiling lights adjusted

Changing the Lightness and Saturation of the tree leaves

9. Make the same adjustment to the material named tree1.

10. Create a test render that includes the trees and the building.

Lightened tree leaves

8.14 Adjusting the mr Physical Sky

The next adjustment you will make will be to the mr Physical Sky's parameters.

1. Select the object in the scene named Tree1_mrproxy01 and isolate the selection.

2. In the Environment and Effects dialog, Environment tab, note that a mr Physical Sky Environment map is already in the map channel and mr Photographic Exposure Control is enabled. This is done automatically when you create a Daylight System with the mr renderer enabled and accept the default in the mr Physical Sky Creation dialog.

3. Open the Material Editor and drag the mr Physical Sky map into the lower-right material slot. Select the instance in the dialog that appears.

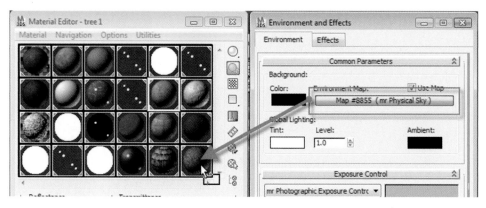

Instancing the mr Physical Sky into the Material Editor

4. In the mr Physical Sky Parameters, disable the Inherit from mr Sky option to break the link from the mr Sky Parameters of the Daylight System object.

5. Change the Multiplier value to 5.0.

Disable Inherit from Sky

Initial render of the mr Physical Sky

6. Set the Area to Render list, and select View.
7. Render the Camera view.
8. Decrease the Horizon height to –0.4.
9. Change the Red/Blue Tint value to –0.1 and the Saturation to 1.4.

Adjustments to height and color

Note: The mr Physical Sky Parameters only affect the appearance of the of the sky and objects in the scene that reflect it. Since you already have surfaces surrounding the building that are reflecting a street level and sky image, it is not necessary to apply a bitmap into the haze channel as is done in other chapters.

10. Render the Camera view again.

Changes to the mr Physical Sky

11. Exit Isolation Mode.

In order to ensure that the sun's highlight is visible in some of the reflective objects, you will exaggerate some of the Sun Disk Appearance values.

12. In the mr Physical Sky Parameters rollout, Sun Disk Appearance area, change the following values:
 * Disk Intensity = 25.0

- Glow Intensity = 25.0
- Scale = 15.5

Note: Since you have several planes surrounding the building, you will not see the effect of the Sun Disk at this point. It will become more apparent when creating final renders. It is also important to note that this is generated from the mr Physical Sky map and not the actual Daylight head object. So when matching the sun's real position in a photomontage, you should always focus on the shadow direction and softness.

Sun Disk Appearance

8.15 Setting up the Rendering Settings

Now that the materials and mr Physical Sky have all been adjusted, the final stage is to set up the rendering settings:

1. In the Render Setup dialog, on the Common tab, change the Output size to 2592 × 1944.

Note: Even though the FG Map file has been rendered at a lower resolution, mental ray allows you to subsequently render higher resolution images of the same proportions accurately.

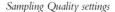

Sampling Quality settings

2. In the Renderer tab, under Sampling Quality, set the Type to Mitchell.
3. Make sure that the Width and Height are set to 5.0.

Note: The Mitchell filter is chosen primarily because the output size is not large and it will help to sharpen the final output. Images of 5000 pixels and more don't require such a complex filter, and a simpler filter like Gauss can be used.

4. In the Options area, depending on the specifications of your computer, you would keep the default—Hilbert (best)—for a computer with limited resources, or select Top-down for a computer with significant resources. Top-down is faster but uses more memory.
5. In the Rendering Algorithms rollout, under Reflections/Refractions, you can decrease the following values if your computer performance is slower:
 - Max. Trace Depth: to 1 or 2
 - Max. Reflections: to 1 or 2
 - Max. Refractions: to 1 or 2

Bucket Order options

6. In the Common tab, check the Save File option, and click on the Files button.

7. In the Render Output file, name the file Photomontage4.

8. Select the Targa Image file type and then select Setup.

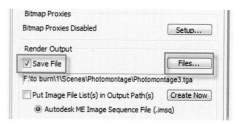

Saving the rendered output

9. In the Targa Image Control dialog, make sure that the Bits per Pixel is set to 32 and that Compress and Pre-Multiplied Alpha are selected. Click OK to exit the dialog.

Note: You can fill in some of the Additional

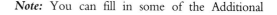

Targa Image file selected

Information to the Targa file if you require. The Targa file was mainly chosen due to its high image integrity and quality.

10. Open the Rendered Frame window.

11. Move the Image Precision Slider to High: Min 1, Max 16. This value controls the quality of the image.

12. Move the Glossy Reflections Precision, and set it to 2.0x–High Quality. This value allows you to adjust the final render appearance in the reflections. Sometimes a high-resolution image is required without much emphasis on the glossy reflections.

13. Set the Soft Shadows Precision to 2.0x–High Quality. This value controls the representation of the shadows on the render; in this case, those generated by the sun.

14. Set the Glossy Refractions to 2.0x–High Quality; this value controls the glossy refractions.

15. In the Camera view, select the Ground object, and change its Object Properties so it is not visible to the camera.

Setup of Targa options

mental ray Render settings

Note: When rendering images of 2 K pixels or more, you will most likely wish to use network rendering. This process was described in detail in Chapter 4.

16.　Render the Camera view.

8.16 Beginning the Photoshop Process

Once the image is rendered, you can begin the process of creating the photomontage in Photoshop:

1.　Open the rendered image, along with the background img_0192.jpg in Photoshop.
2.　Duplicate the background photo by right-clicking on the layer and selecting Duplicate Layer from the menu.
3.　In the Duplicate Layer dialog, choose the rendered image named Photomontage4.tga as the destination of the duplicate. Click OK to close the dialog.
4.　Close the img_0192.jpg file.
5.　In the remaining opened file, duplicate the original rendered layer called "background" by default.
6.　In the Duplicate Layer dialog, rename the layer, render, and close the dialog.

Note: It is good practice to work on duplicated layers rather than the originals.

Duplicating the background layer

Duplicate Layer dialog

Duplicate Layer dialog

7. Right-click on the photo image layer called background copy, and select Layer Properties from the menu.

8. In the Layer Properties dialog, change the name to Photo, and the color to Yellow.

Layer Properties

Accessing Layer Properties

9. Duplicate the Photo layer and call the new layer Photo copy.

10. Remove the visibility icons for the layers Photo and Background.

11. Drag and drop the Photo copy layer adjacent to the Render layer.

12. While the Photo copy layer is selected, click the Add Layer Mask button.

13. While the layer is selected, go to the Channels tab. The Targa image has brought the alpha channel of the building.

14. Hold the Ctrl key and click on the Alpha1 channel. The selection now appears on the photo.

15. While the selection is still active, go to the Tools bar and select the Brush tool.

16. Ensure that the foreground color is set to black (to subtract areas) and the background color to white (to add areas).

Layers duplicated and rearranged

Add Layer Mask

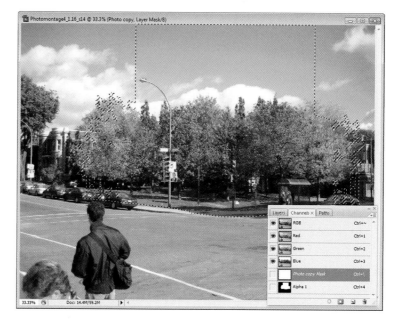

Displaying the alpha channel

17. Click on the Brush properties and set it to something relatively large.

18. Set the Hardness to 100%.

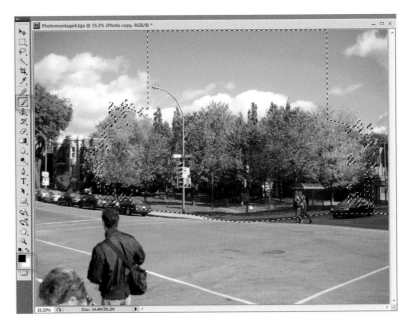

Select the Brush tool and foreground and background colors

Setting the Brush size

19. Click on the selected area and brush the black foreground color to fill in the selected area.

20. In the Layers set, click and drag the Photo copy layer (i.e., the one with the mask) so that it is positioned on top.

21. Position the layer Render just below it.

22. Position the layer Photo in the third row, with the visibility icon on. This way, you will be able to turn on and off the Render layer to see how it fits with the photo.

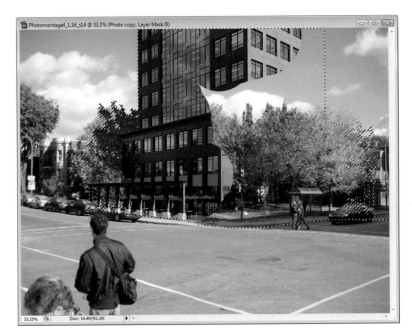

Painting the foreground color

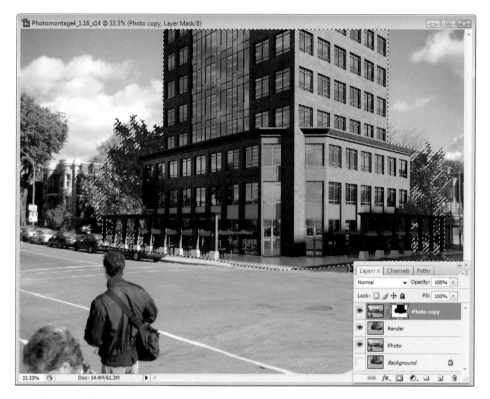

Roughly combined images

8.17 Adding Additional Masks for Foreground Elements

Next, you will add more masks to the existing mask thumbnail to bring elements in the photo to the foreground. To do so, you will use the Polygonal Lasso tool or any other tool you feel more comfortable with to select an area.

1. Use your selection of choice and select the cars to the left of the building.
2. On the Menu bar, click Select and then Save Selection from the menu.
3. In the Save Selection dialog, name the selection "Cars on the Left Side."
4. Repeat this process for the girls and the car in separate masks on the right side of the building.
5. Set the foreground color to white.
6. In the Layers tab, select the Photo copy layer.

Selected area for Cars on the Left Side

7. Open the Channels tab and Ctrl-click to select one mask at a time and paint the white foreground color to reveal the foreground element.

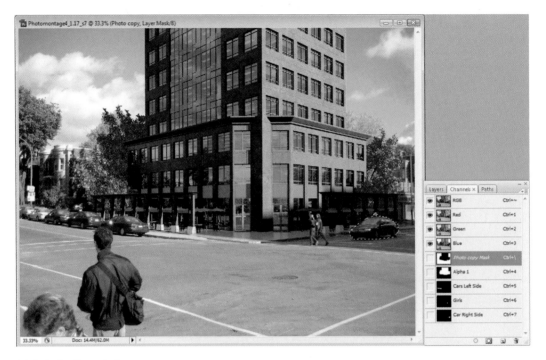

Masks in the Channel tab

8. To blend the masks accurately with the photo/ render, select the layer mask thumbnail on the Layers tab first; select the Blur tool from the Tools bar and drag across the edges that define between the photo and render. The brush size, mode, and strength will help achieve this more accurately.

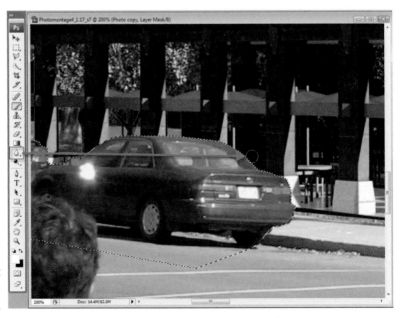

On the final version, the building edges were retouched to remove artifacts generated by the rendered channels.

Blending the edges of the mask

9. In the Channels tab, Ctrl-click to select the main building alpha channel.

10. In the Select menu, choose the Modify > Contract.

11. In the Contract Selection dialog, enter 1 pixel and click OK. The selection is now contracted.

Contract Selection dialog

Selecting the Contract tool

12. Press Shift-Ctrl-I to inverse the selection.

13. Select the Render layer in the Layers tab and press Ctrl-X to cut it.

14. Feather the edges around the Render layer with the Blur tool.

The Cloned Stamp tool was also used to better integrate the pavement of the photo with the rendered one. The final .psd file can be found in your project directories. The previous procedures are the standard way of putting together a photomontage scene. More work can be done to color-correct the entire composition (i.e., with curves, levels, hue and saturation, photo filter, and so on), and replace the window reflections, and so on.

To add people in the scene, simply use the Girls Dummy object in scene. Make it visible to the camera, and then scatter it (copy) around the areas you may want to add the people on (i.e., foreground, distance inside the building, and so on). Apply a white Self Illuminated (Glow) material to them, select all of them in the scene, and isolate them. Delete all the lights, FG, and so on in the scene and save this file as People Sizes.max. Render the Targa image matching the original render pixel and ratio size. Overlay this new black-and-white image on top of your final composition in Photoshop, and start adding photos of real people, matching the camera angle and lighting. The photographs of real people may require color correction.

Blurring the rendered edge

Generally, the final .psd files are saved as .tif for brochures and other marketing purposes. The TIFF file format is preferred by clients and reprographics professionals for superior printing results.

8.18 Modifying the Image to See the Entire Building

If you were to deliver this final image as it is, the client might ask the 3D artist to make the entire building visible from the same camera angle, with more sky and clouds on the upper areas. The request seems extremely difficult to achieve, but there is a relatively quick way of achieving this. In this section, you will be presented with an overview of how to go about this task.

Copy cloning the camera

1. In the main 3ds Max Design file, make a copy clone of the existing camera. Name the camera camera02 fov. Since you want to see the full extent of the building, the only parameter we need to focus on is the Field of View (FOV) of the new camera.

2. In the Camera viewport, switch to the camera02 fov camera view.

3. Click on the General Viewport Label menu and choose Select Camera from the menu.

In the Modify panel, you will note that there is a Camera Correction modifier applied to the camera already. It is very useful to correct the distorted verticals of a camera. One often requires adjustment with its values to find the right balance. When adjusting in a viewport, a tall dialog like the Material Editor can be used as a vertical guide. It's a good trick that works.

Selecting the camera

Switching the camera view

4. In the Modifier stack, click on the Free Camera level to access its parameters. In the FOV parameters of the camera, increase its value to a point where the full building is visible within the camera frame. The FOV value of 135.0 should be sufficient. Display the Safe Frame in the camera02 fov view.

5. Test render the scene with low-resolution settings (i.e., 800 × 600), but reasonably sharp, just for the purposes of finding out the final output size of the render.

Note: The previous FG file cannot be used now because more is visible to the camera.

6. In Photoshop, open the test render file. Select the main photomontage document and save it under a new file name. Resize the canvas height only by pressing Ctrl-Alt-C or selecting the Canvas Size from

Changing the FOV of the camera and displaying the Safe Frame

Enlarging the Canvas Size

the Image menu. In the Canvas Size dialog, increase the height in pixels to a maximum of about 5944 pixels. In the Anchor field, select the middle lower square to ensure that the extra pixels will be added upward only.

7. The canvas is now much taller. Press Ctrl-R to enable rulers on the document and create two vertical ones on each side of the canvas. Select the test render document and enable the alpha channel selection of the building, as previously done. Once the selection is on, copy and save it onto the new tall canvas. On the tall canvas, scale the newly pasted layer proportionally until it fits the proportions of the original building render. To scale proportionally, press Ctrl-T first; next, hold down the Shift key and move its corner handles to scale fit the original building plate. Ensure that the opacity of the pasted layer is low, in order to see through the original plate.

Enabling and drawing ruler lines

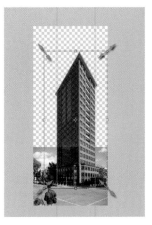

Scaling the new layer proportionally

8. Once it is matched, hold down the Ctrl key and click the layer to select it. There should be a selection around the proportionally scaled layer. Press Ctrl-C to copy it.

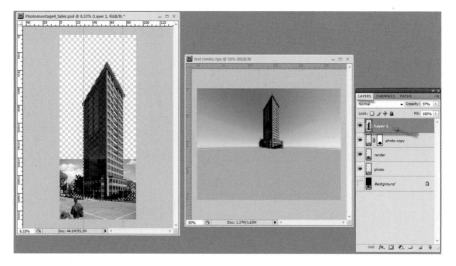

Selecting and copying the layer

9. Select the test render document and set the Image Size (Ctrl-Alt-I) to about 10000 pixels in width, keeping the proportions of the image.

10. Once resized, press Ctrl-V to paste the previously copied layer. The pasted layer seems a bit too big in comparison to the test render document. Use the Delete Layer button (bin) to delete the pasted layer.

Increasing the image size

Increasing the image size

11. Resize again the test render document (Ctrl-Alt-I) to a higher value and press Ctrl-V to paste the layer again to see if it fits.

Note: There is no need to copy the layer again from the other tall main document;

just keep resizing, pasting, and moving the layer until it fits.

The final resized document that matched the pasted layer was approximately 12058 × 9044 pixels.

This means that the final render size for this new camera in 3ds Max Design will be 12058 × 9044 pixels. Rename this new camera as Camera02 fov_12058 × 9044. As you did previously, save the FG Map file at a smaller resolution and render the final file.

Note: For this new big render, there is no need to use the Mitchell filter; use the Gauss filter type instead (width and height = 5.0).

The resized layer

12. If you can, use network rendering or distributed bucket rendering, to speed things up. The extra sky for the taller building has been worked on already in Photoshop. Bring tall sky.jpeg into the final taller .psd file (i.e., 2592 × 5944 pixels) and compose it.

A couple of additional things you can do to the background image:

13. You can add more clouds by using some of the techniques covered earlier.

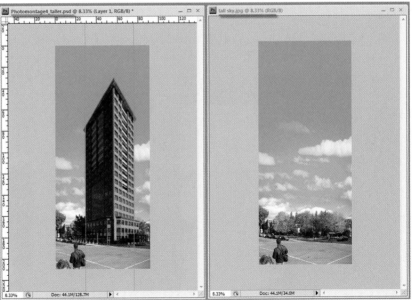

Tall sky background bitmap

14. You can emulate the vignetting effect by using the Gradient tool to darken the upper areas of the overall image.

15. To add a gradient, create a new layer by clicking on its button. Ensure that this gradient layer is behind the building layer and on top of the extra clouds layer.

Creating a new layer

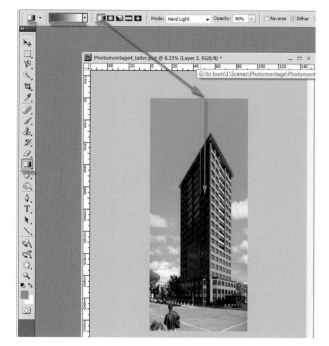

16. To create the Gradient tool (the linear type, as opposed to the bucket), in the main document, click and drag from the very top middle part of the image and drag it down to about the center of the document.

17. Use some of the layer blending tools to blend it with the existing sky. The blending

Identifying the placement of the gradient

tool that worked best this time was Multiply. Set its Fill value to about 70% and adjust its Layer Mask thumbnail as previously done with other layers to nicely blend it. Also, use some of the image adjusting tools (photo filter, hue and saturation, color balance, levels, and so on) to help blend further the gradient layer with the other layers.

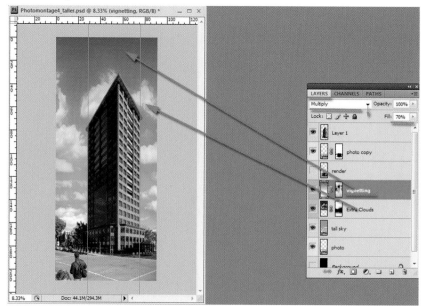

Adjusted image gradient

Due to the planes surrounding the building serving as cloud reflections, the sun disk generated from the mr Physical Sky was being obstructed. To have it visible on the Photoshop composition, you would need to go back to the main 3ds Max file and save it as a new file.

18. Render the reflection elements without the planes in the scene. You would hide all objects that are being used as cloud reflections for the building. On the Render Setup dialog, enable a crop covering the areas affected only by the direct sun in the viewport. Test render at a low setting and size to see where the sun highlights are falling on the building façade.

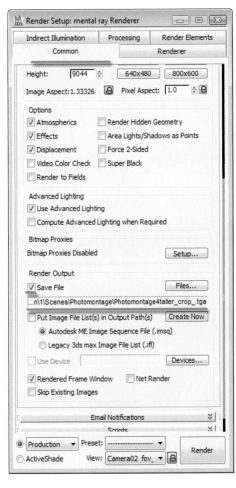

Rendering a crop region for the sun reflections

19. Adjust the Sun Disk Appearance scale values from the mr Physical Sky Parameters. If necessary, move the sun object to ensure that it is visible on the façade of the building (you may have to recompute the FG again, if the light is moved). When you render, rename the new output file render as ..._crop_.

Note: The file was named with underscores, with an eye to the extra names that will be automatically added on top from the Render Elements Parameters name field. If desired, since you are rendering again, you may as well render the whole scene again with all new elements. This is mainly due to the fact that clients may want some quick Photoshop changes that the prerendered elements may help to tackle quickly.

Naming the new render file

20. In the Render Setup dialog, Render Elements tab, click the Add button to bring up the Render Elements dialog. From the list, there are a number of elements that may render black for some of the following reasons:
 • The element or effect(s) is not applied in any of the objects in the scene/environment.
 • The element is not enabled or simply because it doesn't work with mental ray (i.e., some objects in the scene may have shaders applied to them that are not recognized by the element described and/or the objects in the scene may not have the effect applied onto them; therefore, the element enabled cannot extract it).

The following elements render with artifacts: output beauty; output specular; mr A&D Xtra; diffuse inherit illumination with AO; mr A&D Raw: Ambient Occlusion. This last element can be replaced by using the Ambient/Reflective Occlusion shader in the Material Override toggle and later overlaid in Photoshop as a grayscale.

Note: Car Paint material (mi): This shader is not recognized by both mr and the standard element.

There are other elements that don't work properly at all. They are the following: Standard–Shadow, Specular, Self Illumination, Paint, Ink, and Matte.

There are three types of mr A&D elements: mr A&D Level, mr A&D Output, and mr A&D Raw.

Note: mr A&D Level and mr A&D Output: With the appropriate software (i.e., Autodesk Toxik or Autodesk Combustion), you should be able to replace its diffuse and/or control its level of appearance.

Some of mr A&D Raw files, as described, are "raw"; therefore, the renders may appear jagged at times. Test-render between the mental ray and the standard elements in a separate Max file to see how certain elements are represented in the 3ds Max render. The mr A&D elements work only with mr A&D related shaders applied to objects.

mr A&D reflection element types

In the Render Elements rollout, ensure that the Elements Active function is on at all times.

Other functions in this dialog are described as follows:

- **Merge:** This button allows you to load other elements.
- **Delete:** This button allows you to select an element from the list and delete it.
- **Enable:** This option allows you to select individually or a group of elements from the list (Select + Shift + Select or Select + Ctrl) and turn them off or on. The name field allows you to select and rename the elements.
- **File (…):** This button allows you to choose the directory in which the selected element(s) will be saved into.

Once an element is selected from the list, its path destination/ name are added and set automatically according to the file name and path destination set from the Render output under the Common tab.

Adding the standard reflection element

Render setup: Render Elements tab

Also, the Save File Path function has to be on (later, after all rendered elements have been added and set, you can turn it off prior to rendering).

Some of the elements come with their own adjustable parameters; when available, the render parameters are normally displayed below the Output to Combustion group.

21. Add the standard reflection element from the list.

22. Back on the Elements File button, click it to open. Note how the file name and address have been automatically and intelligently added; you can change this, if desired. Create a new folder and call it Rendered Elements.

Note: All subsequent chosen elements will still be added according to the main output file name and folder destination, by default. The trick is to temporarily change the main output file name to where the elements should be saved to. Change it back later, once all elements have been added to the list. Alternatively, customize the bitmap/photometric paths all together, in the Utilities Command panel; it is often unsafe to do this, unless you know exactly what you are doing. For animations, it is always wise to create separate folders for each rendered element; it can easily become difficult to sort out files when all rendered elements are in the same folder.

23. Save the file as an OpenEXR Image File (*.exr) type.

Saving the file to a Rendered Elements folder

Render Elements File to an EXR file

24. EXR files are good to retain the integrity of the rendered elements. On its dialog, choose the Float-32 bits per channel format.

Note: You can also add other important rendering elements such as material ID or mr A&D Output Diffuse Direct Illumination, if desired.

OpenEXR configuration

Material IDs would take effect only if its number were changed in the Material Editor. The Object ID element is also a good alternative. Object IDs are changed in the Object Properties dialog.

The rendered elements should now appear in separate frame buffers on the screen, with their respective names, along with the main render.

Note: Unfortunately, the main render has to be rendered before any rendered elements can be rendered. You will have to wait for the main render to finish before rendering elements.

25. Bring the rendered element(s) into Photoshop and use the layer masks, image editing tools, filters, and the layer blending tools (i.e., Multiply, Dissolve, Lighten, Screen) to overlay and edit them.

Note: As previously mentioned, you can achieve the final result straight from the render. However, in a

Final adjustments in Photoshop

working environment, clients often require quick changes that can be done in Photoshop. Therefore, using this approach is better.

Another way of adding just the sun glare on the façade is to do it all in Photoshop with its tools and filters, or, alternatively, overlay an image of the sun glare on top of the main rendered layer using some of Photoshop's layer blending tools, such as Multiply, Dissolve, Overlay, and Screen and its filters.

Note: For final renders, only use the final Max file, as the geometry in the upper part of the building has been cleaned up.

There is a final PSD file with the extended clouds to the top of the sky, and other elements, in your project folder.

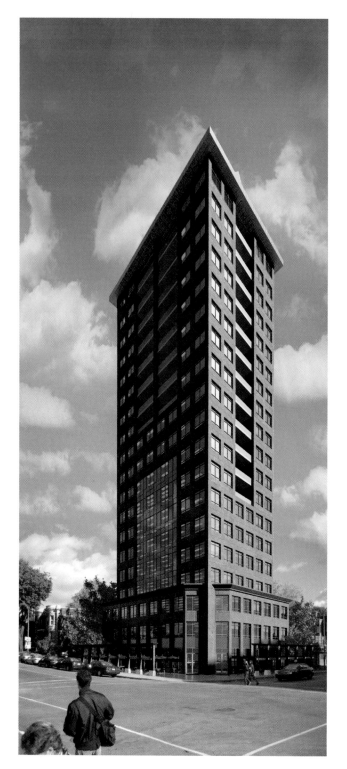
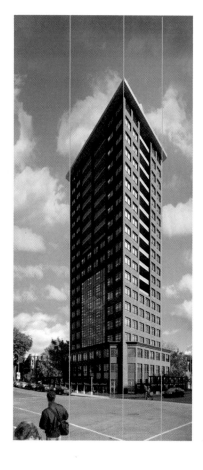

Photomontage of a twenty-story building with guides

Chapter 9

Verified Views

9.1 Introduction

In this chapter, you learn about verified views. Verified planning imagery is part of the process of submitting the final planning application for approval to planning authorities. The verified imagery should be an Accurate Visual Representation (AVR) of the proposed building. Topics covered in this chapter include:

- Data requirements to create a verified view
- How to work with the survey data in 3ds Max Design
- Creating Accurate Visual Representations (AVRs)

9.2 Gathering Data for the Views

The designated views are often chosen by the relevant authorities and Architects/Developers to assess a building's impact on the surrounding environment. The gathering of survey data is carried out by the Surveyor and the photography by the Photographer. The surveyor and Photographer should provide the 3D artist(s) with all photographic and survey records. These records are important not only for the 3D artist(s) but also for the planning authorities to authenticate the process.

You should have the following records:

- The survey point data report
- The camera data information, accompanied with photographs of the tripod on location

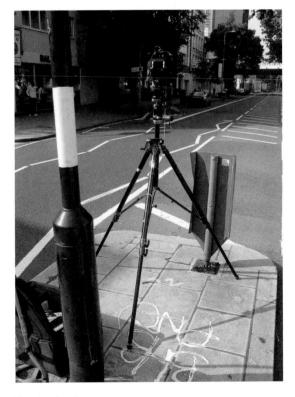

Tripod on location

Camera location

One of the first documents to look at is the survey point report provided by the surveyor. Typically, this will be submitted as an Excel spreadsheet. In the survey report, you should find detailed information of each view with its corresponding survey points. The first row of data is often related to the camera location, and the remaining ones correspond to the survey point locations. This is typical data encountered:

- **The point name row:** Indicates the name of the survey point.
- **Easting:** Indicates the X axis point in 3ds Max Design.
- **Northing:** Indicates the Y axis point in 3ds Max Design.
- **Level:** Indicates the Z axis point in 3ds Max Design.

	Clipboard		Font		Alignment		Number		Styles	

C56	▾	fx	180122.488							

	A	B	C	D	E		F	G	H
1	**11730 - Realistic Architectural Visualization with 3ds Max and mental ray**								
2	Main point positions with description								
3									
4	Point name	Easting	Northing	Level	Description 1		Description 2		
5	View 1	X	y	z	Realistic Architectural Visualization		Southern Extent		
6	Photo 1	531990.155	179224.755	3.117	Photo Location				
7	1_PNT1	531996.530	179234.195	3.005	CATV Cover				
8	1_PNT2	531997.126	179233.973	2.986	CATV Cover		Foreground centre		
9	1_PNT3	531996.795	179233.060	3.005	CATV Cover		Foreground centre		
10	1_PNT4	531996.200	179233.273	3.026	CATV Cover		Foreground centre		
11	1_PNT5	532014.170	179244.243	3.041	Top of kerb, Traffic island		Foreground Right		
12	1_PNT6	532008.841	179269.568	27.115	Parapet level		Middle ground Left		
13	1_PNT7	532008.745	179269.685	26.360	Top right of infil panel		Middle ground Left		
14	1_PNT8	532008.733	179269.689	24.262	Bottom right of infil panel		Middle ground Left		
15	1_PNT9	532033.492	179308.521	6.481	Underside of building overhang		Middle ground Left		
16	1_PNT10	532045.438	179274.222	10.026	Top of Parapet wall		Middle ground Right		
17	1_PNT11	532055.093	179291.719	18.151	Top of chimney		Background Right		
18	1_PNT12	532047.381	179273.515	45.695	Top of Parapet wall		Middle ground Left		
19									
20	Point name	Easting	Northing	Level	Description 1		Description 2		
21	View 2				Realistic Architectural Visualization		Northern Extent		
22	Photo 2	532120.552	179419.251	3.299	Photo Location				
23	2_PNT1	532118.607	179392.985	16.297	Roof Level		Foreground Left		
24	2_PNT2	532101.685	179375.879	2.803	Top of Kerb		Foreground Centre		
25	2_PNT3	532100.992	179364.113	12.659	Top Left of LH window		Middle ground Centre		
26	2_PNT4	532100.981	179364.123	10.218	Bottom Left of LH window		Middle ground Centre		
27	2_PNT5	532096.832	179357.581	12.595	Top Right of RH window		Middle ground Centre		
28	2_PNT6	532096.783	179357.622	10.183	Bottom Right of RH window		Middle ground Centre		
29	2_PNT7	532096.235	179356.851	16.864	Parapet Roof		Middle ground Centre		
30	2_PNT8	532049.216	179200.528	61.587	Top of Plant Room		Background Centre		
31	2_PNT9	532033.544	179205.248	60.629	Parapet Wall		Background Centre		
32	2_PNT10	532056.653	179267.675	45.696	Parapet Wall		Background Centre		
33	2_PNT11	532047.381	179273.515	45.695	Parapet Wall (1_PNT12)		Background Centre		
34									
35									

Typical data points spreadsheet

9.3 Working with the Survey Data in 3ds Max Design

Typically, the next thing to do would be to input this data into 3ds Max Design. You can do this through a script or by individually copying and pasting values from the Excel file into the X, Y, and Z number fields of

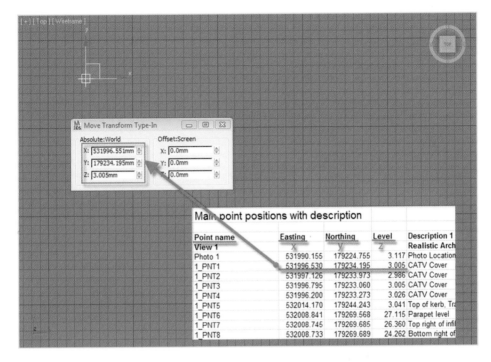

Inputting data points through copy and paste

the Move Transform type-in dialog. Professionals often use the point helper object for the survey points. Don't be alarmed if you can't match the last three digits—3ds Max Design often can't work them out. Besides, it will have little or no impact on the position of the survey points.

Once all the points have been created in 3ds Max Design, you would select the camera survey point and create a 3ds Max Design camera from that. This new camera should correspond to the X, Y, and Z values of its previously created point. The field camera information that is contained in the survey report is very useful, because it has information about the date and time, which can be later used with the Daylight System object in 3ds Max Design.

Camera information

When translating the camera info Field of View (FOV) used on site by the surveyor into 3ds Max Design, companies often use websites such as http://www.panoguide.com/howto/panoramas/lens_calculator.jsp. In 3ds Max Design, type in the newly calculated lens FOV (degrees) of the selected camera.

Panoguide website

It is becoming more and more common for surveyors to be asked to take a chrome ball and a gray ball to the site. The chrome ball is used to capture the environment's reflections and capture the sunlight's position based on its glare, which is reflected on the chrome ball. This can be subsequently emulated in 3ds Max Design with the chrome shader. The gray ball is used to capture the true sun color cast on the ball and to capture other colors in the environment. These balls are simple, cheap, and easy to access. Each ball is separately impaled on a 1.60-meter (approx. 5′3″) standing stick and included with the reference photos of the site. The surveyor would take photos of the east, west, north, and south areas of the site for reflection purposes in 3ds Max Design. Separate 360-degree-type photos should also be taken, if required. If there are any night versions of the verified views, a whole separate range of the abovementioned photos should be taken again.

The surveyor would provide you with a series of photos of the chosen views, indicating where each survey point was taken in the photo. These photos are to be cross-referenced with the survey point Excel spreadsheet.

Note: This example image is being used for reference purposes only. There is no connection between the survey points and the photo. The survey points were taken in England and the photo was taken in Canada.

Survey points on image background

In order to start matching the camera with points in 3ds Max Design, you would keep the survey data information on the photo, add dots on them, and turn the background to black. Save the image in a low resolution to be later loaded in the background of the 3ds Max Design viewport.

This newly saved image would then be opened as the viewport background in the Camera view. The rendered image output size and ratio should also match the photo. You would select the viewport camera, and name it according to its view name, output width, and height (i.e., View 01_2592 × 1944). To camera-match, use only the Select & Rotate tool. Since the camera position has

Survey points–only image

been entered already with the help of survey data, if you need to, you can add the camera correction modifier, but you can adjust the FOV value only slightly.

Camera-matching survey points with the background image

If the viewport background image is not displaying properly, go to the Preference Settings dialog. In the Viewports tab, the Configure Driver button will open the Configure Direct3D dialog. There you can change the Appearance Preferences to match the illustration.

Configuring the Direct 3D Driver

As you rotate your camera to attempt to match all the survey points, at times, you will probably find that you cannot match all of the points 100%. When this happens, simply focus on the middle points and try to ignore the ones from either ends of the viewport.

For additional help in matching views, lighting, composition, and so on, some companies will use 3D context models of the area in question. These surveyed 3D models are approved by the industry and are accurate representations of the existing location(s). Accuracy can be as close as 5 cm (2″) in building height and spot levels. They can be purchased from websites such as ZMapping (http://www.zmapping.co.uk/#/Gallery/).

ZMapping website

At times, it may seem impossible to match a verified view, due to the camera's distortion, angle of view, and so on. You can correct this in Photoshop with the help of the Line tool. Draw parallel lines across the perspective of some of the main areas of the photo in order to find its vanishing point.

With all the lines drawn, you should be able to clearly see where the lines converge (i.e., the white line). In theory, this vanishing point should divide the photo into two equal height distances to make the camera-matching process easier. Unfortunately, this is not the case with the current example image.

Finding a vanishing point *Extending the Canvas size down in Photoshop*

Once you have the white line drawn, enlarge the canvas size of the image to extend the image below so that there is an equal amount of image below and above the line.

Enlarged canvas image

With this new photo height, you should now find it easier to match the camera in 3ds Max Design. It is worth mentioning that with this new photo height, you will inevitably require resetting the render output height value and all the subsequent images that will be used for camera matching (i.e., the viewport background image). Glass Canvas (http://www.glass-canvas.co.uk) is prolific in using this methodology.

Render Setup dialog

9.4 Accurate Visual Representations

Clients normally require two types of final images:

1. The AVR0 is the outline representation of the massing. The general guideline is to have the full outline on the clear areas of the building and dotted lines on obstructed areas. It is imperative to have the most up-to-date survey of the massing, based on the existing OS data, in order to have an accurate visual representation (i.e., to have accurate information of the base of the building).

Outline representation of the massing

To create the outline (AVR0), you would need to have a full black-and-white render of the massing. Bring it into a Photoshop PSD file, contract the selection, and mask it out with the Add Layer Mask tool. To add the dotted lines, select the Brush tool first and click on the Toggle Brush panel. On its dialog, select a sharp brush and increase its spacing. Back in the PSD file, start brushing around the relevant areas.

Selecting the Brush configuration

Brushing the relevant areas of the image

2. The AVR1 is the full CG render.

Full CG render

Please check this website for more examples of verified images: http://ca11j31.cgsociety.org/gallery/497304/.

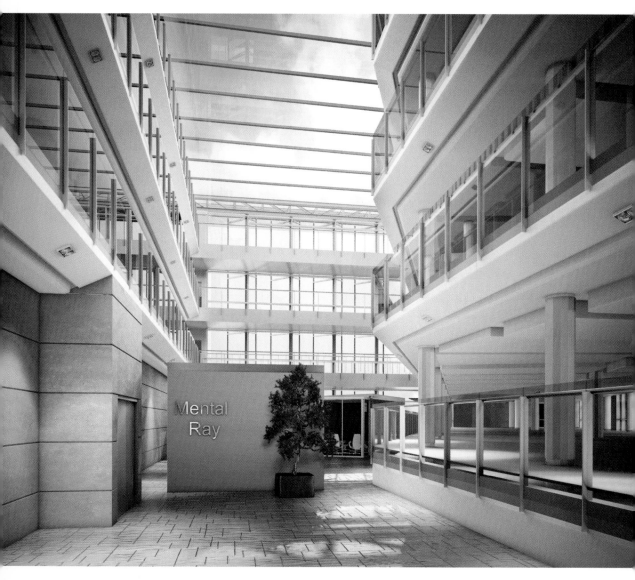

Rendered atrium scene

Section 4

The Atrium

Introduction

In this section, you will learn about creating materials and lighting for an atrium scene, Specifically, you will learn how to:

- Create materials for the atrium scene
- Add daylighting and artificial lights for the atrium and adjust materials

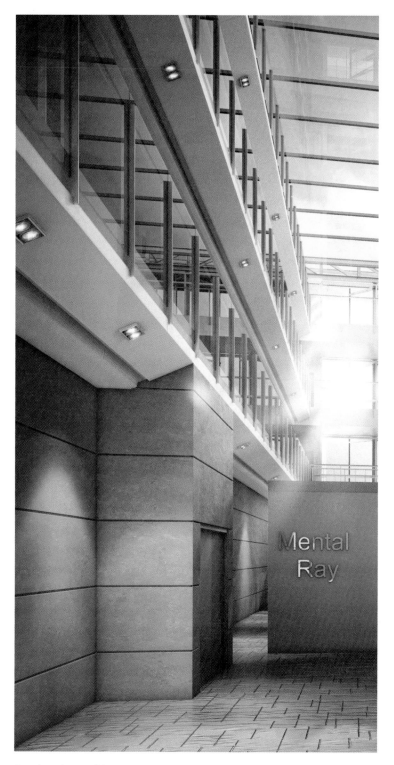

Detail rendering of the atrium

Chapter 10

Materials in the
Atrium Scene

10.1 Introduction

In this chapter, you will see how to prepare materials in an atrium scene. Specifically, you will learn how to:

- Create materials for various elements in the atrium scene
- Create a Glow material for the light lenses
- Assign a material to an mr Proxy object

10.2 Units in the Scene

In this scene, the selected units are meters. Some previous projects in this book have used millimeters. When you open the files in this chapter, you may encounter the File Units Mismatch dialog. Just click OK to accept the default options and proceed. For further explanation, please refer to Chapter 1.

10.3 Working on the Floor Material

When you first open the atrium scene file, you will note that there are many objects in the scene. You will work on the scene essentially one material at a time and apply that material to relevant objects. Start with the floor material:

1. Open the file "ICT MAIN_start materials.max."
2. In the Camera01 view, select the object in the scene named "Slab < AGXXFIN0Sreed > Slab," which is the floor surface of the ground floor visible in the Camera view.
3. Open the Material Editor and select the first material slot along the first row.
4. In the Templates dropdown list, select Pearl Finish.

Starting the Floor material

5. Name the material "floor screed (Pearl Finish)."

Some of the original settings are set to draft settings and therefore may generate artifacts in the render. So your next few steps will be to adjust these settings.

6. In the Main material parameters, make sure that Fast (interpolate) is not checked.
7. In the Fast Glossy Interpolation rollout, change the Interpolation grid density to 1 (same as rendering).

Reflection settings

Fast Glossy Interpolation settings

The next few steps will define the color and texture of the material.

8. In the Main material parameters rollout, click on the Color Map button.
9. Choose Bitmap from the Material/Map button.

Color Map button

Material/Map browser

10. Navigate to the folders that contain your project files and open the "CrazyPav.jpg" image file.
11. In the Bitmap level of the material, Coordinates rollout, change the Blur setting to .01 to sharpen the image.
12. Often, when you wish to use ambient occlusion from the Special Effects parameters rollout of the Arch & Design material, the adjustments made there are insufficient to see connecting shadows. An alternative strategy is to add the Ambient/Reflective Occlusion (3ds Max) shader at the map level, and keep the current bitmap as a submap.
13. Select the Material/Map button at the top of the Parameters section of the dialog.

Bitmap parameters

14. From the Material/Map browser, select Ambient/Reflective Occlusion (3ds Max).
15. In the Replace Map dialog, select Keep Old Map as Sub-Map.
16. In the Parameters rollout, change the following values:
 - Samples: 45
 - Spread: 3.0
 - Max distance: 0.2

Material/Map browser

Ambient/Reflective Occlusion (3dsmax) Parameters	
Samples . ·	45
Bright . ·	
Dark . ·	
Spread . ·	3.0
Max distance	0.2m
Reflective . ·	
Type (0 = occ., 1 = env., 2 = bnorm)	0
Return occlusion in alpha	
Falloff .	1.0
Incl./Excl. Object ID (Neg. = Exclude) . . .	0
Non-Self-Occluding Object ID	0

Ambient/Reflective Occlusion (3ds Max) parameters

Note: These settings are recommended when the model has been accurately created in system units of meters.

17. Click on the Go to Parent button to return to the top level of the material.
18. Change the following Reflection values:
 - Reflectivity: 0.84
 - Glossiness: 0.32
19. Click on the Metal Material checkbox.
20. With reflective materials, it is possible to lose the diffuse color as reflections mix with it. This can be a problem when a client is keen on seeing specific colors in the rendered image. The Metal material function controls this effect.
21. In the BRDF rollout, click on the Custom Reflectivity Function option, if it is not already selected.
22. Change the 0 deg. refl: value to .43.

Adjusting Reflection values

BRDF parameters

Note: It is likely that these values will have to be adjusted once you have assigned lights in the scene. It is a good practice to apply basic material settings prior to creating lights in the scene.

If the real-world surfaces are irregular, the next set of steps will emulate this effect:

23. Click on the Material/Map button at the top of the Material parameters.

24. In the Material/Map browser, choose the Utility Bump Combiner (adesk).

Material/Map buttxon

Utility Bump Combiner

25. In the Replace Material dialog, choose Keep Old Material as Sub-Material. The Bump Combiner allows you to choose three bump patterns and apply them to the material with different strengths.

26. Click on the Bump 1 map button.

27. Select Bitmap from the Material/Map browser.

28. Select "CrazyPav_bmp2 copy.jpg" from your project folder.

29. In the Coordinates rollout, change the Blur value to 0.1.

30. Click on the Go to Parent button to go to the top of the material.

31. Click on the Bump 2 map button.

32. Select Bitmap from the Material/Map Browser and select the bitmap "noise.jpg."

Utility Bump Combiner (adesk) parameters

Coordinates rollout

33. Assign the material to the slab surface.

In the next few steps, you will adjust the scale of the bitmaps that have been applied to the material. When emulating a real-world scene, bitmap scale plays an important role.

34. While the floor slab is still selected, right-click and click Isolate Selection from the Quad menu.

35. Go to the Modify tab of the Command panel and select UVW Map from the Modifier list.

Modifier list

Since the object is basically a flat surface, keep the mapping to Planar.

36. In the UVW Mapping parameters, remove the check in the Real-World Map Size option.

37. Set the U Tile to 8.38.

38. Set the V Tile to 14.21.

39. Back in the Material Editor, in the noise.jpg Bitmap parameters, click on the Show Standard Map in Viewport button.

40. Remove the check from the Use Real-World Scale option.

UVW Mapping Parameters

Bitmap parameters

41. Change the following mapping coordinates:
 - V Offset: − 5.05
 - U Tiling: 0.01
 - V Tiling: 0.07

 The irregular noise bump map is spread across the floor slab surface.

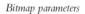

Coordinates and their effect on the map in the viewport

42. Click on the Go to Parent button.
43. Change the Bump 2 Multiplier to 3.0 to make the noise.jpg pattern more prominent in the render.
44. Exit Isolation mode.
45. Render the Camera01 view.

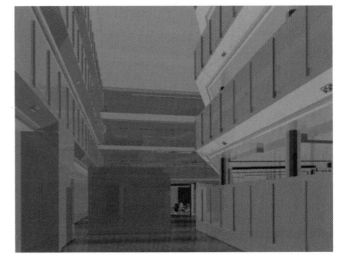

Increasing the Bump Multiplier

10.4 Working on the Marble Material

In this section, you will work on the Marble material that will be applied to the walls on the left side of the Camera view.

Render with Floor material applied

1. In the Material Editor, select the second material slot.
2. In the Templates rollout, select the Pearl Finish template.
3. Name the material "Red Panel (Pearl Finish)."
4. Click on the Diffuse Color map button, and select Bitmap from the Material/Map browser.
5. Navigate to the project folder and select the "MARBLE big.jpg" image.
6. In the Coordinates rollout, remove the check from the Use Real-World Scale option.
7. Set the V Offset to -0.01.
8. Change the Blur value to 0.01.

Selecting the template *Adjusting Coordinates of the marble bitmap*

9. Go back to the Main material parameters.

10. In the Reflection area, change the following parameters:

 - Glossiness: 0.34
 - Remove the check from the Fast (interpolate) option
 - Enable Highlights + FG only

11. Check the Metal material option.

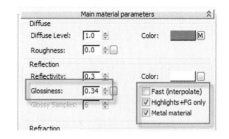

Adjusting Reflection parameters of the material

Note: Enabling Highlights + FG allows the material to produce glossy highlights without reflecting. Enabling the Metal material function allows you to preserve the diffuse color.

12. Click on the Diffuse Color Map button to return to that level of the material.

13. Select the Material/Map button at the top of the Parameters section of the dialog.

14. From the Material/Map browser, select Ambient/ Reflective Occlusion (3ds Max).

Material/Map button

15. In the Replace Map dialog, select Keep Old Map as Sub-Map.

16. In the Parameters rollout, change the following values:

 - Samples: 45
 - Spread: 3.0
 - Max distance: 0.2

17. Click on the Go to Parent button to return to the top level of the material.

18. Go to the BRDF rollout, and make sure that the Custom Reflectivity Function is enabled.

19. Change the 0 deg. refl. value to 0.24.

Note: Although you have disabled reflections by enabling the Highlights + FG only option, the BRDF curve allows you to adjust the size of the glossy highlight. Try some other values for the 0 deg. refl. and note the changes in the material sample.

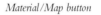

20. In the Fast Glossy Interpolation rollout, change the Interpolation grid density to 1 (same as rendering).

21. In the Special Effects rollout, enable the Round Corners option.

22. Change the Fillet radius to 0.01.

Fast Glossy Interpolation rollout

Note: This value was determined by first using the tape helper in the scene to measure the corner distance of the object. It is a good practice to do this, as you may later find that a random value that is too large will create artifacts on the object when rendering. Another way is to create a chamfer box from the extended primitives tools; and use it as a reference to determine the desired fillet radius.

23. Assign the material to the finish surfaces of the objects named "Wall < AGXXWA$0 $CLAD + INS_120 mm *Grooved TALL* > " and "Wall < AGXXWA0CLAD + INS_120 mm *Grooved* > ."

24. Render the Camera01 view.

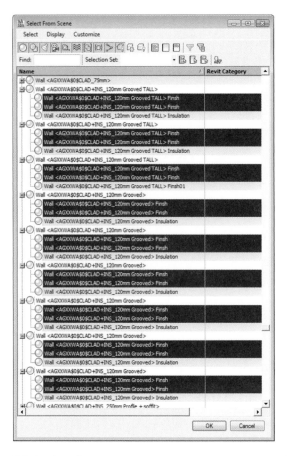

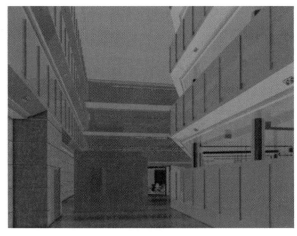

Rendered view with Marble material applied

10.5 Working on the Metal Material

In this section, you will work on the Metal material, which will be used primarily for the roof trusses over the atrium space.

1. Select the third material sample slot on the first row of the Material Editor.
2. In the templates list, choose the Satined Metal template.
3. In the Diffuse area of the Main material parameters, change the Diffuse Level to 0.9.
4. Click on the Color swatch, and adjust the color to a darker gray.

Because you will want Ambient/Occlusion connecting shadows, you will add these into the empty Color Map channel.

5. Click on the Color Map button.
6. In the Material/Map browser, click on the Ambient/ Reflective Occlusion (3ds Max) map.

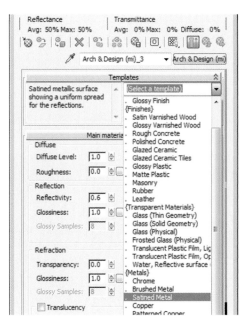

Selecting the Satined Metal template

Diffuse Parameters

7. In the Parameters rollout, change the following values:
 - Samples: 45
 - Spread: 3.0
 - Max distance: 0.2
8. Click on the Go to Parent button.
9. Right-click on the Diffuse Color swatch and select Copy from the menu.

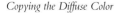

Copying the Diffuse Color

10. Click on the Diffuse Map button to return to the Ambient/Reflective Occlusion parameters level.
11. Right-click on the Bright Color swatch and from the menu select Paste.

Pasting the color in the Bright Color swatch

Note: When using the Ambient/Reflective Occlusion (3ds Max) map, the Diffuse Color bitmap is overridden by the Bright Color bitmap. The bright color can be adjusted manually or replaced with a bitmap to adjust the appearance of the material.

12. Return to the Main material parameters.
13. Name the material "Metal Darker Top (Satined Metal)."
14. In the Fast Glossy Interpolation rollout, change the Interpolation grid density to 1 (same as rendering).
15. In the Special Effects rollout, enable the Rounded Corners option.
16. Change the Fillet Radius to 0.005.
17. Assign this material to the object named "top frame."

Note: The Satined Metal template by default has the Diffuse Color map toggle disabled. When applying any map to the Diffuse Color map channel, you should always enable it. The Diffuse Color map channel can be enabled in the General Maps rollout.

Enabling the Diffuse Color map

10.6 Creating the Glass Material

The next material you will create is the Glass material for the atrium roof.

1. Select the fourth material slot along the first row of the Material Editor.
2. Select the Glass (Thin Geometry) template from the Templates list.
3. Name the material "Roof Light (Glass Thin Geometry)."
4. Click on the Refraction color swatch, and change the default blue to a greenish color.

Changing the refraction color

5. Change the Reflectivity to 0.6.
6. In the BRDF rollout, make sure that the Custom Reflectivity Function is enabled.
7. Change the 0 deg. refl. to 0.1.

Adjusting the Reflectivity

BRDF parameters

8. In the Fast Glossy Interpolation rollout, change the Interpolation Grid Density to 1 (same as rendering).
9. In the Special Effects rollout, enable the Round Corners option.
10. Change the Fillet Radius to 0.005.

11. In the Advanced Rendering Options rollout, enable the Transparency Propagates Alpha Channel option.

This option allows you to extract refractions from the alpha channel in Photoshop or similar application.

12. Assign this material to the object named "roof light."
13. In the Rendering menu, click on the Environment tab.
14. In the Environment and Effects dialog, select the Background Color swatch and change the color to a pale blue as depicted on the figure (R: 154, G:201, B:218).

Advanced Transparency Options

Changing the Background Color

15. Exit the dialog and render the Camera01 view.

10.7 Creating a Glow Material for Light Lenses

The next material you will create is a material for the light lenses, which are found underneath the walkways in the atrium. You want to illuminate the surface of the lens so it appears that light is passing through it, with some of the light being partially absorbed by the glass, thereby illuminating it. In the lighting chapter (Chapter 11), 3ds Max Design light objects will be used to light the scene from points just below the light lens.

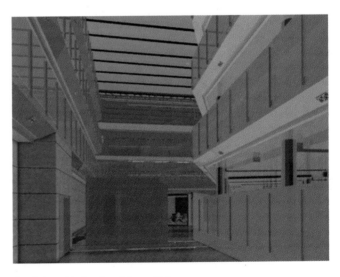

Rendering with the effect of the roof light

1. In the Material Editor, select the fifth sample slot along the top row.
2. Select the Matte Finish template.
3. Change the material name to "Light Lens (Matte)."
4. Change the Roughness value to 0.0.
5. In the Reflection area, change the Glossiness to 0.0.

6. In the BRDF rollout, make sure that the Custom Reflectivity Function is enabled and set the 0 and 90 deg. refl. to 0.0.

BDRF function

7. In the Self Illumination (Glow) parameter rollout, enable the Self Illumination (Glow) option.

8. In the Glow options area, make sure only the Visible in Reflections option is enabled.

Note: With the Glow parameters configured in this manner, you will be able to see the glow effect, but it will not contribute to indirect illumination. The illumination from these lights will be handled by light objects in the next chapter.

9. Assign this material to the object named "obj_1056," which is part of a group called Group36.

10. Render the Camera01 view.

11. There is a small change to the light lens appearance, but it is very subtle.

Selecting the Light Lens object

Main material parameter changes

Self Illumination (Glow) parameters

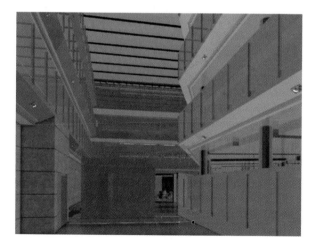

Effect of the Glow material

12. In the Material Editor, change the Luminance value to 30.0. This will strengthen the effect of the glow.

13. Render the view again.

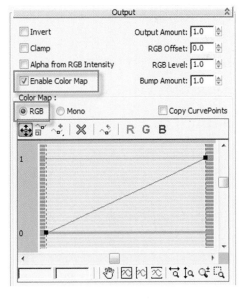

Increasing the Glow effect

The next stage is to apply a map with an orange color to it.

Effect of the increased Glow

14. In Self Illumination (Glow) parameters, click on the Filter Map button.

Filter Map button

15. Select bitmap from the Material/Map button.

16. Navigate to the project folder and open the bitmap "floodlight.jpg."

17. In the Output rollout, check the Enable Color Map option. In the Color Map area, choose RGB.

Output rollout

18. Click on the G and B button.

By default all colors are selected; selecting the G and B button freezes the Green and Blue curves, allowing you to edit the Red curve.

19. Select the right point of the Red curve and move it to a value of approximately 2.31.

20. Click on the Zoom Extents button in the Color Map area to see the entire curve.

21. Unfreeze the Green curve and move the right point on its curve to 1.208.

22. Unfreeze the Blue curve and move the right point on its curve to 0.619.

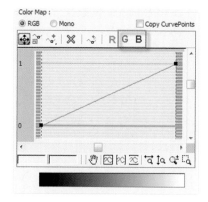

Color Map editing

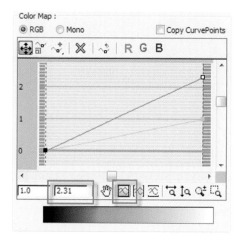

Editing the Red Color Map curve

Adjusted Color Map curve

Effect of the adjusted Color Map

23. Render the Camera01 view.

24. The orange tone is much more apparent now.

10.8 Materials and mr Proxy Objects

In Chapter 1, the importance of and how to create an mr Proxy object was discussed. In this section you will see how to work with materials and mr proxies. When you originally create an mr Proxy object, you should create a material library that contains the material used by the original object. This will make it easy to reapply the material whenever your proxy is used in a scene.

1. Right-click in the viewport and select Unhide by Name.

2. In the Unhide Objects dialog, select the mrProxy01_4th plant, and then click Unhide.
3. In the Material Editor, select the sixth sample slot along the first row.
4. Click on the Get Material button.
5. In the Material/Map Browser dialog, in the Browse From: area, select Mtl. Library.
6. In the File area, click Open.

Get Material

Opening a Material library

Choosing the Plant material from the library

7. Navigate to your project files and open the file "plants.mat."
8. Double-click on the material called "plant."
9. Close the Material/Map Browser dialog.
10. Assign the Plant material to the mr Proxy object.
11. Render the scene.

Note: This (multi/subobject) material fitted perfectly with this proxy, because the material was originally generated from this proxy's real tree object. Therefore the proxy had internally preserved its original subobject Material IDs and UVW Map parameters. A different material may not have fitted so well. In addition, attempting to add a modifier to the proxy (i.e., a UVW Map) will corrupt the proxy.

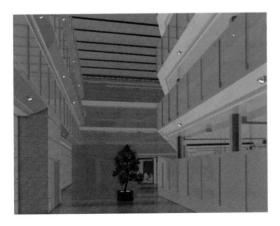

Rendering with the mr Proxy object

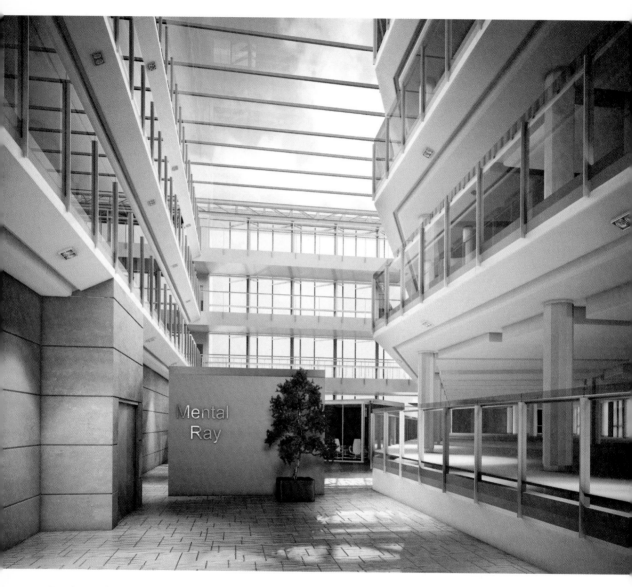

Rendering of the atrium scene

Chapter 11
Lighting the Atrium Scene

11.1 Introduction

In this chapter, you will add lights to the atrium scene and adjust some materials for the final render. Specifically, you will learn how to:

- Create and modify a Daylight System
- Use Sky Portals to enhance light from the exterior
- Add artificial lights to the interior
- Adjust materials based on the lighting

11.2 Units in the Scene

In this scene, the selected units are meters. Some previous projects in this book have used millimeters. When you open the files in this chapter, you might encounter the File Units Mismatch dialog. Just click OK to accept the default options and proceed. For further explanation, please refer to Chapter 1.

11.3 Scene Setup

A couple of adjustments have been made to the scene that should be mentioned at this point. In order to keep rendering times to a minimum for such a large file, the Render Output size has been adjusted to 400 × 300.

Also, the camera named Camera_Entrance has had the Camera Correction modifier added to it. The Camera Correction modifier allows you to reduce foreground by pointing the camera upward. Typically, this adjustment would result in vertical

Render Output size

elements in the scene having a perspective diminishing—an effect that the human eye does not detect, and therefore the image would seem unnatural.

Applying a Camera Correction modifier

Camera Correction modifier in the Modify panel

Camera target tilted upward to reduce foreground and capture upper elements of atrium

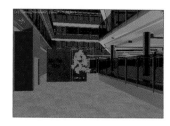

Camera inserted in the scene with camera and target at the same Z-Height. Note the amount of ground in the foreground.

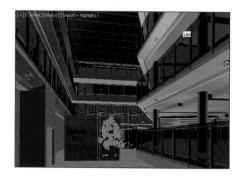

Camera Correction modifier applied

11.4 Creating the Daylight System

Start lighting the atrium by placing a Daylight System in the scene and adjusting its parameters.

1. Open the file "ICT MAIN_start lighting.max."
2. Click on the Create tab in the Command panel.
3. Select the System button, then the Daylight button.
4. In the Daylight System dialog that appears, select Yes to continue with the daylight creation process.
5. Click and drag to create the compass rose in the Top viewport.
6. When you release the left mouse button, the mr Sky dialog will appear; click Yes to continue.
7. Drag cursor to create the Daylight object and click to finish the creation process.
8. Click on the Modify tab of the Command panel.

Daylight System button

9. In the Daylight Parameters rollout, change the position to Manual.

In the next few steps, you will use Hardware Shading so that you can analyze the shadows that come from the Daylight System. If your hardware configuration does not support hardware shading, simply skip these steps.

10. In the Camera viewport, select in the Shading Viewport Label menu, Lighting and Shadows, and then Enable Hardware Shading.

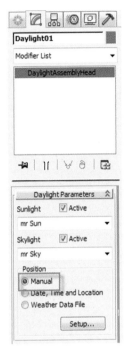

Daylight set to the Manual position

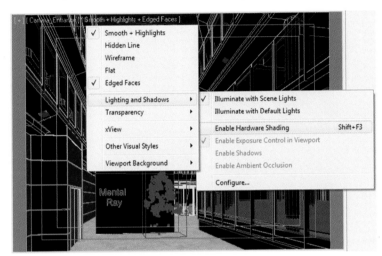

Enabling Hardware Shading

11. In the same menu, make sure that the following options are enabled: Illuminate with Scene Lights, Enable Hardware Shading, and Enable Shadows. All other options should be off.

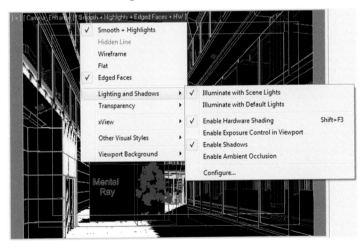

Hardware Shading options

Selection Filter

12. In order to more easily select the Daylight object, on the main toolbar set the Selection Filter pulldown menu to Lights.

13. Select the Daylight object in the Top viewport, and move it to the right. You should see the effect on the shadows in the Camera viewport.

Camera view before moving the Daylight System *Camera view after moving the Daylight System*

14. You can simply move the Daylight object and the Compass helper with the help of the Move Transform type-in dialog to the following locations:
 * Daylight object: X = 191.0, Y = −102.0, Z = 105.0
 * Compass helper: X = 1.5, Y = −9.0, Z = 0.0

Note: In order to select the Compass object, you will need to switch the Selection filter to Helper.

The aim of positioning the sun in its current location is to get the daylight to slightly catch the tree and the blue pod. If you like, you can position the Daylight object to give you another lighting effect in the scene. Once you are satisfied with the position of the sun, your next step will be to adjust the Final Gather settings. If your computer's performance is being slowed by Hardware Shading, you can turn it off. In addition, should you still find viewport refresh slow, switch the Camera view from Smooth and Highlights into Wireframe mode.

15. Open the Render Setup dialog box and select the Indirect Illumination tab. By default, the FG settings are set to custom.
16. Make sure the Project FG Points from Camera Position (Best for Stills) is selected in the pulldown list.
17. Make sure the Initial FG Point Density is set to 0.1. This setting should be kept as low as possible. Although it can be useful to improve a FG solution, it takes too long to compute.
18. Change the Rays per FG Point to 150. This value is critical to eliminate artifacts in complex scenes; higher values will simply take too long to process.
19. Change the Interpolate Over Num. FG Points to 150. This value is the most useful function to eliminate artifacts and does not dramatically increase rendering times.
20. Change the Diffuse Bounces to 1. This value is very important to compute Indirect Illumination. High values may increase render times dramatically, often without significant effect on the indirectly illuminated areas.

Note: In order to avoid increasing Diffuse Bounces, you can place additional lights strategically in your scene and produce the same effect.

21. Make sure the Weight value is set to 1.0. The weight determines the percentage of diffuse bounces values being used; 1 equals 100% of whatever value of the Diffuse Bounces.

22. Test render the Camera view.

Effects on the scene with FG settings

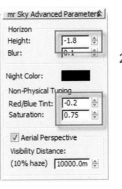

FG settings for Indirect Illumination

In the next few steps, you will adjust the Daylight System and the exposure settings in the scene:

23. Select the Daylight object.

24. In the Modify panel, under the mr Sun Basic Parameters, change the Multiplier to 5.0. This *will help to produce brighter highlights in the scene from the daylight.*

25. Adjust the Softness value in the Shadows area to 0.2. This will sharpen the direct shadows from the sunlight—but not overly.

26. In the mr Sky Parameters rollout, increase the Multiplier to 2.0. This will help increase the indirect light in the scene.

27. In the mr Sky Advanced Parameters, change the Height in the Horizon group to −1.8. This will have the effect of lowering the horizon in the rendering.

28. In the Non-Physical Tuning group, change the Red/Blue Tint to −0.2 and the saturation to 0.75. This will have that effect of tinting the light from sky to be slightly bluish.

29. Render the Camera view again.

mr Sun Basic Parameters *mr Sky Parameters*

Effects of changing Daylight Parameters

mr Sky Advanced Parameters

The render is brighter overall, as are the highlights from the direct sun. The image still needs to be brightened up a bit.

11.5 Adding Sky Portals to Brighten the Scene

The next stage is to increase the skylight indirect light by adding mr Sky Portals:

1. In the Create tab of the Command panel, select the Light button and ensure that the Light Type list is set to Photometric.

2. Select the mr Sky Portal button and then click and drag in the Top viewport to create the portal object. Zoom out as desired to create the portal about the size of the building.

mr Sky Portal

Creating the first mr Sky Portal

3. Go to the Modifier panel, and in the mr Skylight Portal Parameters, change the Multiplier to 25.0.

4. Since you are emulating diffuse light from the sky, click on the Filter Color Swatch and adjust the color to a bluish tint: R: 0.118, G: .38, B: 0.706 Alpha: 1.0.

mr Skylight Portal Parameters

5. Change the value in the Shadows Samples list to 32.

Note: For a large scene like this, it is important to increase Shadow Samples as a way of improving the shadows from the portals and reducing artifacts in the render. This may increase render times slightly. Often, this step is unnecessary.

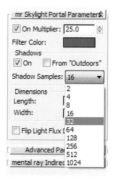

Shadow samples

6. In the Dimensions area, change the Length to 98.0 and the Width to 200.0.

7. In the Advanced Parameters rollout, change the Color Source to the Use Scene Environment option.

In the next few steps, you will move and rotate the original portal and then create two duplicates to project light from the sides of the building.

8. In the Front viewport, use the Move tool to move the mr Sky Portal to a point above the building.

9. In the Top viewport, rotate the mr Sky Portal approximately −25 degrees about the Z axis. This portal will enhance light coming from the atrium skylight.

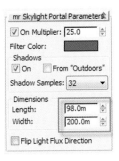

Adjusting the dimensions of the mr Sky Portal

Advanced Parameters

Moving the mr Sky Portal

Rotating the Sky Portal

10. With the portal selected, press Ctrl-V.

11. In the Clone Options dialog, select Instance.

12. Repeat this process to create a third mr Sky Portal.

13. Select the second mr Sky Portal; it should be named mr Sky Portal02.

14. In the Top viewport, click and then right-click on the Select and Rotate tool.

15. Type the following, in the Rotate Transform Type-In, Absolute World: X: −90.0, Y: 180.0, Z: −89.9.

Cloning the Sky Portal

Rotating the Sky Portal

Moving the Sky Portal

16. Click on the Select and Move tool.
17. In the Move Transform Type-In, type in the following coordinates: X: −48.0, Y: 2.0, Z: 20.0. This portal is used to enhance light coming in from the entrance of the building.

Note: You should see a small arrow projecting from the plane in the viewport. If it is not pointing toward the building, there will be no effect on the lighting. If it is pointing in the wrong direction, you can select the Flip Light Flux Direction option in the mr Skylight Portal Parameters rollout. In this case, since the three mr Sky Portals are instanced, you would either have to make them unique or rotate the portal rather than using this tool.

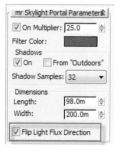

Flipping the Light Direction in a Sky Portal

18. Select the third mr Sky Portal.
19. Use the following Absolute World rotation values to rotate the portal into position: X: 90.0, Y: 0.0, Z: −25.0.
20. Move the portal to the following position: X: −4.0, Y: −43.0, Z: 20.0.
21. Test render the Camera view.

Positioning the last Sky Portal

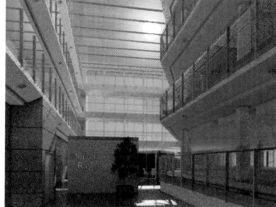

Effects of the Sky Portals on the scene

Note: When using a mr Sky Portal, you can use an hdr image to add realism to the light being emitted by the portal. To do so, go to the mr Sky Portal Advanced Parameters; in the Color Source area, choose the Custom function and add the relevant image from its adjacent map button.

11.6 Adding Interior Artificial Lights

The scene is brighter now; however, it could use more light in the interior with yellow tones to make the scene warmer and more appealing. To add color and additional illumination, create photometric spotlights.

Photometric Target Light

1. In the Create panel, select the Light button.
2. Make sure the Lights List is set to Photometric, and select Target Light.
3. In the Front viewport, click in a clear area to begin the creation process.
4. Drag the target downward so the target light points toward the ground.
5. In the Modify panel, in the General Parameters rollout, uncheck the Targeted option.

Removing the Light Target

Note: You initially created a target light and then removed the target in order to properly position the light's direction in the scene. After the direction is set, it is easier to move light objects that do not have targets.

Placing the Target Light

6. In the Shadows area, remove the check in the On option to turn off the light's shadows. Removing shadows casting for these secondary lights will provide fast renders, in addition to controlled illumination.
7. Change the Light Distribution (Type) list to Spotlight.
8. In the Distribution (Spotlight) rollout, change the Hotspot to 17.0 and the Falloff/Field to 64.0.
9. In the Intensity/Color/Attenuation rollout, change the color in the list to HID Mercury.
10. Click on the Filter Color swatch, and change it to a warm orange: R: 240, G: 166, B: 49. These color

Changing the Light parameters

Changing the Light parameters

Color changes

changes will provide a warmer color to the interior lights.

11. In the Dimming area, click on the Percentage checkbox.

12. For the Percentage value, enter 6139900.0.

Note: The percentage value is high due to the fact that the scene is large, and the default values will have no effect on the scene. A rule of thumb is to start with values of 900.0 and work your way up or down, depending on what works best.

13. In the scene, select the group named Ceiling Lights and the Photometric light you just created.

14. Isolate the selection (Alt-Q).

15. Select the light only, and move it to a position under one of the upper floor's recessed light objects. To facilitate the positioning of the light, use the following Absolute World Coordinates: X: 1.81, Y: −1.68, Z: 21.19.

Positioning the light

16. Zoom in on the Top viewport and clone (instance) the lights to locate them where you see the geometry for the other recessed light fixtures.

Instancing the lights on the upper level

17. In the Front viewport, select all the lights you just created and clone (instance) them to the second level.

Instancing the lights on the second level

18. Select the third light on the second level from the left, and Clone (Copy) it to the first level. You use Copy in this case because you will now adjust the parameters of this light to create a nice web light effect on the ground level.

Copying a light to the ground level

19. With the light you just created on the ground level selected, go to the Modify tab of the Command panel.

20. In the General Parameters rollout, select Photometric Web from the Light Distribution (Type) list.

21. In the Distribution (Photometric Web) rollout, click on the <Choose Photometric File> button.

22. Navigate to your project files and open the file "Nice recessed.IES." This is a Photometric Web file that controls the distribution of light from the fixture.

Photometric Web *Photometric File* *Nice recessed web file*

Note: 3ds Max graphically displays the IES energy and general property information in the rollout.

23. In the Intensity/Color/ Attenuation rollout, in the Dimming area, change the percentage value to 2000700.0.

24. Click on the Wireframe Color of the light object, and change it to Red.

25. Clone (instanced) this new

Changing the Wireframe color

light to the light positions on the ground level that are visible to the Camera view.

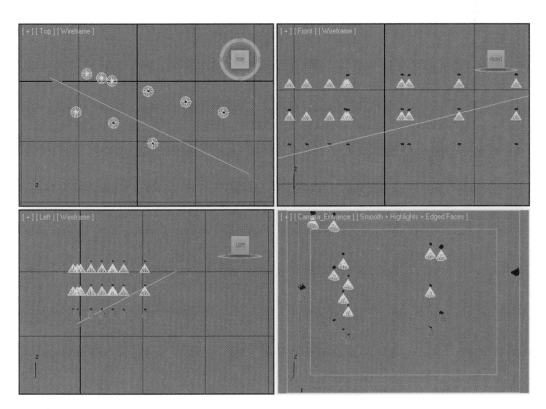

Copied ground level lights

26. Exit Isolation mode, and test-render the scene.

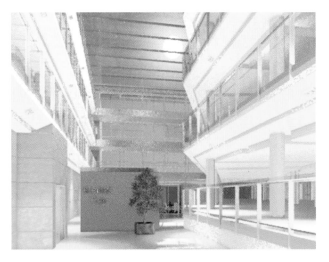

Effect of adding artificial lights

11.7 Controlling the Brightness of the Image with Exposure Control

With the number of lights you now have in the scene, the image appears to be overly bright. To control the brightness, use the mr Photographic Exposure Controls available in the Environment and Effects dialog.

1. Open the Environment and Effects dialog, either from the Rendered Frame window, from the Rendering menu, or simply by pressing 8 on the keyboard.
2. In the Environment tab, under mr Photographic Exposure Control, change the Exposure value to 15.5.
3. Make sure that the Camera view is active and click on the Render Preview button.

mr Exposure Control

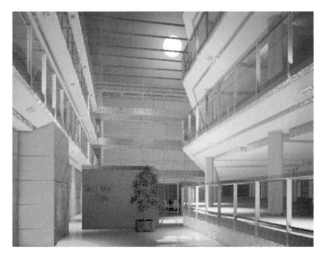

Effects of adjusting the mr Exposure Control

4. In the Image Control area, change the shadows to 1.0 to darken the areas of the image in shadow.
5. Change the Midtones to 1.4.
6. Adjust the Vignetting to 12.0 to darken the edges of the image. Test-render the scene again.

Note: The preview available in the Exposure Control rollout gives a reasonable estimation of

the effects of the adjustments made in the dialog. You can make several adjustments and see their effects before you do another test render in the Renderer Frame Window.

11.8 Adding Clouds to the Sky Background

In this section, you will add a sky image to the mr Physical Sky background, which is created by default with the Daylight System.

1. With the Environment and Effects dialog open, open the Material Editor.
2. Click and drag the Environment map from the Common Parameters rollout of the Environment and Effects dialog to an unused sample slot (first column, second row).
3. When the instance (Copy) map appears, select Instance and click OK.

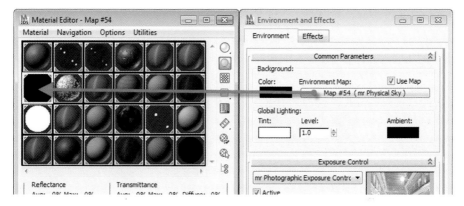

Creating an instance of the mr Physical Sky in the Material Editor

4. In the mr Physical Sky Parameters rollout, remove the check in the Inherit from mr Sky option. This will disengage the settings from the Daylight System.
5. In the Camera viewport, select any small object in the scene (e.g., a spotlight) and isolate the selection. This will accelerate the test renders of the sky.

Isolating an object *mr Physical Sky Parameters*

The sky background

12. Test-render the sky in the Camera view.

Test render after sky adjustments

6. Test-render the sky in the Camera view.

7. The sky is not bright enough or blue enough. The horizon appears to be a bit high for this camera view. You will make some adjustments in the Sky parameters to correct this:

8. Change the Multiplier to 5.0.

9. In the Horizon and Ground group, set the Horizon Height to about −1.8.

10. In the Non-Physical Tuning area, change the Red/Blue Tint to −0.2.

11. Decrease the saturation to about 0.75.

mr Physical Sky Parameters			
Sun Disk Appearance			
Disk Intensity:	1.0	Scale:	4.0
Glow Intensity:	1.0	(1.0 = "real" size)	

☐ Use Custom Background Map:	None	
☐ Inherit from mr Sky		
Multiplier:	5.0	
Haze:	0.0	☑ None
Horizon and Ground		
Horizon Height:	-1.8	Blur: 0.1
Ground Color:	⬛	☑ None
After Dark		
Night Color:	⬛	☑ None
Non-Physical Tuning		
Red/Blue Tint:	-0.2	☑ None
Saturation:	0.75	☑ None
Aerial Perspective (when used as lens / volume shader only)		
Visibility Distance (10% haze):	0.0m	

Adjusting mr Physical Sky Parameters

The next step is to incorporate the sky bitmap into the Sky parameters:

13. Click on the Map button adjacent to the Haze value.

14. Select Bitmap in the Material/Map Browser and open the "cloudy sky.jpg" from your project files.

15. In the Coordinates rollout, change the coordinates to Texture.

16. Remove the checkbox from Use Real-World Scale.

☐ Inherit from mr Sky		
Multiplier:	5.0	
Haze:	0.0	☑ None
Horizon and Ground		
Horizon Height:	-1.8	Blur: 0.1
Ground Color:	⬛	☑ None
After Dark		
Night Color:	⬛	☑ None
Non-Physical Tuning		
Red/Blue Tint:	-0.2	☑ None
Saturation:	0.75	☑ None

Adding the sky bitmap

Coordinate adjustments

17. Set the Coordinate type back to Environ.
18. Change the following settings:
 - Offset U: 0.1
 - Offset V: 0.1
 - Tiling U: 2.0
 - Tiling V: 2.0

Adjusting the coordinates of the bitmap

19. In the Output rollout, change the RGB Level value to 10.0. This will increase the intensity of the bitmap so that it does not get lost in the color generated by the mr Physical Sky.

20. Test-render the sky in the Camera view.

Adjusting the RGB Level

Sky with bitmap background

Color Map Output curve

21. Click on the Enable Color Map option. This will enable you to further fine-tune the levels of the bitmap through adjusting the curve points at the bottom of the Output rollout.

22. Click on the Add points button and add three points on the curve.

23. Click on the Move button and adjust the five curve points:
 - 1st point: 0.0; 00
 - 2nd point: 0.415; 0.128
 - 3rd point: 0.642; 0.247
 - 4th point: 0.848; 0.533

- 5th point: 1.0; 1.2

24. Test-render the sky again.

Adjusted sky background

Adjusting curve points

The sky looks good now.

25. Exit Isolation mode.

11.9 Creating a Final Gather Map File

Since your lighting is now fixed and there should not be any changes to it, you can now create a Final Gather Map file to accelerate renderings. Test renders of adjustments to materials will benefit from this process as well as the time required to create the final render. When you create and reuse a FG Map file, it bypasses that phase of the render process. In addition, you can create a FG Map file at a resolution such as 400×300 to use on 4000×3000 final rendering.

1. Go to the Render Setup dialog. In the Common tab, keep the resolution to 400×300.
2. In the Indirect Illumination tab, Reuse (FG and GI Disk Caching) rollout, make sure that the Single File Only (Best for Walkthrough and Stills) is selected from the list.

FG Reuse mode

3. Enable the Calculate FG/GI and Skip Final Rendering mode.

4. In the Final Gather Map area, select the Incrementally Add FG Points to Map Files option from the list.

5. Click on the Browse button, in the Final Gather Map area, and name and save your FG Map file (*.fgm).

Browse to save the FG Map file

7. In the Indirect Illumination tab, in the Reuse (FG and GI Disk Caching) rollout, click on the Generate Final Gather Map File Now button.

Generate FG Map file

Finalizing FG Map settings

6. Go to the Processing tab of the Render Setup dialog; in the Translator Options rollout, click Enable in the Geometry Caching area. In large scenes, this function will reduce translation processing time.

Enable Geometry Caching

Note: When saving the FG map file, it is advisable to save it on one machine only; also, avoid using distributed bucket rendering when saving the FG Map file.

8. Now that the FG map file has been saved, you can go back to the Render Setup dialog, Indirect Illumination tab, in the Reuse (FG and GI Disk Caching) rollout, and choose the Read FG Points Only from Existing Map Files option.

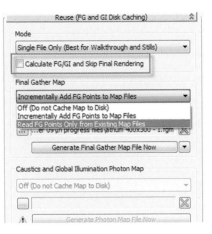

9. Remove the check from Calculate FG/GI and Skip Final Rendering.

Result of the FG Map file calculation

Note: Now that you have created an FG Map file and set it to be reused, 3ds Max Design will skip any FG processing and go directly to rendering. You must ensure that FG settings, lights, camera position, and geometry will no longer be modified, as an FG solution will be affected by their changes, producing a render with errors. You can continue to adjust most material settings apart from self-illumination and displacement maps.

Reusing the FG Map file

10. On the Processing tab of the Render Setup dialog, click to lock the Geometry Cache.

11.10 Fine-Tuning Materials

Next, you will start fine-tuning materials in the scene. Since you have saved your FG Map file this process will be faster. In the render created in the previous section, there are some areas that could do with less indirect illumination. One such area is the red wall area in the lower left of the image. You will adjust the walls' FG settings at the material level without having to recalculate the entire FG map.

1. Open the Rendered Frame Window.

2. In the Area to Render, choose the Crop type.

Locked Geometry Cache

Choosing crop area

3. In the Camera viewport, move the handles of the region to include the walls on the lower left of the image.

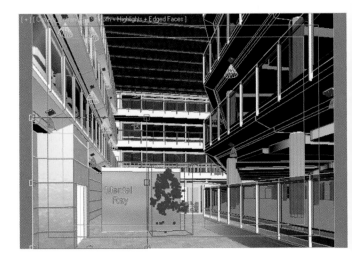

Adjusting the crop region in the viewport

4. Back in the Rendered Frame Window, disable the Edit Region button.

5. Render the Crop Region.

6. Open the Material Editor and select the red panel (Pearl Finish) material (first row, first column).

7. At the bottom of the Advanced Rendering Options rollout, in the Indirect Illumination Options area. Change the FG/GI multiplier to 0.7.

8. In the Material Editor, click on the Select by Material button.

Rendered Crop Region

Adjusting FG settings at the material level

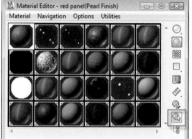

Select by Material

Render Selected Objects Only

9. In the Select Objects dialog, click on Select.

10. In the Rendered Frame Window, click on the Render Selected Objects Only button.

Note: This function enables only the selected object(s) to be rendered; however, it only works once a prerendered view/region/crop of an equal size image is in the frame buffer already from the previous render. It is fast, because it keeps intact the previous view/region/crop image on the frame buffer, and only computes the render of the selected object(s).

11. Click Render.

New image with material FG settings adjusted

11.11 Creating a Final Render

Next, you will adjust settings in the renderer to create a final image. You will change the final output size and the sampling quality of the render.

1. In the Render Setup dialog, Common tab, change the Output Size to 4000 × 3000.

2. In the Render Output area, click on Save File.

Changing the Output Size

3. Click on the Files button.

4. In the Render Output dialog, name the file "Atrium Final," and select the .tga format.

Note: The Rendering size is appropriate to maximize printing quality. The .tga file is selected because it saves alpha channel settings and maintains image quality.

Saving the rendered output to a file

5. Click on the Setup toggle in the Render Output dialog.

6. In the Targa Image Control dialog, make sure that Bits-Per-Pixel is set to 32 and the Compress and Pre-Multiplied Alpha option is selected.

Targa Image Control

Saving the rendered output to a file

7. Click OK to exit the Targa Image Control dialog, and then Save to exit the Render Output dialog.

8. In the Rendered Frame window, make the following changes to the mental ray Render settings:
 * Slide the Image Precision (Antialiasing) slider to High: Min 1, Max 16.
 * Set the Glossy Reflections Precision to 2.0x–High Quality (optional).
 * Set the Soft Shadows Precision to 4.0x–High Quality (optional).
 * Set the Glossy Refractions Precision to 2.0x–High Quality (optional).

mr settings in the Rendered Frame window

9. Set the Area to Render to View.

10. Toggle off the Render Selected Objects Only button.

11. In the Render Setup dialog, Renderer tab, Sampling Quality rollout, set the Filter Type to Gauss. When rendering large files, it is often not necessary to use other, sharper filters, such as Mitchell.

12. In the Options area, make sure the Jitter option is enabled; this will eliminate jaggy areas in the render.

13. In the Bucket Order list, make sure that Hilbert (best) is selected. If you have a fast computer, the Top-down or Bottom-up option will compute renders faster by using more memory.

14. In the Rendering Algorithms rollout, Raytracing Acceleration area, change the Method to BSP2.

15. In the Reflections/Refractions area, change the following parameters:
 - Max. Trace Depth to 5
 - Max. Reflections to 1
 - Max. Refractions to 5

Note: Lowering the Reflections, Trace Depth, and Refractions is done to prevent render times from being severely affected by the number of glass and reflective materials in the scene.

16. Save your file.

17. This rendering may take a fair amount of time to process; when you have some time to execute it, click Render.

Note: If your computer has low specs, you may find that the final renders will take a long time to finish. You can choose to reduce the mr Portal Light Shadow Samples from 32 to 16. In addition, you can also go to Global Tuning Parameters and change the Soft Shadows Precision: Glossy Reflections and Refractions to 1.0. Making these changes to the mr Portal Light Shadow Samples will invalidate the FG Map file, so you will need to recreate it.

Area to Render

Sample Quality settings

Rendering algorithm settings

Note: When rendering images of 2 K pixels or larger, you will most likely wish to use network rendering. For more information, please see Chapter 4.

Rendered image

A harbor scene rendered at dusk

Section 5

mr Physical Sky

Introduction

In this section, you will learn about adjusting the mr Physical Sky Environment map.

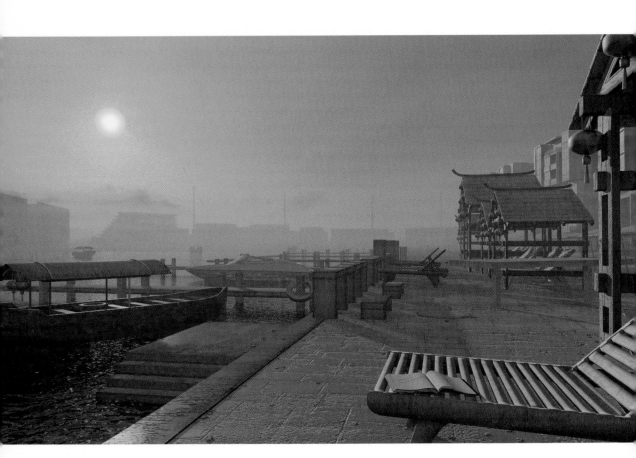

A harbor scene rendered at dusk

Chapter 12

<div align="right">

Working with the mr
Physical Sky Shader

</div>

12.1 Introduction

In this chapter, you will learn about enhancing the exterior environment through the use of the third component of the daylight system, mr Physical Sky. mr Physical Sky is an environment map that you find in the Environment and Effects dialog and is automatically inserted as the Environment Map when you chose mr Physical Sky when the Daylight System was created. In this chapter, you will learn how to:

- Render a disk of the sun or moon using mr Physical Sky
- Adjust the parameters that affect the appearance of this disk element
- Create camera haze
- Apply a bitmap background that will interact with the mr Physical Sky shader

12.2 Controlling the Daylight System

As you have seen in other tutorials, when you create a Daylight System, the date, time, and location of the sun defaults to San Francisco, June 21st, at noon. These values are displayed in the Control Parameters rollout, which appears when you initially create a Daylight System and can be accessed when you modify a Daylight System by selecting Setup from the Daylight System Parameters in the Modify panel.

In the Time area, you can input:

- Hours, Minutes, Seconds
- Month, Day, and Year

Control Parameters *Daylight Parameters*

In the Location area, you can input geographic location:

- In terms of Latitude and Longitude
- By selecting locations in the maps accessed through the Get Location button
- By adjusting the direction of North for your scene

Note: If you select a location through the Get Location dialog and subsequently adjust the Latitude or Longitude, the Location will disappear from the rollout.

Geographic Location

A Weather Data File can be accessed from the Control Parameters or from the Daylight Parameters. After selecting the Weather Data File option, click the File button. The Configure Weather Data dialog allows you to load up a Weather Data from files available via the Internet.

The following links are good examples:

- http://apps1.eere.energy.gov/buildings/energyplus/cfm/ weather_data3.cfm/region = 4_north_and_central_ america_wmo_region_4/country = 1_usa/cname = USA
- http://apps1.eere.energy.gov/buildings/energyplus/cfm/ weather_data.cfm

Configure Weather Data file

Note: Some of these data files may have been created years ago.

Websites with weather data

Selecting a Weather Data file

However, you can request more recent data from the website.

1. Open the file "epw render.max."
2. If the File Load: Units Mismatch dialog appears, click OK to adopt the file's unit scale.
3. Select the Daylight System and go to the Modify panel.
4. In the Daylight Parameters rollout, the Weather Data File is already selected; click on the Setup button.
5. In the Configure Weather Data dialog, note that the Weather Data File .epw

Accessing the Configure Weather Data dialog

is already loaded.

Note: Sometimes the default parameters may be set up too early in the day or too late at night and therefore a completely black render will result.

6. Click on the Change Time Period button.

Configure Weather Data dialog

7. In the Select a Time period from Weather Data, move the slider and note the change in the Time period above. For more precise adjustments, you can use the Months, Days, Hours, and Minutes spinners.

8. Click on the Display Data as Animation option.

9. To enable 3ds Max Design to calculate the necessary frames to compute the animation, select the Skip Hours and Skip Weekends options.

10. Click on the Match Timeline button, which will adjust the total number of frames of the animation.

You are ready to render the animation.

12.3 mr Physical Sky and the Sun Disk

The sun disk—or moon, for that matter—is a rendition of the spherical shape of the sun. It is generated by the mr Physical Map Environment shader at the location of the Sun object in the Daylight System.

What is of greater interest to us at the moment is the ability to place the sun object at a specific location in our scene. In the Daylight Parameters rollout, select the Manual option, which will allow you to place the sun by using the Select and Move tool. Although using this method is not necessarily correct based on the location of the scene on the earth and a time of day and year, it allows you to add some artistic license and improve the composition of the image.

Select a Time Period from Weather Data

Setting up an animation

Moving the Sun to a Desired Location

In the following steps, you will relocate the sun so that it will fall into the field of view of the camera.

1. Open the file "Harbour Physical Sky_Start.max."

2. If the File Load: Units Mismatch dialog appears, click OK to adopt the file's unit scale.

3. Render the Camera view.

Initial render

4. Select the Daylight01 system.
5. In the Daylight Parameters rollout, select the Manual option in the Position area.
6. Click on the Select and Move button in the Main toolbar.
7. Move the top of the daylight object in the Front viewport so that the angle of the system is approximately 10 to 15 degrees off the horizontal. You should be able to see the sun object in the Camera viewport.
8. Render the Camera view.

Daylight Parameters

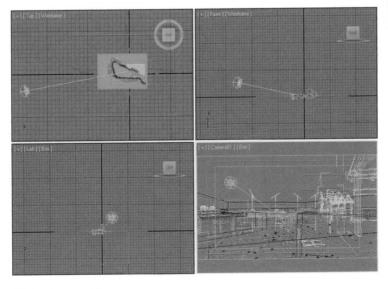

Moving the sun position

Rendered sun position

Further adjustments of the mr Physical Sky need to be done in the Environment and Effects dialog and the Material Editor.

12.4 The mr Physical Sky Shader

When you open the Environment and Effects dialog, note the presence of the mr Physical Sky in the Environment Map slot.

Creating an instance of this map in the Material Editor will reveal the mr Physical Sky Parameters.

mr Physical Sky in the Environment Map channel

You will be able to see the effect of these parameters only when you render the scene. Numerical values are based on the scale of the objects as well as the units chosen.

Sun Disk Appearance Group

Note that there's a slight offset between the position of the daylight object in the viewport and the sun disk appearance when rendered.

Disk Intensity: Its appearance seems to remain intact whether the value is high or not; however, when a bitmap is loaded in the haze toggle, it becomes more apparent when its values are increased. Default = 1.0.

Glow Intensity: Sets the amount of glow around the sun. Default = 1.0.

Scale: Sets the size of the sun disk appearance when rendered. Default = 4.0.

Use Custom Background Map: When enabled, allows a bitmap to be applied to the environment. Default = none.

Inherit from mr Sky Group: When unchecked, unlinks the mr Physical Sky Parameters from the mr Sky component of the Daylight System object parameters (skylight).

mr Physical Sky in the Material Editor

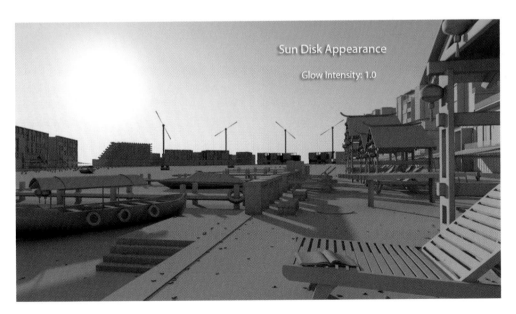

Glow Intensity set to 1.0

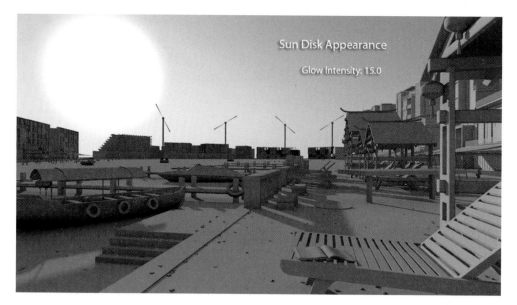

Glow Intensity set to 15.0

Note: If you have unlinked the mr Physical Sky parameters from the mr Sky, there is a chance that the horizon height values will no longer match (if you have adjusted them from their default values). When you render, you will see two horizon lines. Therefore the Horizon height of both the mr Physical Sky parameters and the mr Sky should be identical.

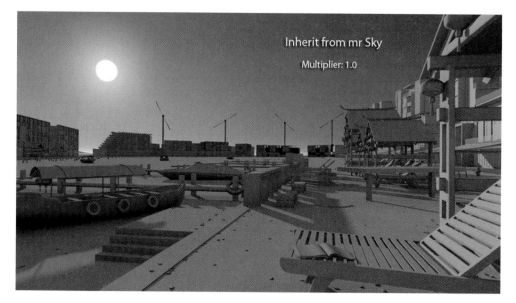

Multiplier set to 1.0

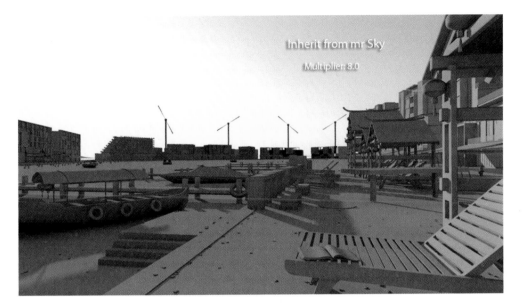

Multiplier set to 8.0

Multiplier: Sets the brightness of the sky. When on, default = 1.0.

Haze: Sets the amount of haze (fog) in the sky. This is mainly to blend a bitmap with the current sky. Note that when using a bitmap in this slot, the RGB Level value under the Output Parameters rollout must be 6.0 or above for visible results. Default = 0.0.

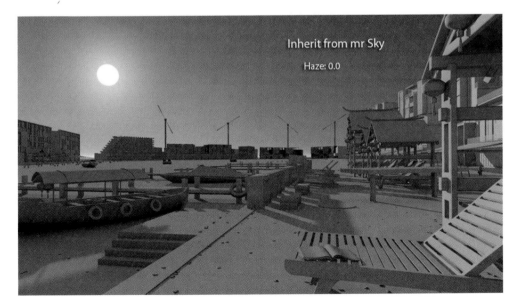

Haze set to 1.0

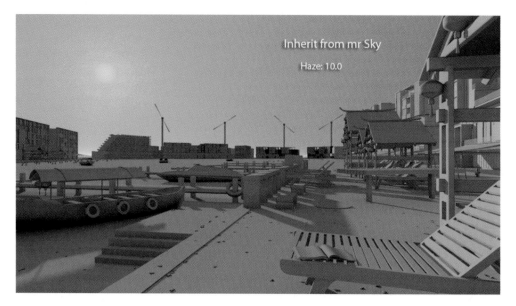

Haze set to 10.0

A map can be assigned to the Haze value to give a varied texture to the sky. See more about this in the following tutorial.

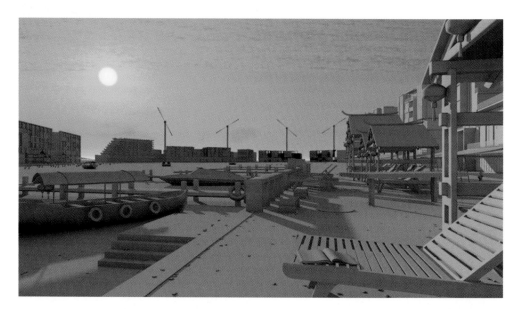

Haze with a bitmap

Horizon and Ground Group

Horizon Height: Sets the position of the horizon line. In a typical two-point perspective, where the camera and target are at the same Z height, the horizon is in the vertical center of the view (i.e., halfway up the Y axis).

This value allows you to adjust where the horizon is positioned relative to this default location. It is easy, though, to create a view where the horizon is not visible in the view. For example, a view looking up or down where only sky or ground is visible will not display the horizon line. The default 3ds Max Design perspective view does not see the sky, and therefore the horizon line is not visible. Default = 0.0.

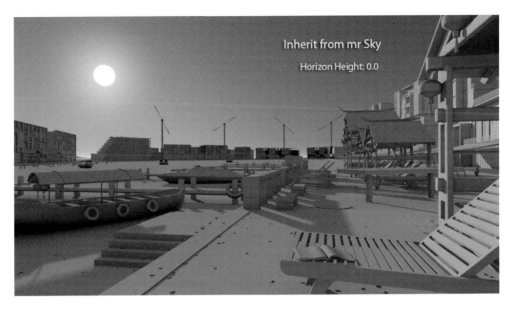

Horizon Height = 0.0

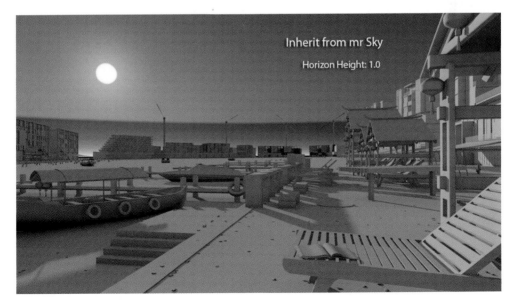

Horizon Height = 1.0

Blur: Determines the blurriness of the horizon line. Default = 0.1.

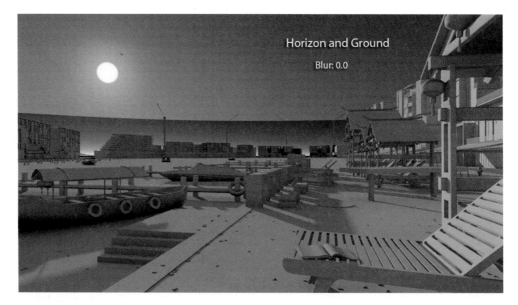

Blur = 0.0

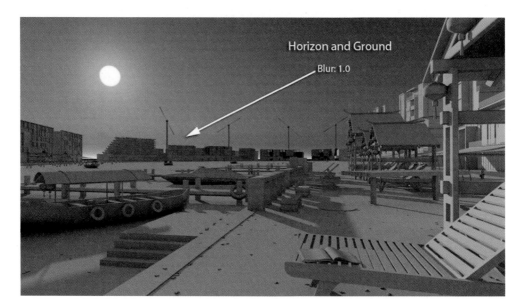

Blur = 1.0

Ground Color: Sets the color of the lower part of sky's horizon line. Its default color can be changed by clicking its color slot. Or, alternatively, load a custom bitmap on the empty slot. Default = Dark gray.

After Dark Group

Night Color: Sets the color of the sky as the Daylight System object comes closer to the horizon line; note that the night color transition happens automatically. Its default color can be changed by clicking and holding its color slot. Or, alternatively, load a custom bitmap on the empty map slot. Default = Black.

Non-Physical Tuning Group:

Red/Blue Tint: Sets the color or tint of the sky. Negative values start from -0.1, which is equivalent to a light tone of blue, to a darker tone of blue, which is equivalent to -1.0. Positive values start from 0.1, which is equivalent to a light tone of yellow, to a darker tone of yellow, which is equivalent to 1.0. Alternatively, a custom bitmap can be loaded into the empty map slot. Default = 0.0 (neutral).

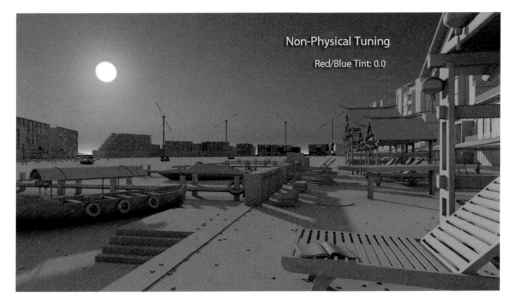

Red/Blue Tint = 0.0

Saturation: Sets the saturation of the Red/Blue Tint. This option is very useful to tone down strong colors like dark blue (-1.0) or dark yellow (1.0). Default = 1.0.

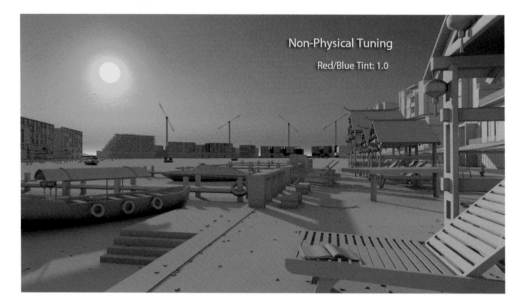

Red/Blue Tint = 1.0

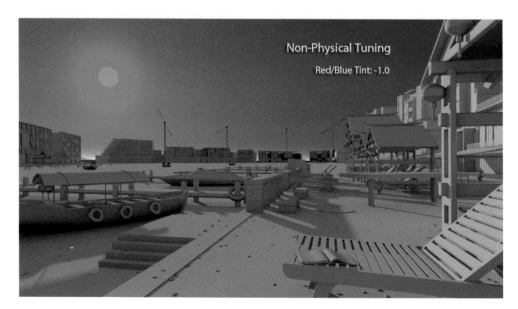

Red/Blue Tint = − 1.0

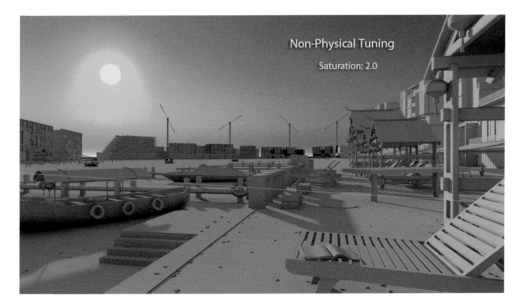

Saturation = 2.0

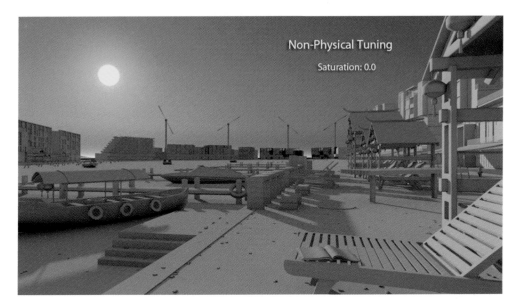

Saturation = 0.0

Aerial Perspective (When Used as Lens/Volume Shader Only) Group

Visibility Distance (10% haze): Sets the visibility of the sun disk under the haze (10%). Note that this option is recommended only when using this shader as a camera shader, as this will enable the haze's distance control.

12.5 Creating Camera Haze

In the following steps, you will create a camera haze, which will allow you to control the haze depth.

1. Open the file "Harbor Camera Haze_Start.max."

2. If you see the File Load: Units Mismatch dialog, click OK to adopt the file's unit scale.

3. Open the Render Setup dialog box.

4. Click on the Renderer tab.

5. Go to the Camera Effects rollout.

6. Click on the map slot next to the Lens option in the Camera Shaders Area.

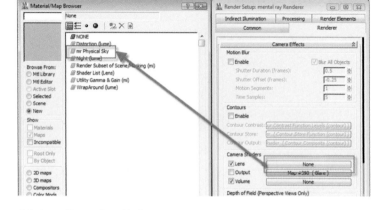

Selecting a Camera Lens Shader

7. Select mr Physical Sky from the Material Map browser. Click OK to close the dialog.

8. Drag and drop this map into the Volume Map slot; select Instance when prompted by the Instance (Copy) Map dialog.

Instancing the mr Physical Sky Shader *Result of the instanced shader*

9. Open the Material Editor.

10. Drag and drop the map in either the Lens or Volume slot into a Material Editor sample slot.

11. Select Instance when prompted by the Instance (Copy) Map dialog.

12. Open the Environment and Effects dialog.

13. Drag and drop the map in either the Lens or Volume slot into the Environment Map slot.

14. Select Instance when prompted by the Instance (Copy) Map dialog.

Instancing the shader in the Material Editor and the Environment Map

Note: Even though there already is a mr Physical Sky map in the Environment Map slot, it is not instanced to the one in the Camera Shader slots. The previous operation creates an instanced map.

15. Render the Camera view.

Render with default values

No haze appears in the view, as the default Visibility distance of 0.0 disables the haze.

Aerial Perspective (when used as lens / volume shader only)

Visibility Distance (10% haze): 200.0mm

16. In the Material Editor, change the Visibility distance to 200.0.

Visibility value set to 200.0

17. Render the Camera viewport.

Render with the Visibility value set to 200.0

A very obvious haze now appears in the image. You can adjust the distance to your liking, so the haze starts closer to the camera or farther away.

Note: These parameters are similar to the Daylight System object. The Daylight System object parameters interact with the objects in the scene, whereas the mr Physical Sky parameters affect only the sky. Its interactivity only goes as far as being visible on reflective surfaces.

12.6 Using a Bitmap Background in mr Physical Sky

In the next few steps, you will insert a background in the mr Physical Sky shader so that the background will interact with the other settings in the mr Physical Sky:

1. Open the file "Harbor Sky Bitmap_Start.max."
2. If you see the File Load: Units Mismatch dialog, click OK to adopt the file's unit scale.
3. Render the Camera01 view.

Initial render

4. Open the Material Editor dialog box.
5. In the Rendering pulldown menu, select Environment.
6. Drag and drop the map in the Environment Map slot (mr Physical Sky) shader from the slot to a material slot in the Material Editor dialog box.
7. The instance (Copy) map dialog box will pop up. Choose the instance method followed by OK to close the dialog box.

Instancing the mr Physical Sky shader

8. The mr Physical Sky Parameters rollout will appear.

9. Uncheck the Inherit from mr Sky option.

10. Click on the Haze Map slot and choose Bitmap from the Material/Map Browser dialog followed by OK to close the dialog box.

Selecting a bitmap for the Haze Map channel

11. Go to the project folder and open the bitmap "Sky Sunset copy.jpg."

12. Once the bitmap is loaded, in the bitmap coordinates, change the Mapping to Screen.

13. Change the Blur value to 0.5. This will sharpen the bitmap.

14. Go to the bitmap Output rollout and set the RGB Level value to about 20.0. Higher values are recommended so that the bitmap will be more visible in the rendering.

RGB output level

Adjusting the bitmap coordinates

15. Render the Camera view.

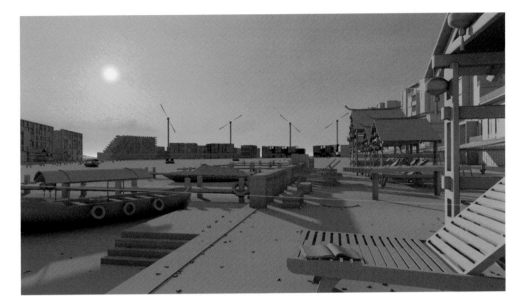

Render with Sky bitmap

12.7 Daylight Object and the mr Physical Sky

The Daylight object parameters are similar to the mr Physical Sky parameters; however, in addition, we have the mr Sun Basic parameters and mr Sun Photons.

mr Sun Basic Parameters

Multiplier: Sets the intensity and influence of the directly lit areas in the scene.

Shadow Softness: Sets the sharpness of the sun's shadows in the scene. High values soften the shadows and lower values sharpen them.

Softness Samples: Sets the quality of the soft shadows, if any, in the scene. This value may cause the render to take longer. Increasing the default value is often not required.

Inherit from mr Sky: Breaks the dependency link of the Nonphysical Tuning parameters to the mr Sky parameters. When on, the Nonphysical Tuning parameters are grayed out. The Red/Blue Tint and Saturation values work similarly to the previously described mr Physical Sky parameters.

mr Sun Photons: When using GI, enabling Use Photon Target will allow you to set a Radius value to restrict photon calculations from going beyond the set radius. This can help save unnecessary GI computation. The radius gizmo can be seen interactively in the viewport.

Render with sky bitmap

mr Sky Parameters

Multiplier: Locally sets the intensity and brightness of the indirectly lit areas.

Ground Color: Sets the color of the lower part of the sky's horizon line. Its default color can be changed by clicking on its color slot. Or, alternatively, load a custom bitmap on the empty slot. Default = Dark gray.

Sky Model: This list enables you to load a variety of sky types: Haze driven, and Perez all weather & CIE. Each sky model has its own parameters.

Perez All Weather & CIE
Diffuse Horizontal: This value measures and controls the luminance of indirectly lit areas only, horizontally.

Direct Normal Illuminance: This value measures and controls the luminance of directly lit areas only.

CIE
Overcast Sky: When checked, it overcasts the sky

Clear Sky: When checked, it clears the sky.

mr Sky Parameters set to CIE

The remaining parameters work similarly to the ones described in the discussion of the mr Physical Sky parameters.

Index

H

I

415 2299888
Wakefield Bldg

5859791
ofic abov
Relto to 1500 Sq